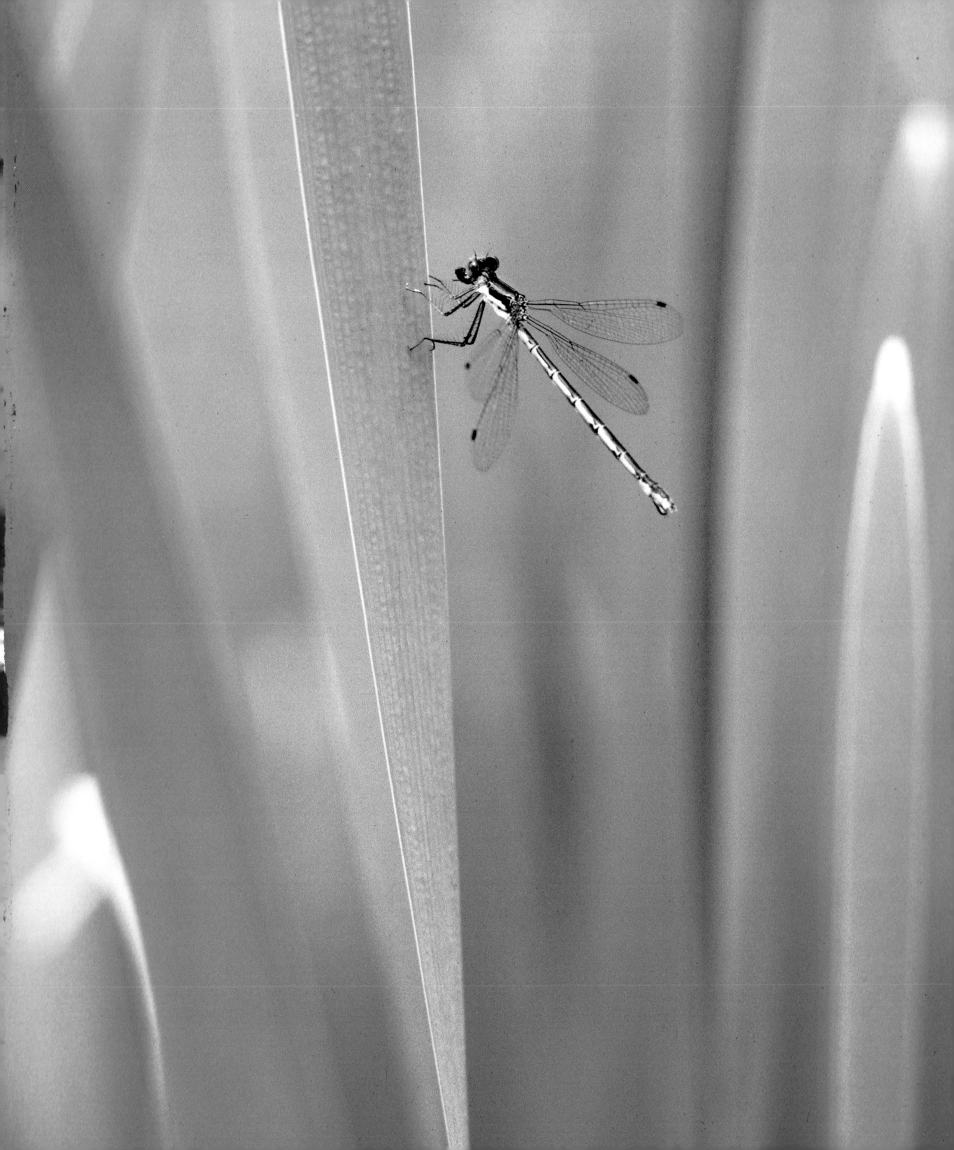

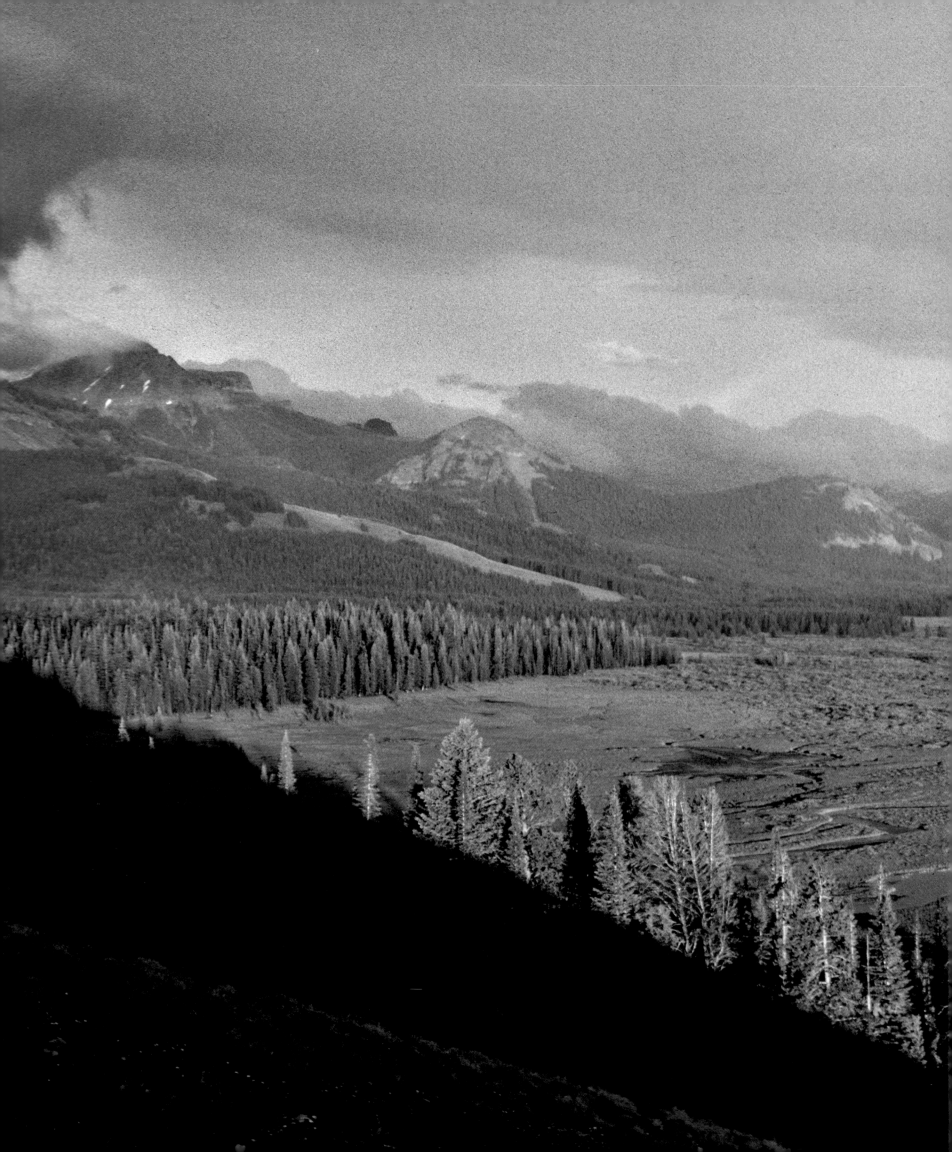

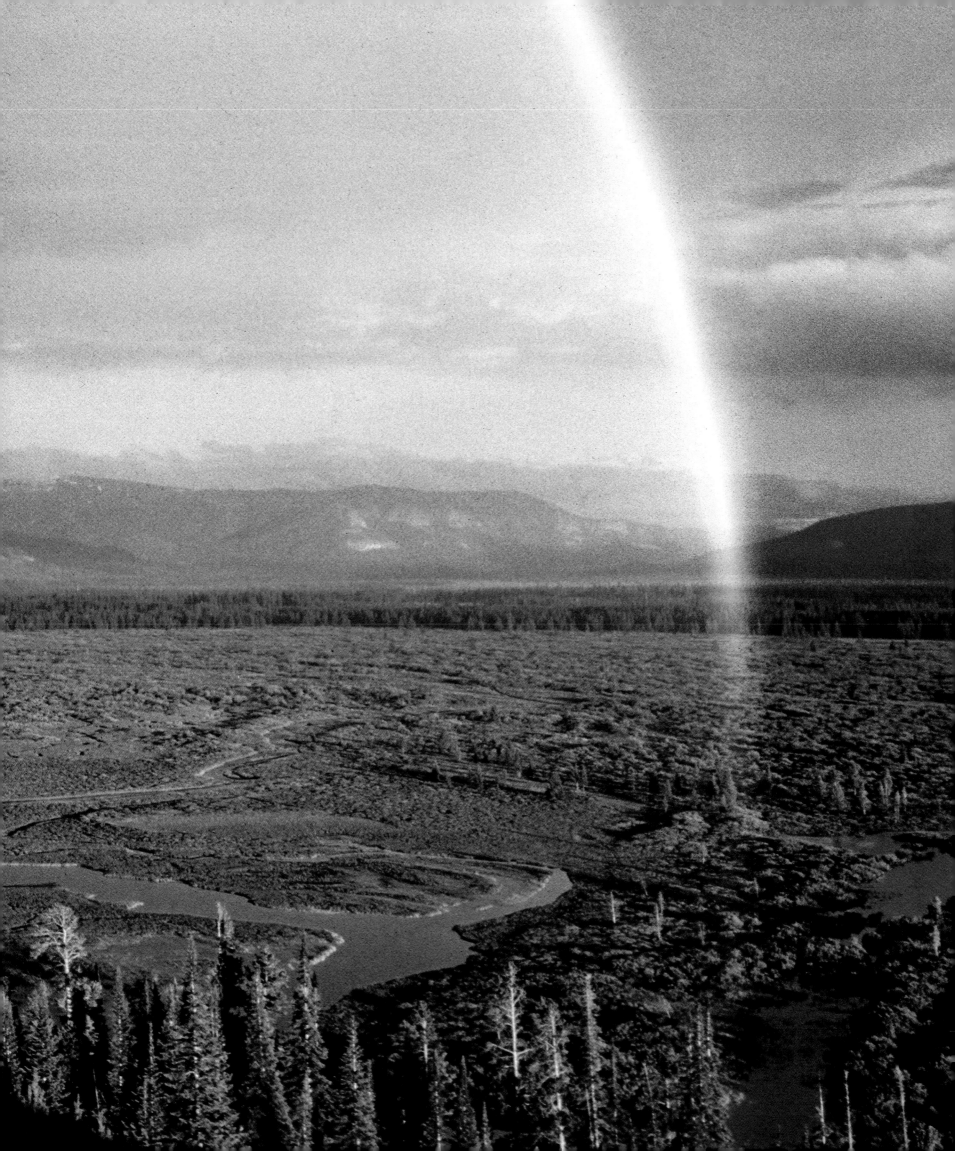

A quick evening rain shower came east across the Southeast Arm of the Lake and out over the Yellowstone marsh at the north end of the Thorofare trail.

The clouds on the horizon opened up and revealed the sun. I raced up the ridge to get a higher perspective as the rainbow appeared briefly in the thinning rainfall, creating a margin of color in the vast open sky.

Grizzly cubs are curious, intelligent, and playful. They will play with sticks and rocks, chase each other around, and wrestle and bite each other. They can climb trees and are agile and limber. This grizzly cub was lying down in the grass, twisting, squirming and sitting. Like most juveniles, it burned up energy and ended up in curious positions.

THE ABUNDANCE *of* SUMMER

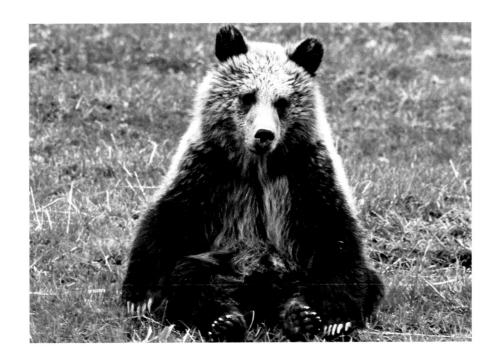

THE SEASONS OF YELLOWSTONE

by Tom Murphy

Crystal Creek Press

THE SEASONS OF YELLOWSTONE

The Abundance of Summer is the third of a four-volume set by Tom Murphy called *The Seasons of Yellowstone.* The turning of a full year in Yellowstone Park gives us four distinct seasons. Each one overlaps and flows into the next one but has its own unique character.

Spring's uniqueness comes from the powerful pulse of light warming the land. It starts and maintains the growth of vegetation and supports the birth of a myriad of creatures.

Summer is defined by the growth of the wildlife and the luxuriant leaves, flowers, grasses, and forbs. The long warm days and cool nights make it the most pleasant and easy season.

Autumn brings maturation and independence for the young animals, the rut and mating season for many large mammals, and the drive to put on fat for the coming winter. It is the time for the seeding of plants and starting the process of dormancy for trees, bushes, grasses, and forbs.

In winter the struggle to endure and survive the harshest weather of the year is evident in every part of Yellowstone. It is the season of simple, quiet, and clean beauty. Snow sweeps over the landscape reforming the land into smoother and softer shapes while the cold, at the same time, is brittle and sharp.

Please send us your name and address if you would like to be notified when the winter volume, which completes this set, is released.

All photographs in this book are available as archival giclée prints.

Crystal Creek Press, 402 South 5th Street, Livingston MT 59047 406 222-2302

Published in 2009 by Crystal Creek Press
Livingston, Montana

Book design by Adrienne Pollard
Printed and bound in China by C & C Offset Printing Co., Ltd.

ISBN 0-9668619-8-1 (clothbound)

Hot mineral-laden water from the Lower Geyser Basin flooded this area years ago and killed the lodgepole pines. Through capillary action some of the minerals were pulled up into the trees, coloring their trunks white up to four feet from the ground and preserving them from decay. The flooded area has remained a marsh, thick with reeds and sedges.

Everybody needs beauty as well as bread, places to play in and pray in, where nature may heal and give strength to body and soul.

—JOHN MUIR
author and naturalist
(1838-1914)

Yellowstone is one of the finest wild lands left in the world and millions of people go every year to see it.

Before 1872, when it was set aside as the world's first national park, few white people had seen this wild land; although, archaeological evidence clearly shows that people were here for at least 10,000 years. Pre-literate people traveled across it to reach other parts of the intermountain west, or they occupied it seasonally to utilize its wildlife and other resources. A few small groups lived permanently in the northern areas at lower elevations where the climate was more moderate.

When modern Europeans arrived here in the 1830s, they came to take the easy riches, primarily the furs of otter and beaver. When the fur wealth was exhausted, the area was largely ignored until the next wave of white people came looking for gold and silver, though they found little since the Yellowstone plateau is primarily volcanic.

As the wealth of Europeans and Americans increased, more people had leisure time to travel for sightseeing, to enjoy the experiences of places unfamiliar to them, and to learn. The first white settlers tried to profit from the tourists and travelers. James McCartney and Henry Horrs' baths and

"hotel"at Mammoth; McGuirk's claim of the Boiling River for a hot bath house; and Jack Barronette's Yellowstone toll bridge, were all established before Ferdinand Hayden came in the fall of 1871 to investigate the geothermal curiosities for the United States Government and before Yellowstone was made a park on March 1, 1872.

The world benefited because a small group of people saw the possibilities of a new concept for preservation and conservation, a national park. The national park idea was the best idea this country ever had according to writer Wallace Stegner.

Three things came together to allow the Park to be established. First, few white people had any prior claim to this government land. An argument at the time for the establishment of this area as a Park was that the land was worthless. It had no minerals and little timber, it was too cold for agri-

culture, and too remote to be of value for anything else except sightseeing. Second, in 1870 and 1871, a few influential individuals rejected the chance to claim private ownership of geysers, lakes, and waterfalls and instead worked for the common good to make it a place that remained virtually untouched for everyone to enjoy. Third, the Northern Pacific Railroad, a land grant railroad with a route planned in the 1860's up the Yellowstone River north of the Yellowstone Plateau and on west to Tacoma, saw a National Park as a great possibility for commerce. They supported the Park's establishment because they could see good business possibilities from hauling tourists to this place. Railroads were powerful and influential and with their political and economic clout, they supported and helped pass the National Park bill.

Congressmen voting in January and February of 1872 had no idea that this new creation would be successfully copied by other countries around the world, even though the Park itself was a virtual orphan at the start. The altruistic language of its organic act unfortunately provided no guidance for practical management of the Park, and no money was allocated for six years to even put up a sign. The first superintendent only visited Yellowstone twice in his five-year tenure.

There was also powerful criticism of the idea to exclude private ownership and commerce, an argument we still hear today concerning our public lands. There was no model in place for managing, promoting, and policing a remote communally-owned park. The Park was nearly voted out of existence by Congress in 1885, in a secret scheme by Superintendent Robert

Carpenter and his friends in Congress to abolish the Park and to steal the land around Old Faithful and other popular geysers and the Lower Falls. After struggles with legal jurisdiction, poaching, hotel concession rights and anti-park sentiments, the Secretary of the Interior Lucius Quinctius Cincinnatus Lamar sent the army to manage the Park in 1886. The army and their acting superintendents did a good job of managing the Park until the National Park Service was established in 1916 and a force of civilian managers and law enforcement officers took control.

For the first forty years of its history, Yellowstone was promoted as civilization surrounded by wilderness. Now it is perceived as wilderness surrounded by civilization. Many of today's visitors come to see the wild character of Yellowstone. Wildlife is visible every day from the roads and parking pullouts. With some luck, visitors can witness some of the daily life stories of animals ranging from warblers and jays, to elk and bison, to wolves and grizzly bears. Yellowstone is still a sanctuary and nursery for nearly all of the Northern Rocky Mountain wildlife that existed here in proto-historic time. It contains the majority of all the world's geysers, which are rare geothermal features found only in volcanic regions. Most geyser basins in the rest of the world have been severely damaged or destroyed by humans. Yellowstone's geyser basins and wild ecosystems are still mostly intact and relatively secure because of the continuing force of the original altruistic ideals of the National Park founders. Despite the 466 miles of roads in Yellowstone, most of the Park retains a powerful wilderness character. The backcountry is de facto

wilderness because the Park's ecosystems are maintained for processes of natural abundance, diversity, and ecological health.

<div align="center">★ ★ ★</div>

The things that I like most about the Park are its natural wildness, its unmodified landscape, and its clear dark skies. After living more than 30 years next to Yellowstone and spending several thousand days wandering around it on foot or skis, in canoes or rubber rafts, I still see something new and different every day that I am there, and I am now more attracted by and intrigued with Yellowstone than I have ever been.

In the summer I can walk to the most remote occupied building outside of Alaska, the Thorofare Backcountry Ranger Cabin. I can paddle 141 miles around the perimeter of one of the most beautiful, wild lakes in the world, Yellowstone Lake. I can climb some of the least visited peaks in the lower 48 states in the Absaroka and Gallatin mountains. I can hike over 1000 miles of established backcountry trails and expect to see no one for days at a time on most of the trails. I can watch wildlife and witness nearly all of their stories from birth to death.

Under some of the clearest skies, and beside some of the cleanest water in the world, I can rest my heart in the peace, continuity, and strength of a residual piece of healthy, dynamic land where life goes on without our interference as it has in its wisdom and power for thousands of years. The connection to this force of continuity and strength rejuvenates me every time I get close to the heart of Yellowstone. This can begin even when looking out the windshield of a car, but I truly connect

when I get out on the land and walk. This connection to the dirt, to the sage, to the rocks and rough-barked pine trees is real. The connection to the dew-covered grasses soaking my pant legs, to the smooth tangy smell of sulfur springs, to the flutter of a junco's wings, to the repetitious chirps of robins from the aspen groves along Slough Creek at sunrise is real. The connection to the quiet sighs and little splashes of the small morning waves on the Southeast Arm of the Lake, to the full moon rising over the Trident while I sit on a downed log in a marshy meadow full of monkshood, gentian and elephant head flowers along the Thorofare is as real and honest as anything I have ever witnessed.

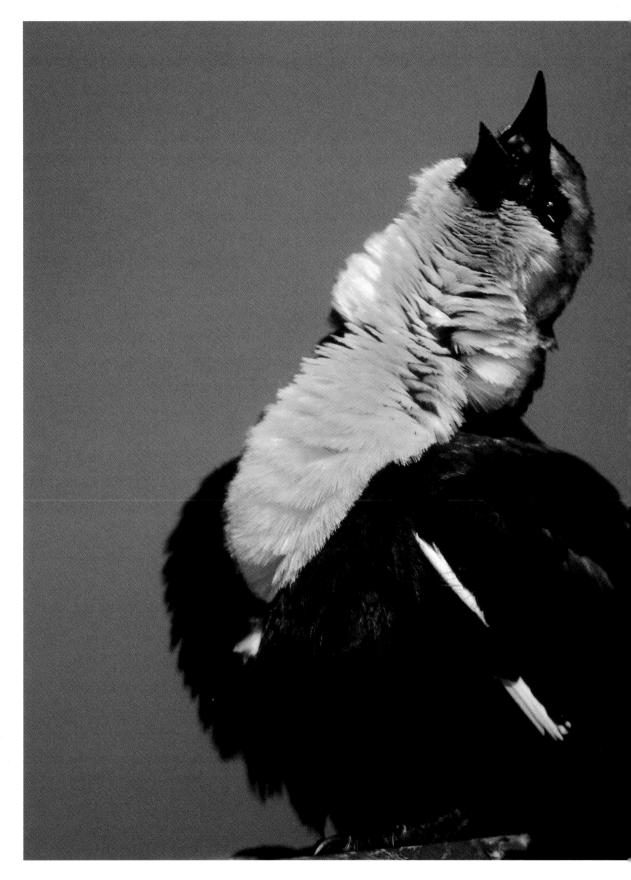

Male yellow-headed blackbirds defend a section of a marsh from other males, protecting a nesting area for their mates.

If you sit and watch a marsh full of these birds for an hour or so, you will discover the boundaries of each individual. Within each bird's territory will be a couple of favored observation perches, like this one, from which this male watched over his domain with a sharp eye and a noisy voice.

One evening, I was sitting on a hillside near Lynx Creek watching the sunlight as it stretched across the valley to Bridger Lake. Having seen no one for a week, I glanced at a cobble of petrified wood at my feet and realized that it had been flaked by someone, possibly thousands of years before, who had scattered pieces down the slope while making a tool and watching the same landscape under a similar late afternoon sky.

While climbing among the ridges near Parker Peak, I discovered a rock structure about 6'x 8' on a cliff edge overlooking the head of the Lamar River. Hoodoo Peak, Lamar Mountain, Pollux and Castor Peaks, and the Grand Teton in the faint distance spread for miles before me. This rock enclosure was typical of vision quest sites where prehistoric people went to get a sense of who they were and what they could do with their lives. It was still an appropriate place to seek the answers to the same questions in our modern world. The mountains all around are nearly unchanged from the past hundreds or thousands of years. The answers can still be found in wild places like this, places that are still honest without human economic forces dominating them, without "civilized" roads, ski lifts, power lines, hydroelectric dams, houses and yard lights, which twist and damage places to serve our wants, while destroying the complex lives and needs of things like butterflies, grizzlies and pine nuts.

We seek the answers to our own existence, but we must consider the rest of our neighbors. Our neighbors include all creatures because we all share the same planet. Going to a wild place like the Yellowstone backcountry makes it easier to listen because the source is pure and clear. It is closer to the basics of reality. Yet it can be difficult to stop and listen even in a wild place like Yellowstone. It takes open-minded effort to go to these mountains and hear the songs of life and truth in the risky quest for answers. After we get past our need for basic life sustenance and a community of other people, the next step is to connect with the community of all life, to recognize that we are a part of all of it, with responsibilities to support every single part of our world community as equals.

★　　　★　　　★

After dark one August, on the east side of Yellowstone Lake, lightning flickered way off to the west. For the first ten minutes I couldn't hear any thunder. The storm front came on toward me from the southwest until I could see the twisted, bright fingers of the lightning. I could count to three before the sound hit the trees above me and passed me to hit the ridge behind me. After another three or four seconds, the echo came back from the east muffled a little by the trees. Then after another few seconds an even more faint rumble came from the echo which had bounced off hillsides to the south. When the storm was all around me, each flash of lightning created a series of sounds mimicking the first sharp

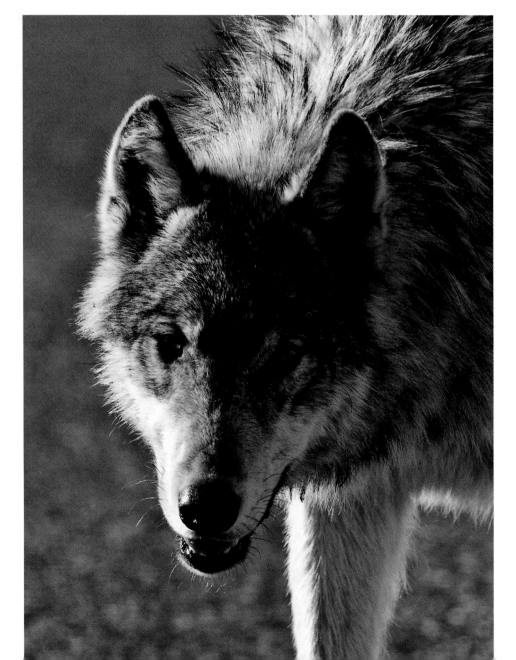

Yearling, Druid Peak Pack,
Lamar Valley.

boom followed by different deeper echoing tones, funneled and bounced off the clouds above, muffled and smothered by vegetation, pulled sideways by wind, and acoustically modified by concave rock faces.

It is while hiking, unencumbered, that I live the most lightly on the land. One day, while hiking near the base of Mount Stevenson, I was caught in a sudden, heavy rain shower. I crawled under a large spruce tree below its soft, springy, drooping branches. It was a perfect umbrella. Sitting in the dry dusty needles and bark chips heaped up at the base of its two and a half foot diameter trunk, I watched from my refuge, an amazing cascade of raindrops. At first the big drops smacked into the earth and raised tiny clouds of dust, but soon everything was wet, and then the big drops raised little plops of muddy water. The grasses hissed and bent from the raking sheets of rain. Small muddy rivulets formed everywhere within five minutes. Water rushed down the slopes and pushed or carried needles, stems, mud and pebbles. It created puddles and pools that looked as if they were boiling from thousands of rain drops. A few pieces of hail and ice appeared even though the temperature had been nearly 80° a few minutes before. Looking more closely at my retreat under the spruce tree, I watched shiny black ants climbing over the debris I sat on, and I saw spider webs clinging to the low branches around me. After about ten minutes of heavy rain, I started to wonder when the moisture would penetrate the branches above me. So far they had worked like shingled thatch to channel the rain away from the trunk and down to the needle tips. Then water started to drip through the branches

straight down the back of my neck. The tree was becoming saturated from top to bottom. I noticed a spot of sun appearing below the dark cloud which was the source of this fantastic rain show. When I pulled my light jacket out of my pack to put over my head, I noticed my hair was full of pine needles, and I sneezed from all the dust I had disturbed. After a couple more minutes it stopped raining. Now it was dripping quite a lot under the tree, so I crawled out to let all that moisture soak the dusty needles there. I walked out in the muddy open. My pant legs and shoes were soaked after walking only a hundred yards, but the world smelled like the beginning of everything good. The muddy rivulets were murmuring, and you could hear little pebbles being tumbled in the water. Gusts of wind fluttered the trees, shaking out buckets of large water drops. The birds, silent during the rain and probably doing just what I had done, started to sing and move around again. The warm earth steamed a little and produced a rich aroma of vegetation, mushrooms, sweet flowers and composting organisms.

On another hike, I climbed up Cache Creek drainage toward Republic Pass. I felt the air getting a little cooler with each mile. It was a hot day and the still air felt as though it was sticking to me. Bugs freely whizzed around me, sometimes landing and biting my neck, face, and arms. Suddenly I noticed a low moaning sound and saw the tree-tops moving all around me. Little random puffs of wind started to pat me on the face and flutter my pant cuffs. I welcomed the wind to cool me off and blow the bugs away. Ahead of me in a large meadow, I could see the wind tearing

along through the grass, picking up bits of loose grass and leaves and rushing away with them in spiraling loops. When I walked out into the full force of the wind, dirt filled my eyes. I had to stop and rub them clean before I could go on. The bugs were gone, perhaps clinging to trees, forgetting about me. The wind twisted my hair and pulled and slapped at my clothes. The wind became so strong that it knocked me off balance. Some dead pines had tipped over and were caught partway down by neighboring trees. These logs, cradled on the branches of their neighbors, were making musical squeals, squawks, and thumps when they moved at different speeds and in different directions from their supporting neighbors. Once in a while in the distance I could hear a tree making a loud crackling thud when it toppled to the forest floor. When I turned to face the wind and looked behind at the dark cloud above me, the wind tried to pull my breath away or stuff it forcefully down my throat. All the motion, noise, and heightened smells changed my hiking experience into a much more complex one, one where all my senses were grabbed and shaken. All the commotion created another thing for me to think about. I had to be even more conscious and aware of the risk of surprising a bear who was experiencing the same thing I was and couldn't hear or smell me as easily. I felt more alive than I had all day. Watching for the possibility of a cold rain shower, I avoided the downwind side of dead trees and rubbing the dust and grass pieces out of my eyes, I let the wind pummel me and remind me that this was where I preferred to be.

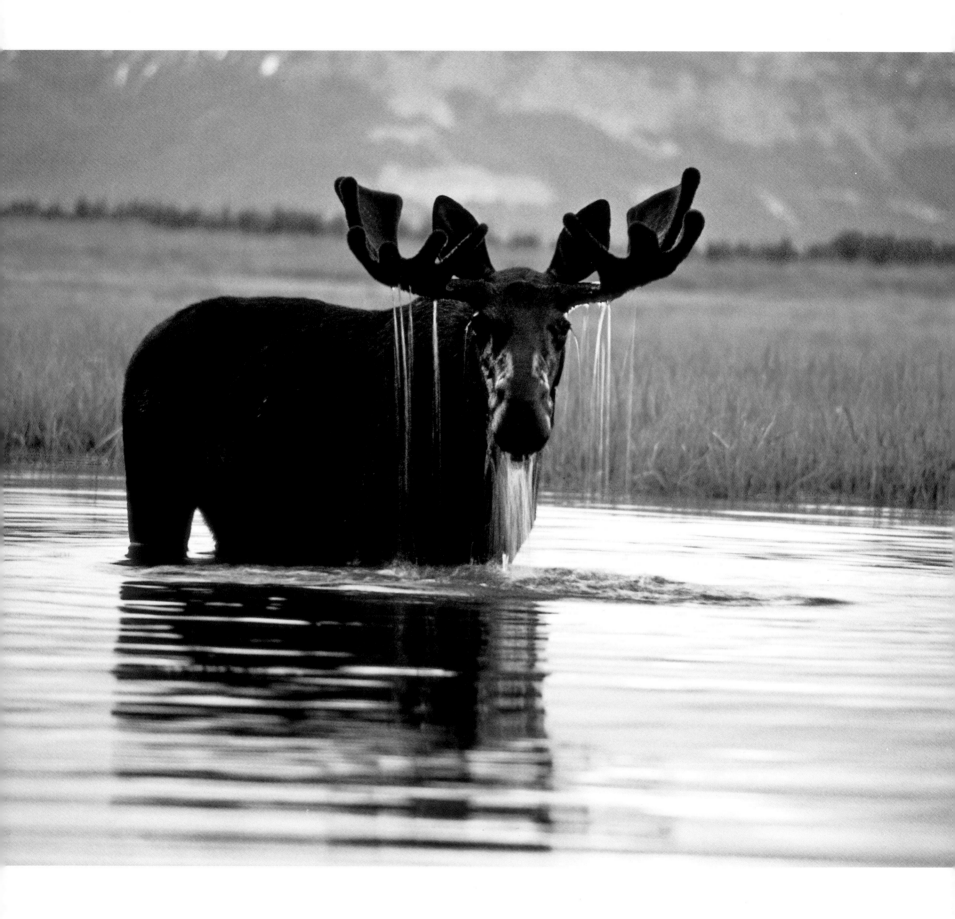

Moose are primarily browsers, feeding on forbs and the stems, bark, and leaves of trees and shrubs.

After sunset one July evening this bull was standing in a pool along Beaverdam Creek completely submerging his head to collect the aquatic plants on the bottom of the pond. When he pulled his head out of the water, he momentarily held his head still to let the water run off his head, eyes, and nose. This was a 1/4 second exposure at that brief moment of his stillness.

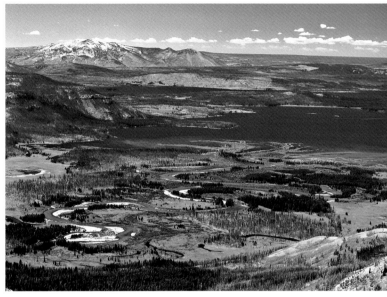

Yellowstone River delta, Red Mountains, Southeast Arm of Yellowstone Lake.

Clematis is a member of the buttercup family.

It grows slender vines up to 12 feet long in woods and brush. The blue flowers are delicate sepals, not petals.

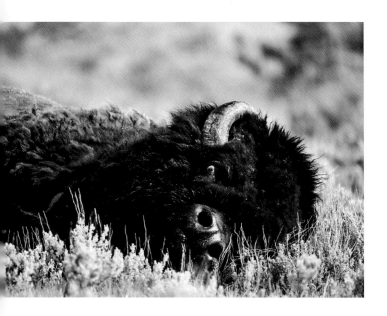

A bull bison is a powerful creature.

Weighing up to a ton, it looks deceptively big and slow. It is able to run up to 30 miles per hour and is agile. Its massive head appears out of proportion, compared to its slender hind quarters. The horns grow during its entire life and are formidable weapons. While rubbing on a bush this bull accidentally tangled an ear ornament in his thick hair. He was walking towards the Hayden Valley on a warm July evening.

In early summer before the rut begins, bison bulls are in small bachelor groups.

This bull had patches of winter hair still stuck to his shoulders, and flies and mosquitoes circled around him apparently causing some itching. Seeking out a flat patch of dusty soil, he lay down, squirmed and threw himself sideways against his hump, first on one side and then the other. When he was finished he stretched out flat, looking over the low sage around him, apparently contented. But his nostrils flared from his heavy exertion, and he had a peculiar wild look in his eye due to the odd angle of his head.

The bison mating season is in July and August.

Most of the year bison bulls are quiet, but when the rut starts they become noisy and aggressive creatures. Their vocalizations are deep rumbling grunts that sound like a 2000 pound pig. They stick their tongues out and expel air from deep in their lungs through the resonating chambers of their lungs and throats. If you are within 100 yards of them the sound sometimes will make your own chest vibrate.

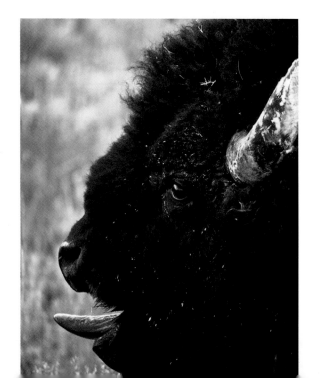

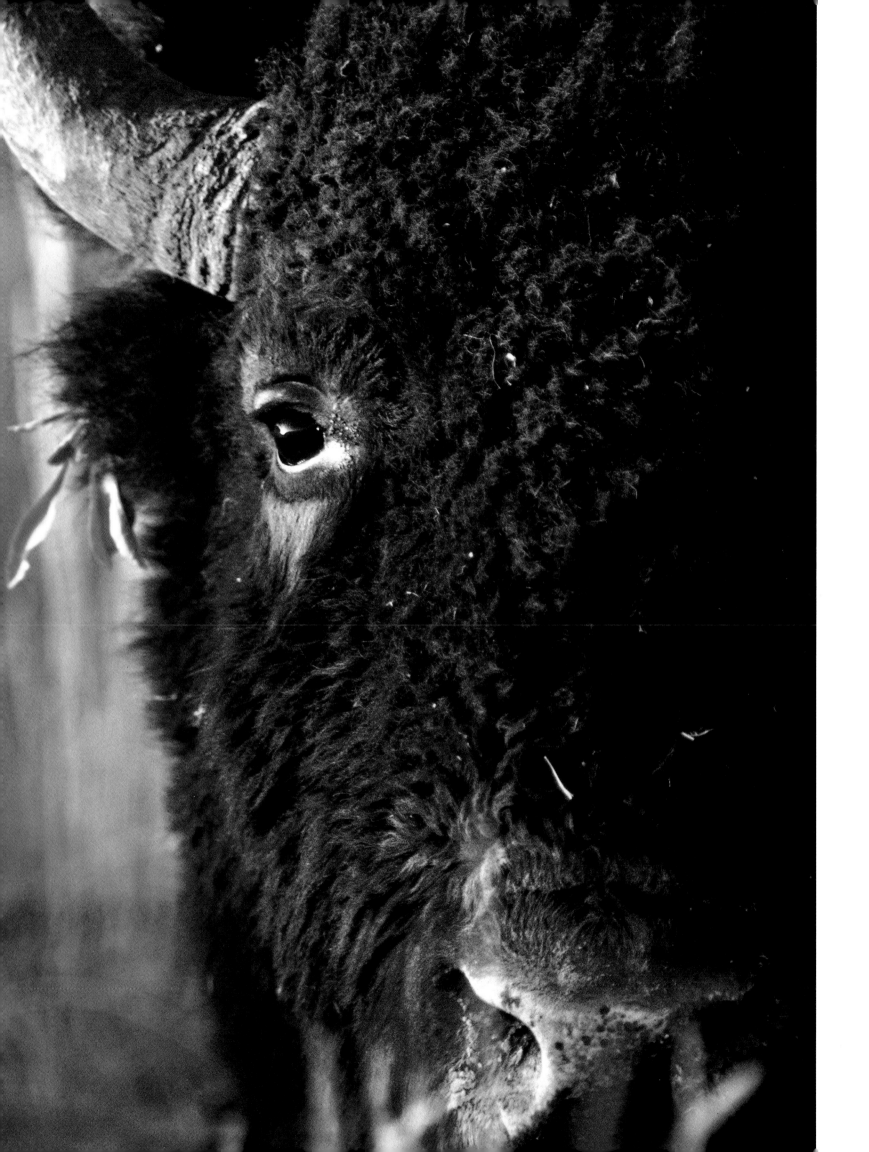

In early August, Bob Bennett and I left the parking lot at about 6:00 a.m. to hike west into the Hayden Valley past Sulfur Mountain.

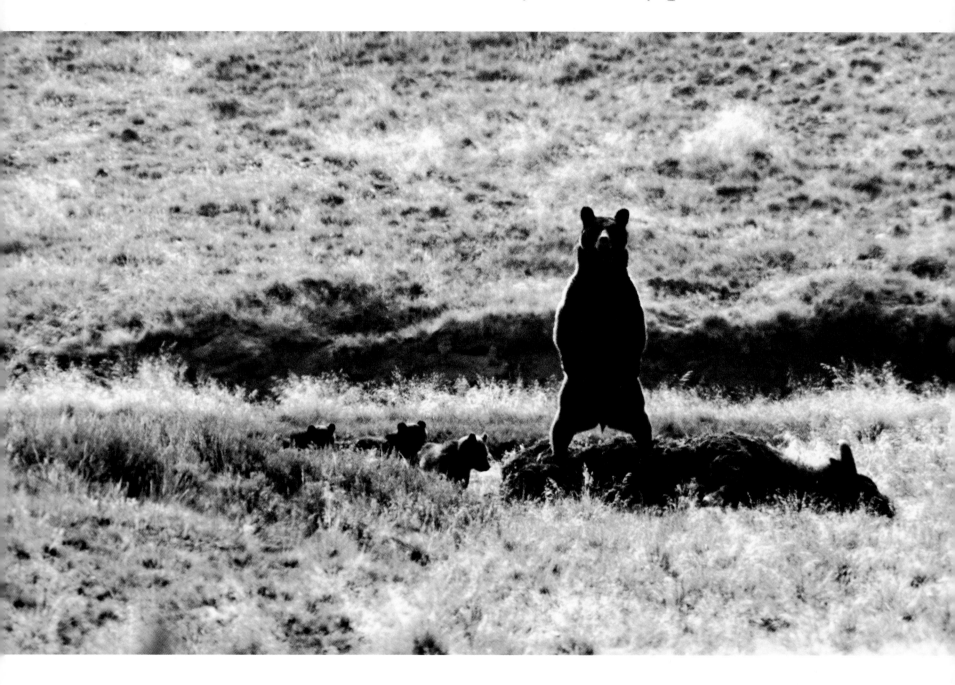

We planned to watch the bison activity in the backcountry and have a nice long hike through the open, rolling sagebrush and grassland stretching for miles to the west toward Mary Mountain. Nearly one and a half miles in we came upon a small herd of about 25 bison cows and calves. We stopped about 300 yards from them and watched for a few minutes. They were pretty quiet; so I changed direction a little to go around them. We walked 50 yards or so over a small rise and to our left about 60 yards away I saw a bison bull carcass lying in the sage. The feet were extended toward us, and the carcass was still nearly intact. I stopped and pointed

it out to Bob, who had a pair of binoculars. He wasn't familiar with using them, and while I speculated that the bull may have been killed by another bull during the rut, he found the bison in his binoculars. We were not going any closer since we were in bear country. Many times a bear will claim a carcass, and when it is not actively feeding, it will lie nearby to protect it from other scavengers.

I did not see any sign of a bear from our perspective 60 yards away. After a couple of minutes we started to walk to the southwest in the same line of travel in which we were originally going, which would take us away from the carcass past the small bison herd. After taking about six steps I saw a grizzly bear's head pop up between the legs of the bison carcass. It was looking toward the belly of the bison, so it didn't see us. I pointed to the bear and said quietly, "Bob, we gotta get out of here." He started to look with his binoculars, and I said, "No, we gotta get out of here." I now went west directly away from the bear and toward the small bison herd. I was going to use them as a shield from the bear if I could get to them. Watching over my shoulder I could see the bear had not seen us as we started for the bison herd. Again Bob stopped and turned to look with his binoculars, I immediately stepped back to him and told him to stop looking and follow me.

We walked only about fifty more yards from where we had first seen the bear when it saw us, jumped up, and started to run around the carcass throwing dirt on it, becoming very agitated. I decided we should look as non-threatening as possible so I stopped, set my tripod and 700 mm lens down and knelt behind it. Bob knelt right beside me. We didn't say much, but I was thinking, "This is going to hurt." Shortly after we had kneeled down, I realized this was a female bear because she woke up her three cubs of the year. Now I knew it was even more serious because the most dangerous time to be near a bear is when she has cubs or when she has a carcass. This had some sort of geometric increase in risk. The sow stood on her hind legs a couple of times to get a better look at us and swung her body back and forth, huffing and popping her jaws, which meant she was upset and warning us away. Maybe we should have stood up again and walked away some more, but I wanted to continue to be as non-threatening as possible. While I was waiting to see if this really was going to hurt, I made a couple of photographs. About eight seconds after I made this photograph, she dropped onto all four feet and charged us, running straight at us as fast as she could through the sage, the three little cubs running after her, trying to keep up. When she started towards us, I stood up, trying now to look as big as I could. Bob stayed right beside me. When she started toward us, I planned to stand my ground and if she got within 50 yards, to raise my arms in the air and look as tall as I could, and if she was still coming at 10 yards away, to drop to the ground, curl up in a ball with my knees up to my stomach to protect my belly and my hands behind my neck to protect my spine, and hope she chewed on Bob. She was running very fast, but it seemed as though things were happening in slow motion at the same time. She got about 50 yards away from us and then spun around, running over her three cubs, and headed straight back towards the carcass. The three cubs scrambled up and took off after her again. They ran past the carcass and off to the east up a hill about an eighth of a mile away and over it out of sight.

I don't think I breathed until she had disappeared, and I knew I was going to live. Bob and I exchanged words of relief and after a couple of minutes walked on to the southwest around the small bison herd. At lunch, after we had thought about our experience while hiking through the valley, Bob asked me, "What would you have done if I hadn't been there?" I said, "I would have gotten farther away," because I wouldn't have stopped to look through binoculars before she saw me. I don't know if I would have reached the bison herd, if I had been on my own. If I had been there alone, I would have looked a lot smaller than I did with Bob standing right beside me.

Foxtail grass.

Fifteen to twenty thousand elk live in Yellowstone during the summer.

Cows weigh about 500 pounds and can live up to 18 years. They live in matriarchal groups and most undertake seasonal migrations driven by snow accumulation and forage limits.

Walking aimlessly around, this elk calf was not hungry; she investigated mud puddles and watched the activities of her relatives.

All the others grazed quietly, chewed their cud, or shooed the flies away by wiggling their ears.

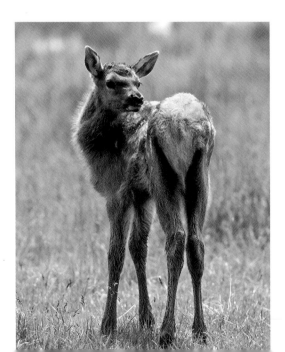

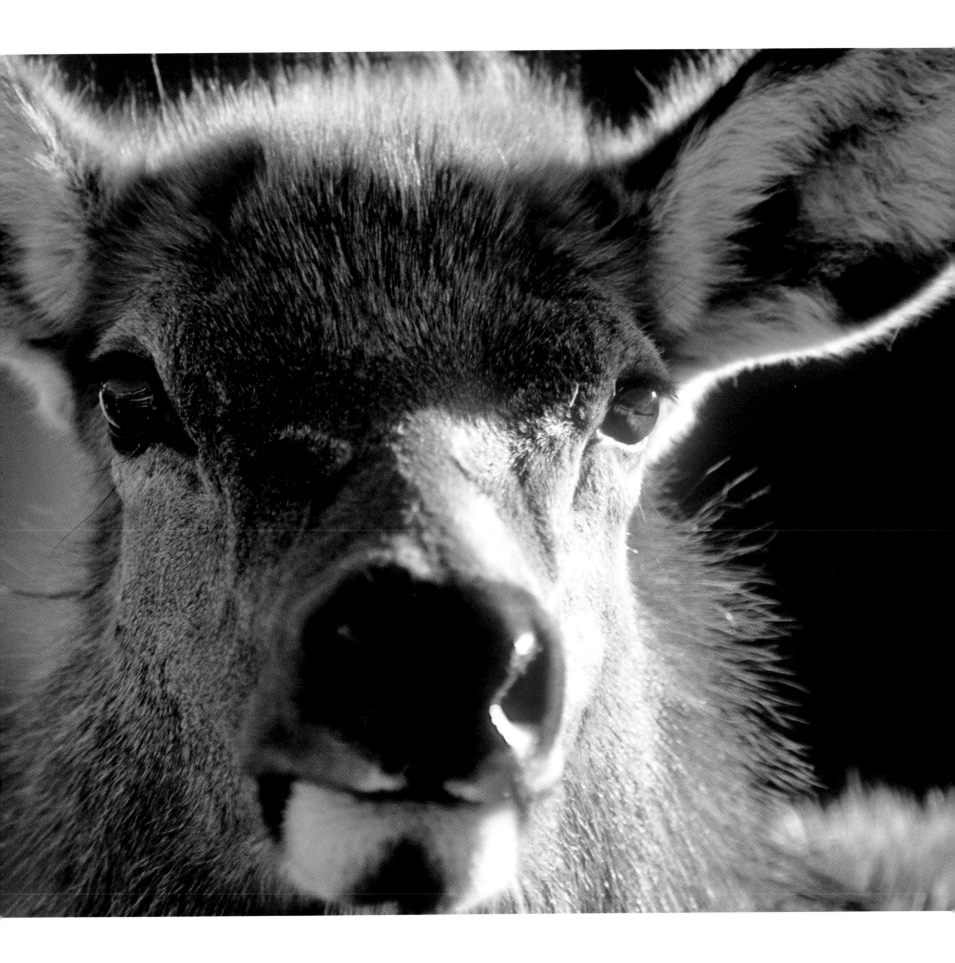

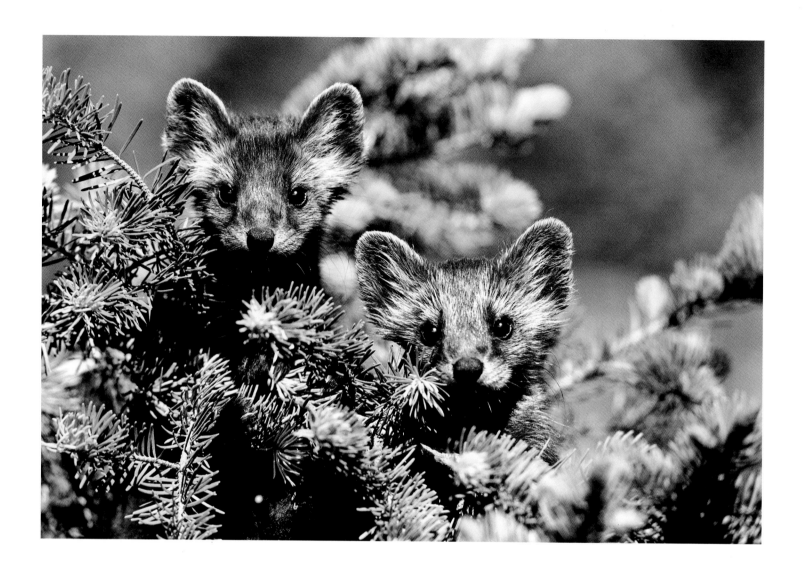

Pine martens are a
member of the weasel
family called mustelidae.

All mustelids have five toes on each foot
and are generally long and slender with
comparatively short limbs. They all have
anal glands from which they can exude
or spray a nasty smelling musk, which is
used for protection or for attracting a mate.
The pine marten has a soft dense under

fur with glossy guard hairs, which for
hundreds of years has been highly prized
for its beauty and durability. An efficient
carnivore, it feeds primarily on rodents,
especially squirrels, but it is an opportunistic
feeder and will eat bird's eggs, frogs and
even berries.

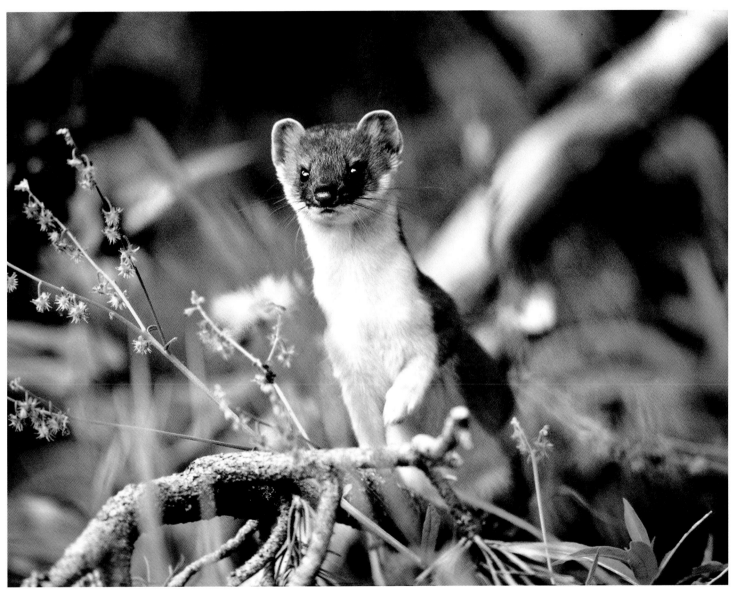

Short-tailed weasel.

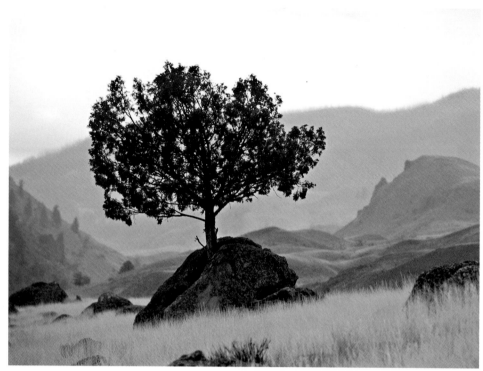
Glacial erratic, nurse rock, juniper.

Often active in the daytime, great gray owls hunt primarily for rodents in the grass near stands of dense timber.

The large facial disks help to focus the sounds of their prey into their ears which are near their eyes.

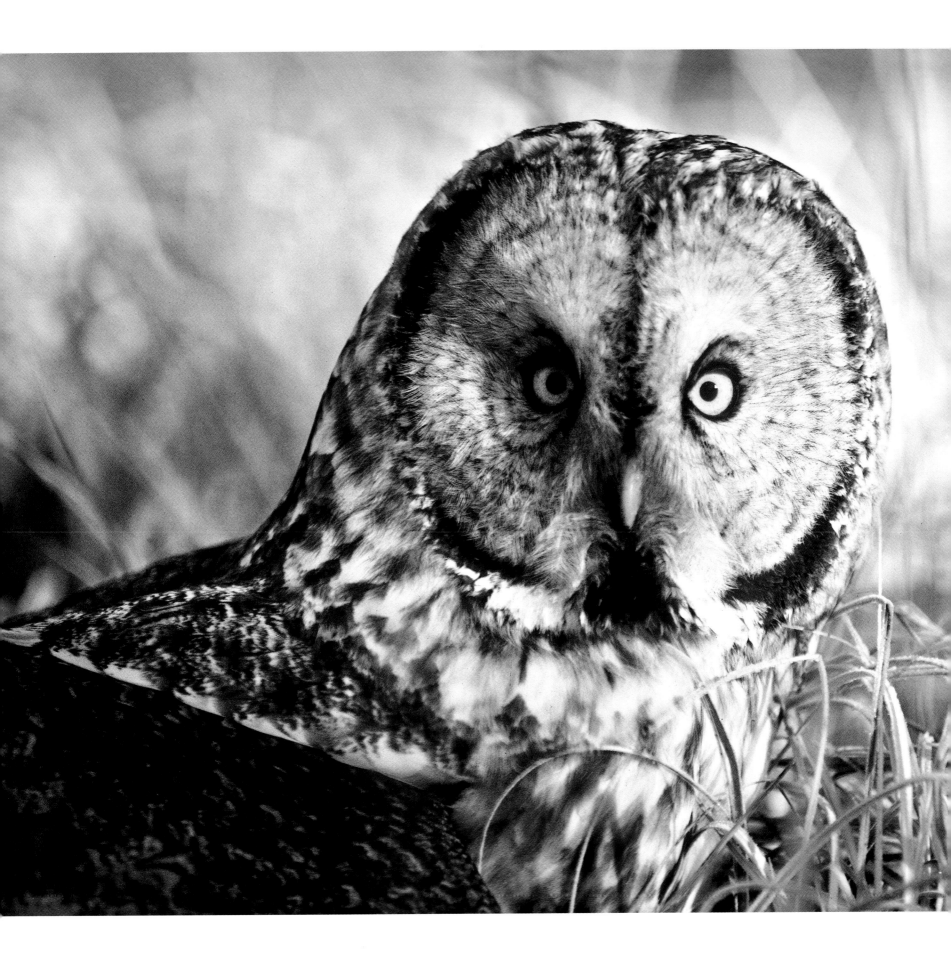

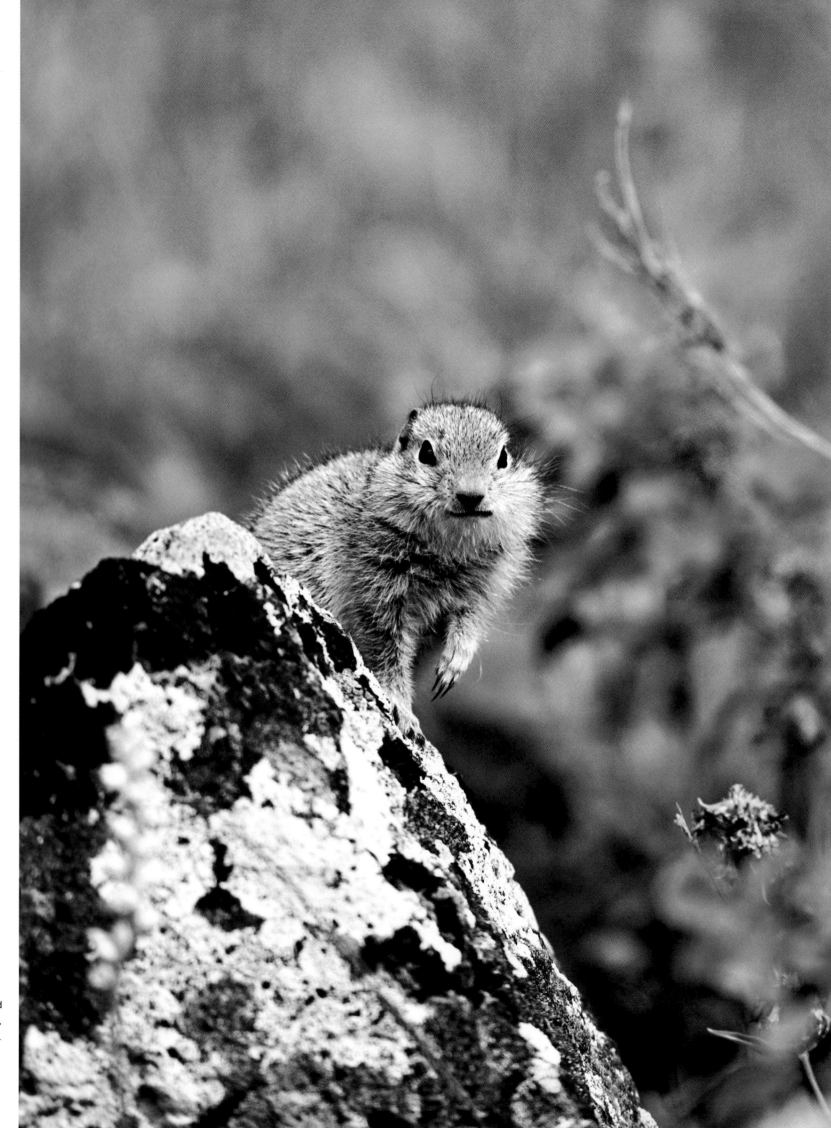

Uinta ground
squirrel,
penstemon.

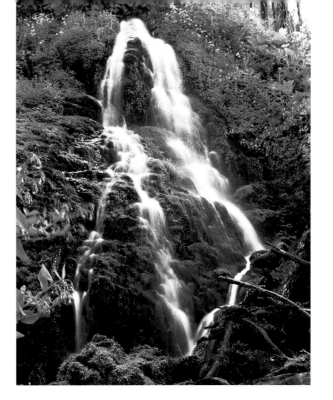

Near Yellowstone Lake this spring comes out of a fist-sized hole on a hillside and pours down over a 30 foot cliff.

Drink the water and it will give you an ice cream headache with its teeth-aching cold water, that is if you can find it in the regenerating forest burned in the Red Shoshone fire of 1988.

Lichens are composite organisms made by a symbiotic association of cyanobacteria or green algae and filamentous fungi.

Lichens take on the external shape of the fungal partner. The algae cells contain chlorophyll which allows them to live in mineral environments by producing their own organic compounds. Some fix atmospheric nitrogen and some extract minerals from the object they are attached to. They are often the pioneer life form appearing on bare rock in extreme environments.

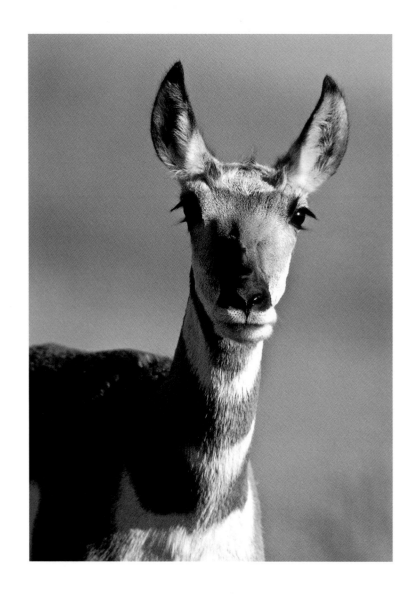

A small herd of pronghorn does and kids was moving south near Stephens Creek during a light, early-morning rain shower. The sun appeared briefly through the clouds and spotlit this one doe and produced a rainbow above her.

She stopped about 300 yards away to watch me set up my tripod and frantically make six photographs before she walked on and the rainbow vanished. Rainbows are ephemeral and pronghorn are skittish, so it is hard to get them together in the same frame.

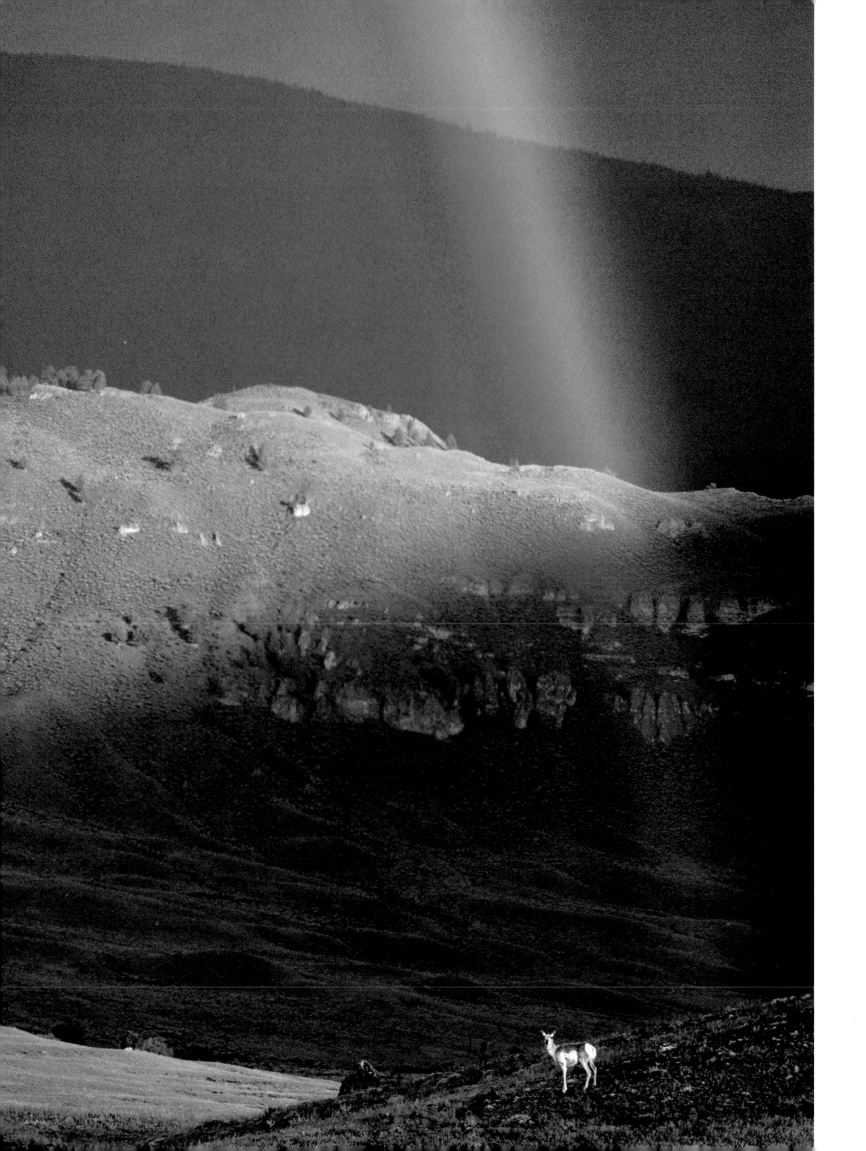

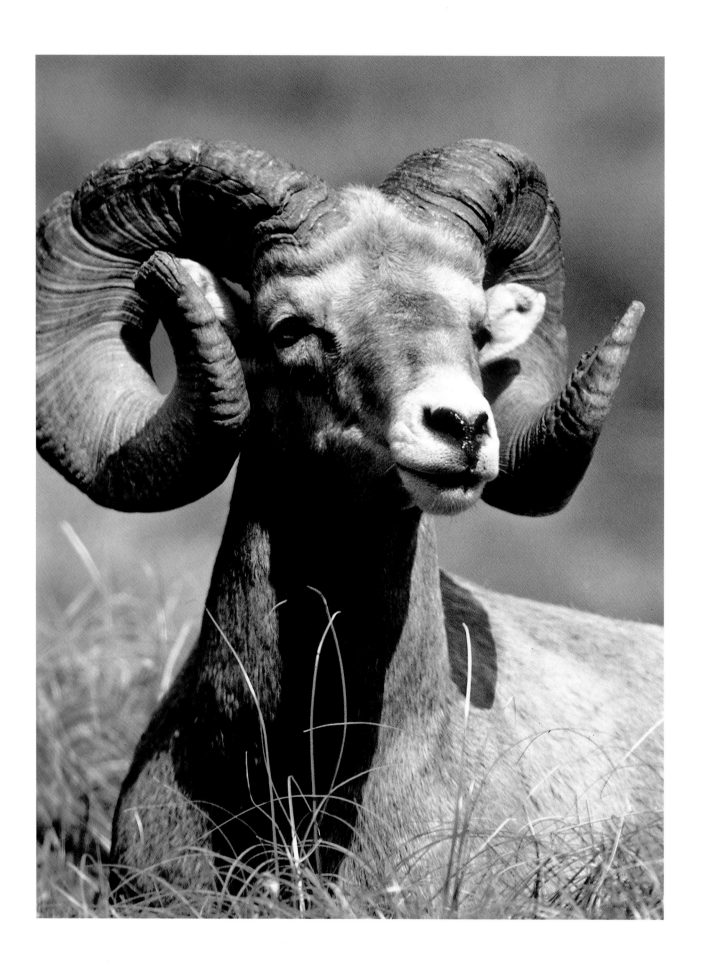

All bighorn sheep have horns, but the ram's horns are much larger.

Rams' spiral horns provide a broad surface to absorb the shock of their heads crashing during the rut. Horns also seem to serve as display organs to advertise their social rank.

Large-horned rams dominate smaller-horned rams, resulting in less energy wasted fighting and maintaining social status.

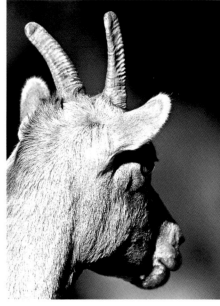

Bighorn ewe.

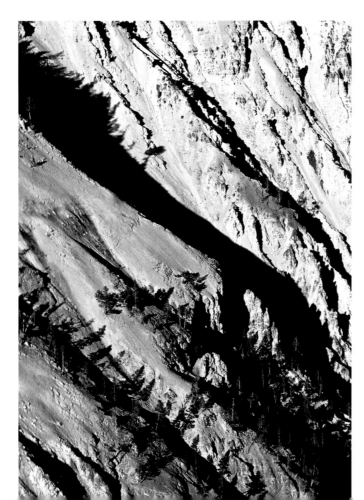

Grand Canyon of the Yellowstone lodgepole pine.

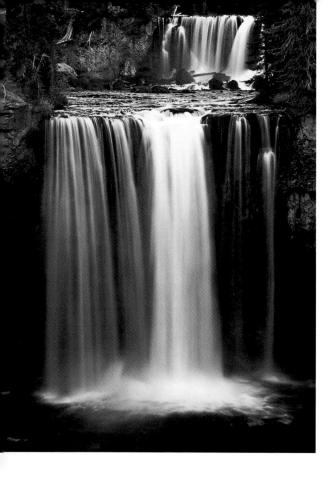

There are only four species of amphibians in Yellowstone Park: two species of frogs, one toad, and this blotched tiger salamander.

Colonnade Falls is a two-stepped waterfall with a 35 foot upper and a 67 foot lower fall about 100 yards apart. The Bechler River drops over these two steps of hard volcanic rock. This waterfall is one of many in the southwestern part of Yellowstone called Cascade Corner. With the highest annual precipitation in the Park, 80 inches on average, and the lava flow which created the Pitchstone Plateau, this area has abrupt vertical relief with resistant hard ridges of rock along its stream courses, perfect for dramatic waterfalls.

All amphibians begin their lives as eggs, then hatch to become aquatic gill-breathing larva or tadpoles which then metamorphose into lung-breathing terrestrial adults. Salamanders in the larval stage have large feathery gills behind their heads and will reach adult size before becoming lung-breathing and terrestrial. They hibernate in underground burrows.

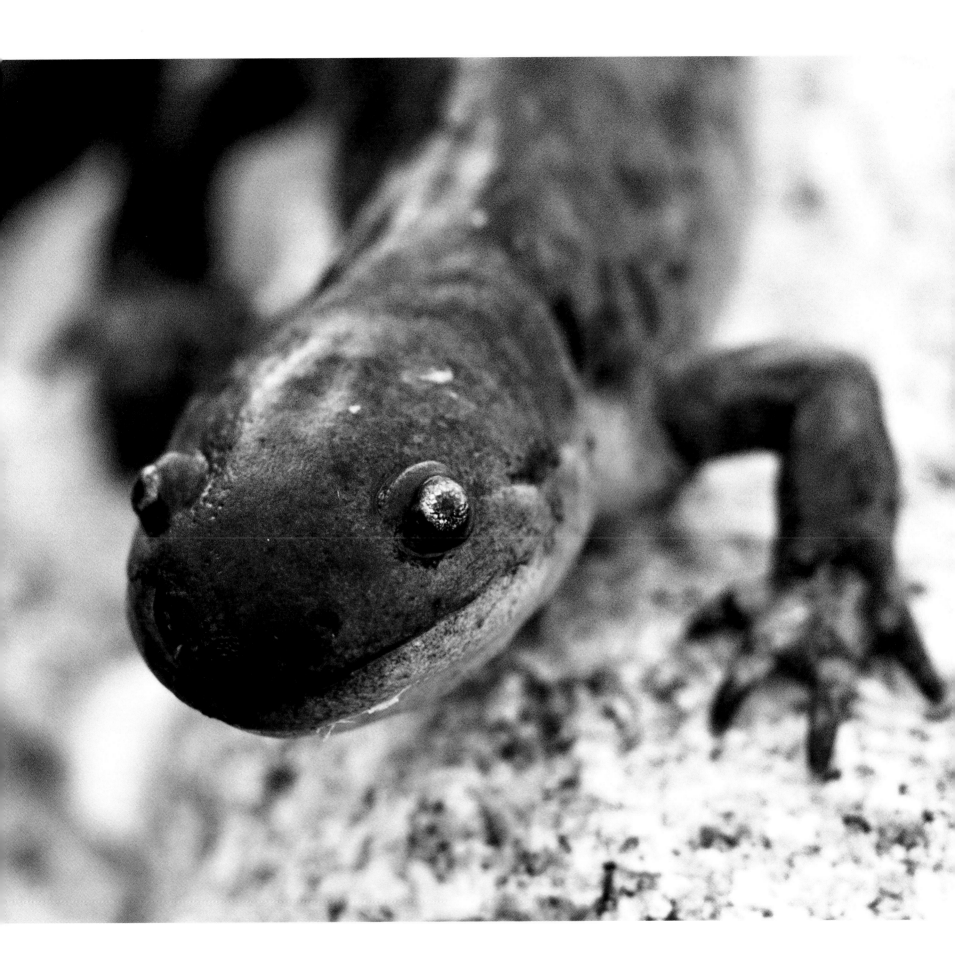

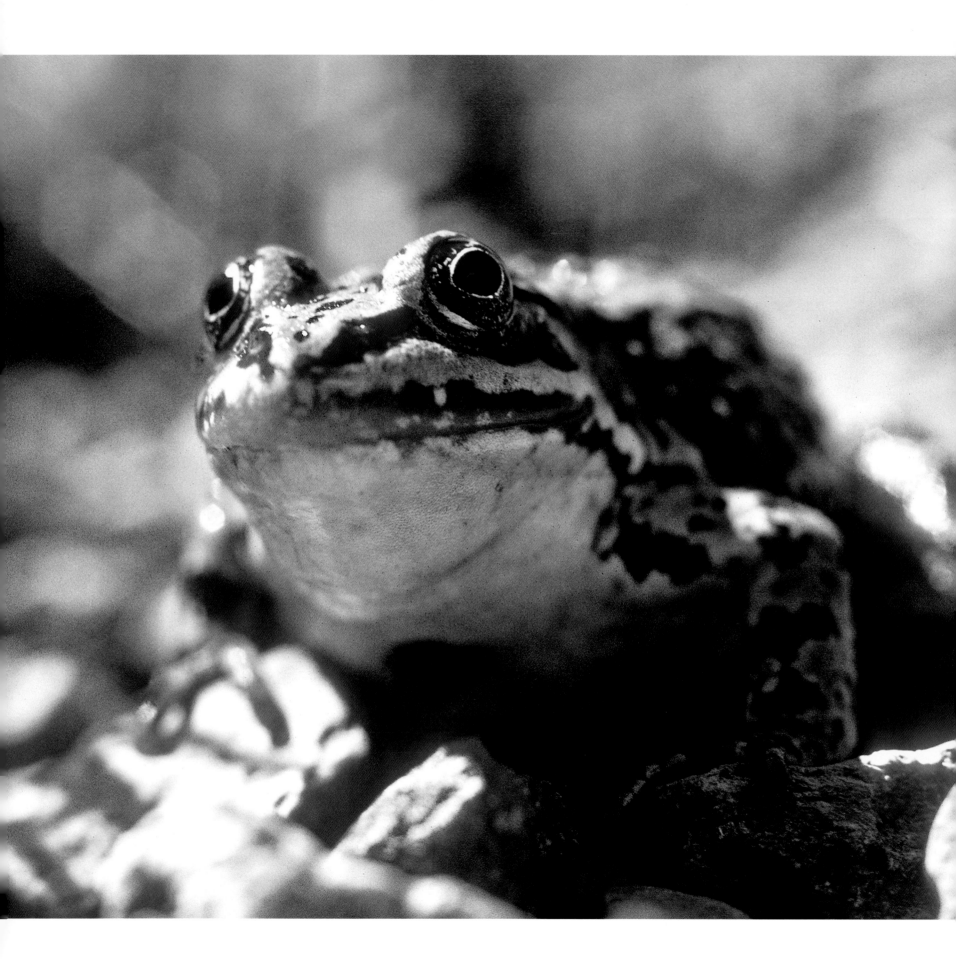

Along a dry stream channel
near Columbine Creek, this frog
sat in the gravel strip among
the high meadow grasses.

There were a lot of mosquitoes and
insects for the frog to eat near this marshy
stream which flows off the southwest
slope of Top Notch Peak to the Lake.

It was risky for the frog to be in
the open because everything—from
herons to coyotes to hawks to snakes—
would like to eat it.

In this photograph the
rich reds on Colter Peak
come from the warm sunset
light passing through some
thin smoke from a forest
fire in Idaho.

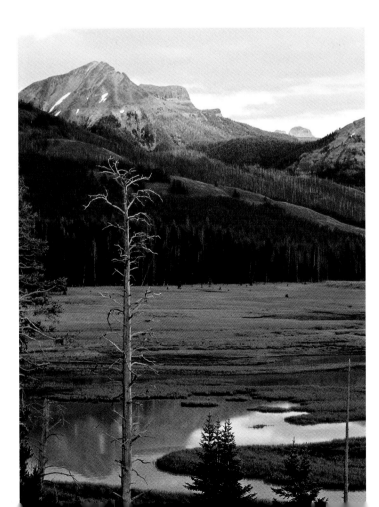

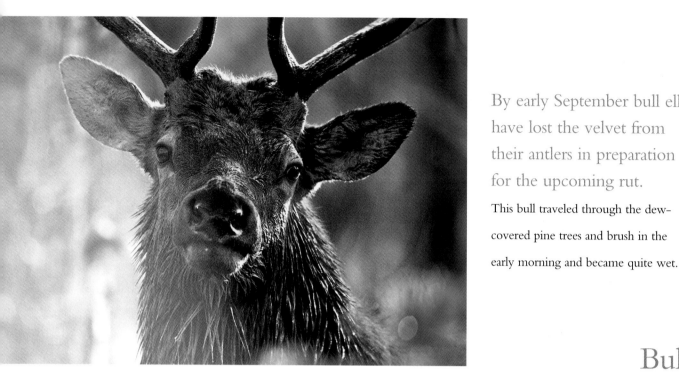

By early September bull elk have lost the velvet from their antlers in preparation for the upcoming rut.

This bull traveled through the dew-covered pine trees and brush in the early morning and became quite wet.

Bull elk shed their antlers in April and within a week are growing new ones like these.

This one was licking his lips. I am grossly anthropomorphizing this image by saying that he was expressing his feelings for the photographer, because he actually paid little attention to me.

Steamboat Point, on the east shore of Yellowstone Lake just south of Mary Bay, was named for the sounds of steam escaping from fumeroles on the steep hillside that resemble the sounds of a steamboat.

The high bluff provides a beautiful view of the broad expanse of the main body of the lake, and on clear days you can see the Red Mountains, Big Game Ridge, and other peaks on or near the south boundary of the Park.

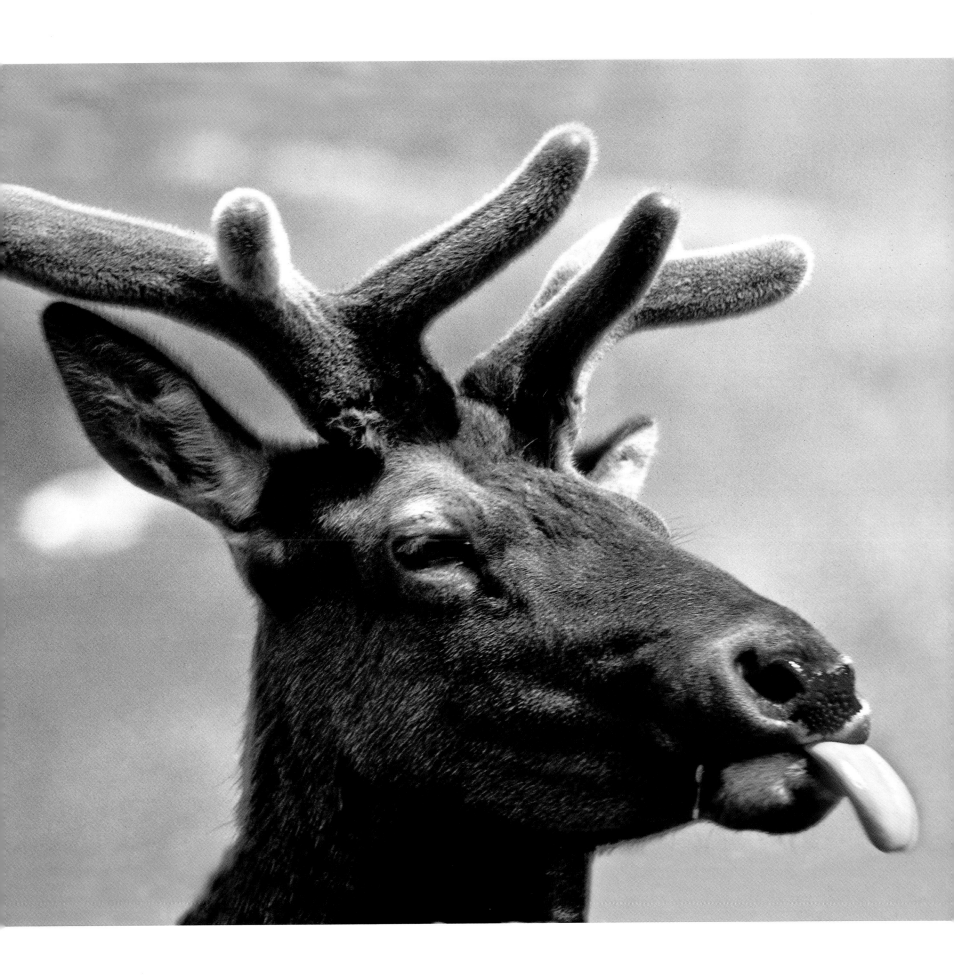

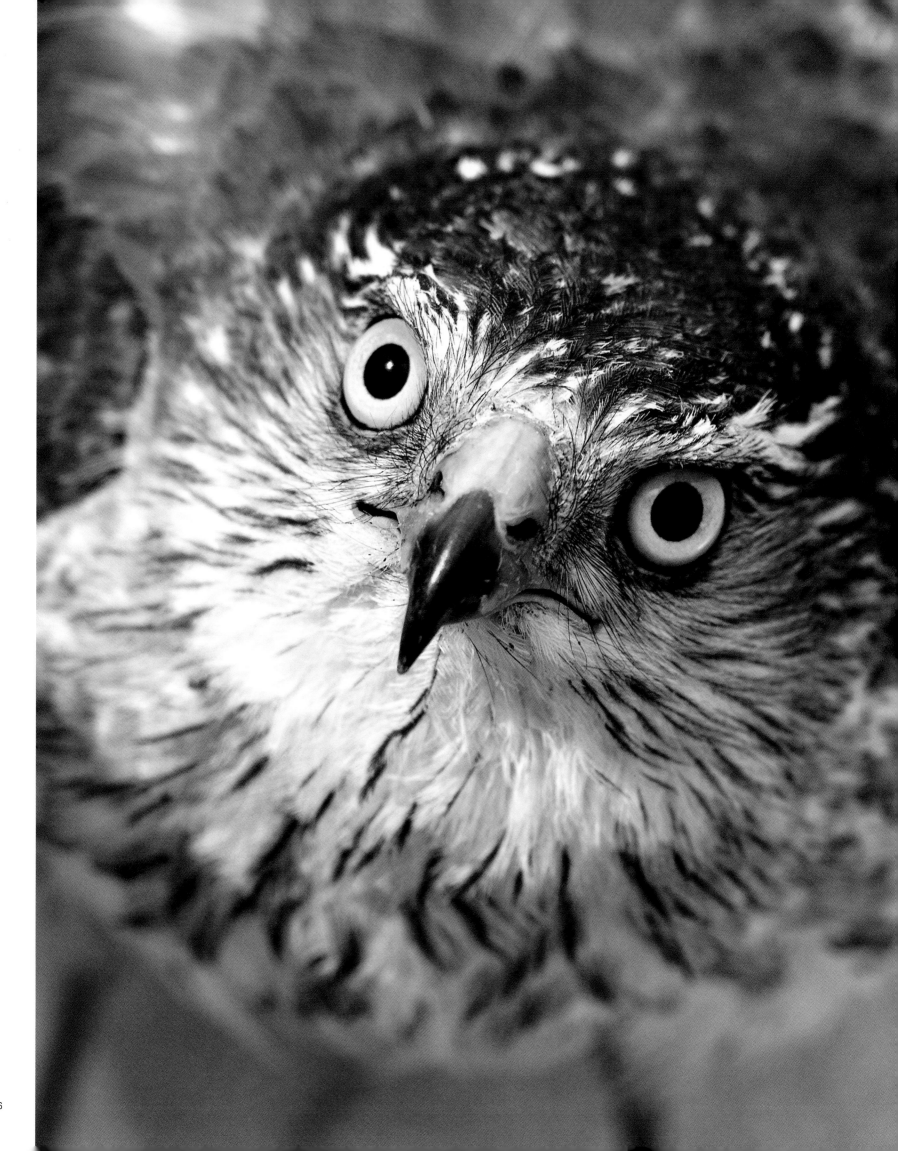

Sharp-shinned hawks
are members of a
genus called accipiters
which are long-tailed
hawks with short,
round tipped wings.

Sharp-shinned hawks are agile flyers, traveling with several quick wing beats, then a glide, and are found mostly in wooded areas. They primarily eat other birds but also eat insects and small mammals.

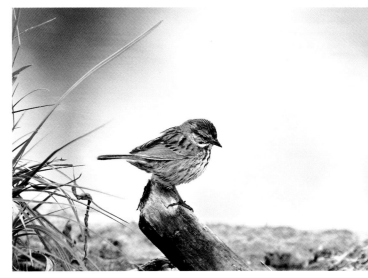

Song sparrow.

Pine trees are lucky to be able to grow in this talus slope near Madison Junction.

The large, angular boulders are creeping downslope making soil formation difficult. The thin trunks and short, brushy tree branches indicate how marginal their hold is on life. The coarse texture of the gray boulders, some as big as cars, is a striking contrast to the sharp thin trees.

Brimstone Basin is a geo-
thermal area primarily consist-
ing of fumaroles. When the
bare sterile soil here is dry it
squeaks underfoot as one walks
among the dead mineralized
trees killed by shifting thermal
activity. Most of the trees in
and around the basin are white
bark pine, which produce
cones full of nutritious seeds.

The dead trees on the harsh hillsides have
become severely weathered and checked
with reddish brown and black stains.
Many times the trees sprout and grow in
dense clumps. They may have come from
a single cone that held dozens of seeds or
from a squirrel's forgotten winter cache.
Sharing a spot eight feet across, these five
trees have blended and embraced for over
two hundred years.

A young grizzly bear,
about four years old,
fed above the shore of
Yellowstone Lake near
Sedge Creek in a two-
year-old burn from
the 2003 East Fire.

He was eating the new forbs growing
out of the fertile ash under the burned
trees. Stopping to take a nap against the
corner of two logs, he looked up and
around occasionally to see if everything
was still safe.

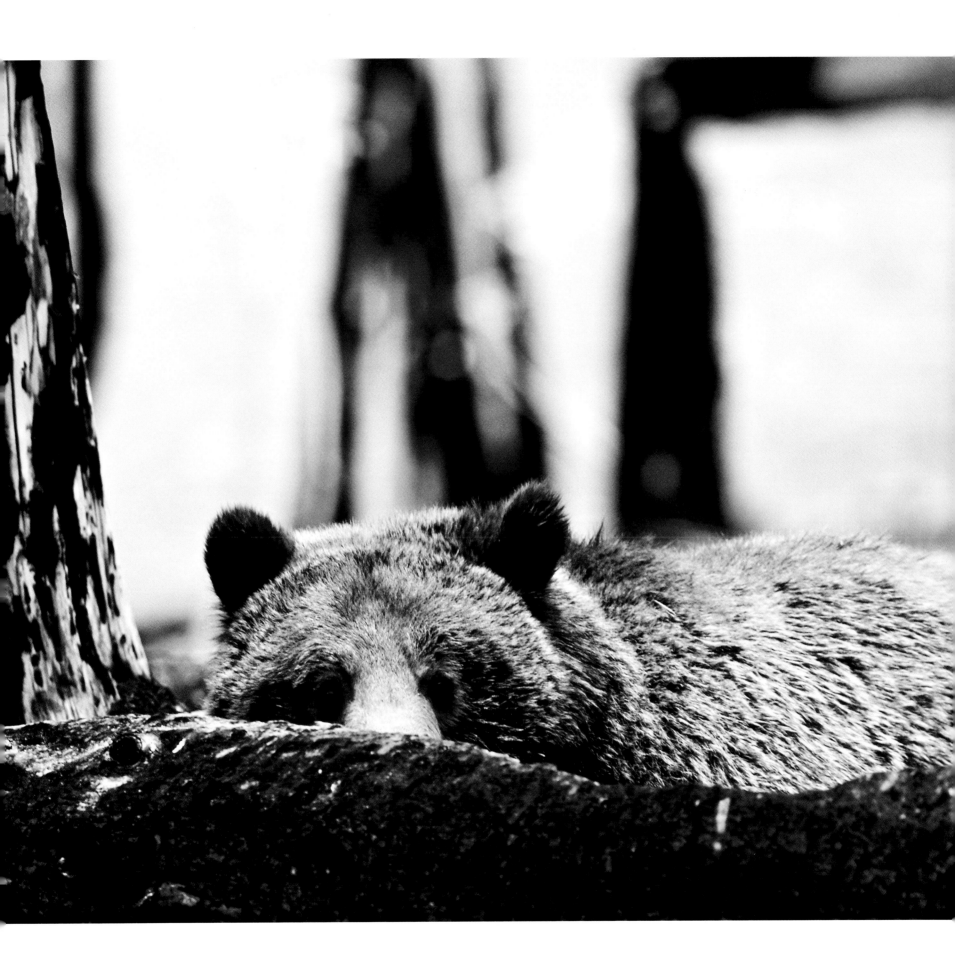

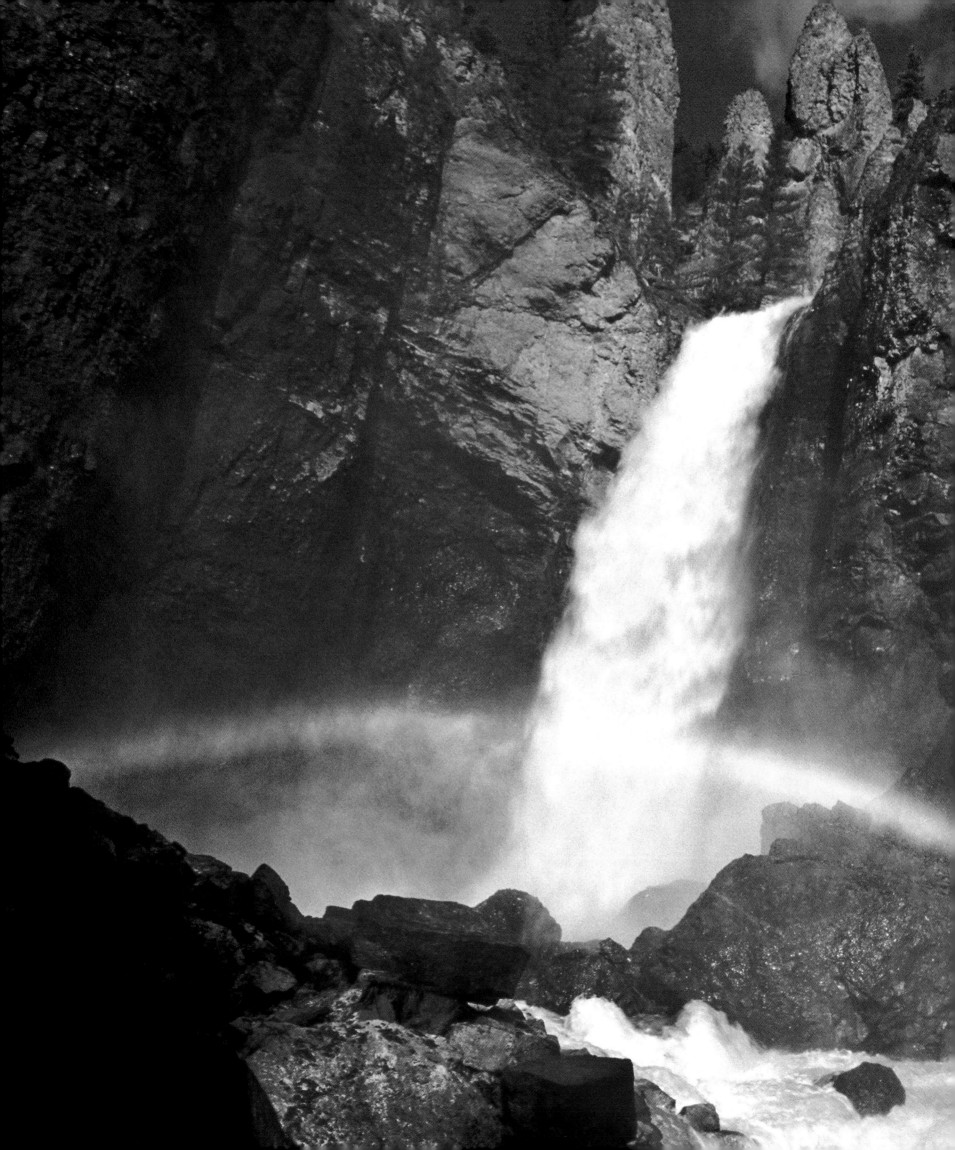

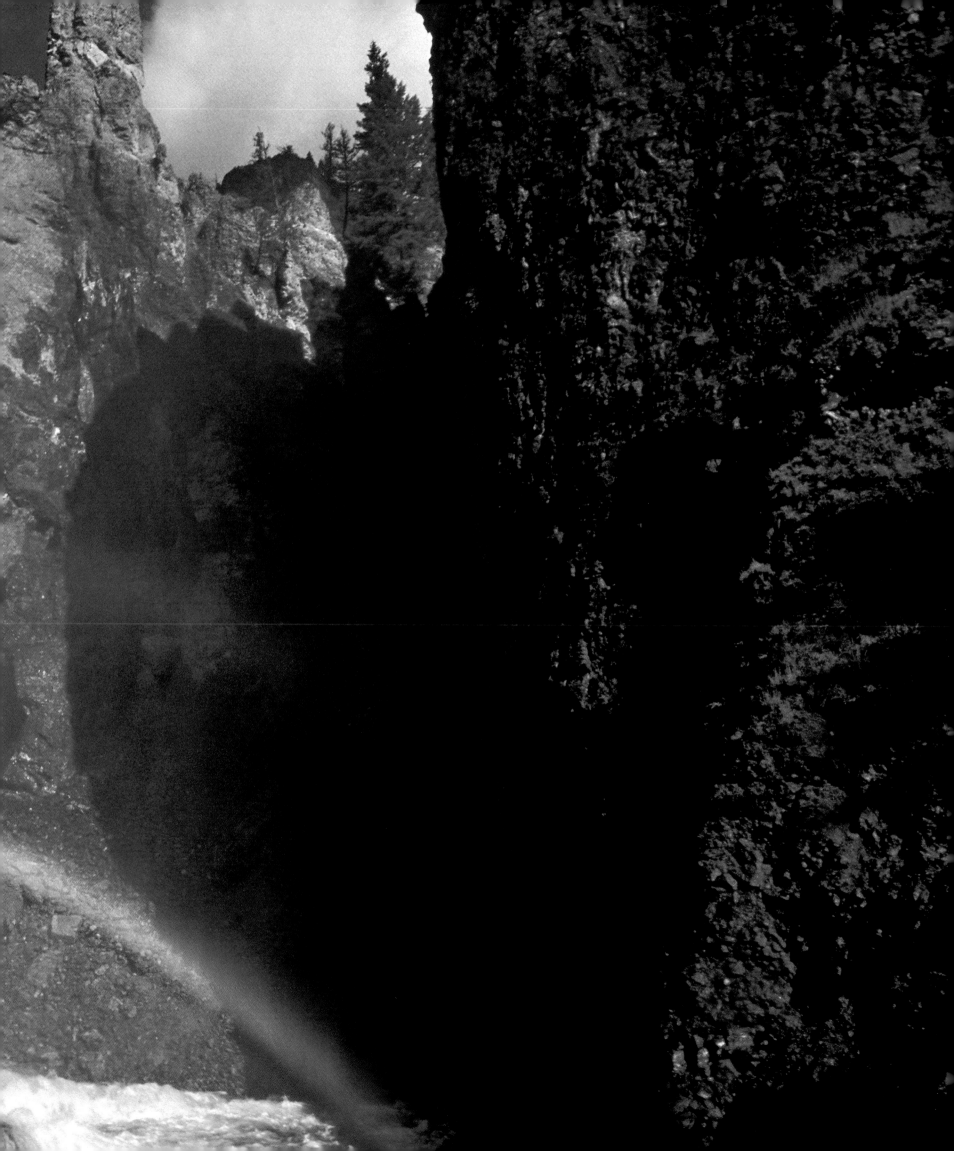

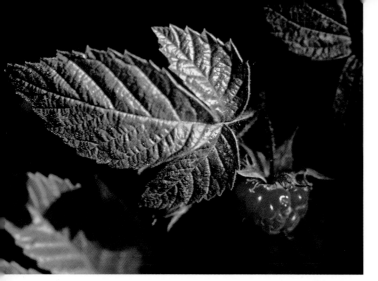

Wild raspberry.

A moonbow, also known as a lunar rainbow, is a rarely-seen natural phenomenon. It is not that uncommon, but it is so subtle we rarely notice it.

Like any rainbow, two elements need to be in place at the same time for it to be observed. One is a bright light source behind the observer, and the other is a veil or cloud of water mist. The mist can be rainfall or spray from a waterfall or other wild disturbance in water. Dunanda Falls faces south on Boundary Creek and falls 150 feet off a lava cliff onto a jumble of large boulders creating a constant heavy mist which drifts around the base of the falls and blows downstream through a short canyon. I hiked in the dark a couple of miles up Boundary Creek to the base of the falls on the night of a full moon. The moon didn't rise up over the east canyon wall until about 11 p.m., and when it did it was bright enough in the clear sky to create a moonbow visible to anyone who looked. To the naked eye it appeared as a shimmering blue arch bent across the base of the falls above the boulders. This exposure was a minute long, and the moonlight not only created the moonbow, it lit up the rocks. Star tracks are visible above the falls in the black sky, and the film saw all the colors of the spectrum.

(pages 40-41)

Tower Creek slides over a lip of Eocene conglomerate rock and falls 132 feet in one clear, straight drop. That is why it is called Tower Fall and not Tower Falls. The water hits the rocks at nearly 100 miles per hour. The wind-torn edges of the water column and the impact on the rock create a steady cloud of mist. The narrow canyon below the fall angles off to the east-northeast and ends at the Yellowstone River. There is a rainbow visible in the mist only around the summer solstice when the sun rises at its northern-most position. The sun needs to light up the mist from a low angle up the canyon to create a rainbow. The rest of the year when the sun rises farther south it does not light the mist until its angle is too high to see a rainbow.

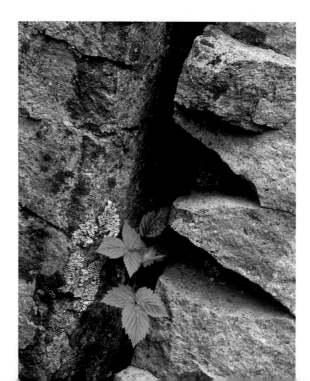

Down in the dark, cool crack in this slab of rhyolite, a wild raspberry bush has rooted and emerged into the light.

Now that it has reached the sun, it should do well, since raspberries like hot, open hillsides.

42

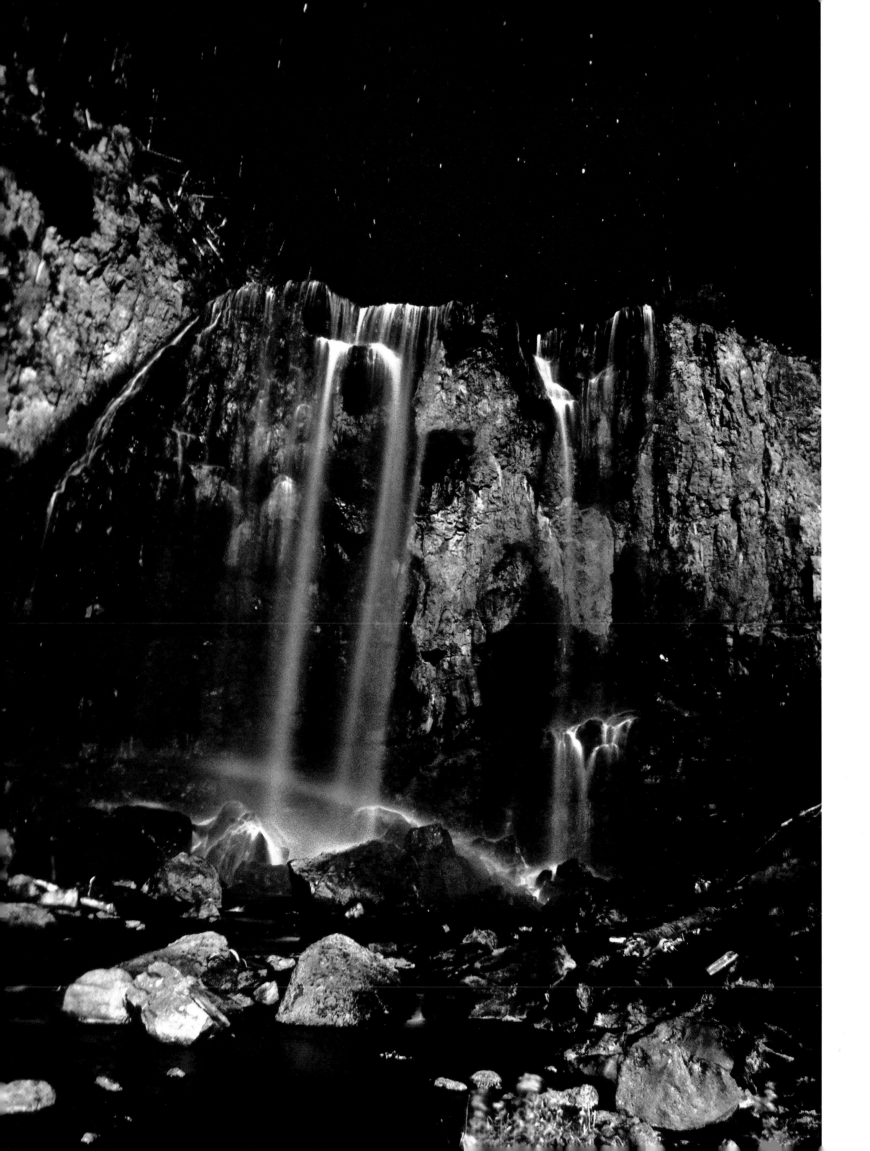

Waterfalls of Yellowstone.

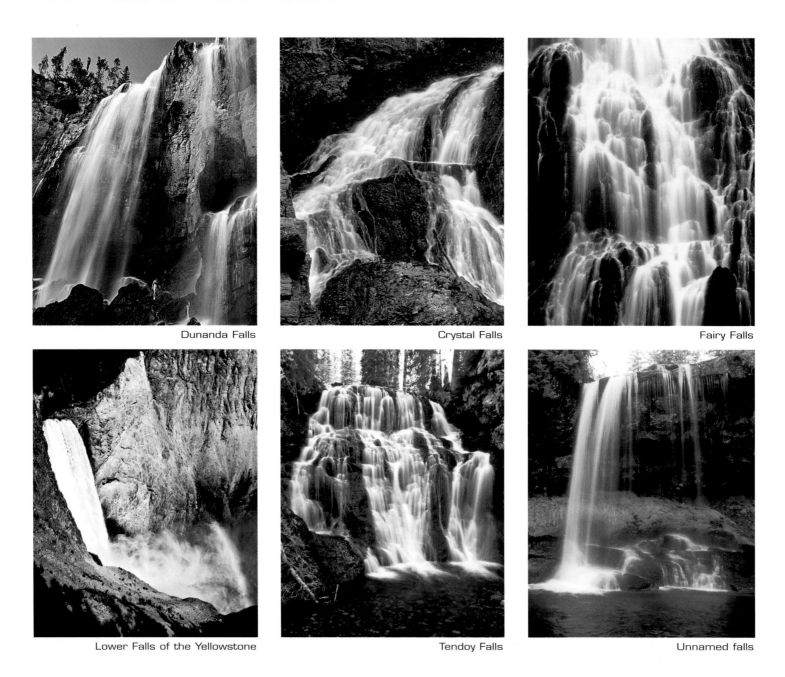

Dunanda Falls

Crystal Falls

Fairy Falls

Lower Falls of the Yellowstone

Tendoy Falls

Unnamed falls

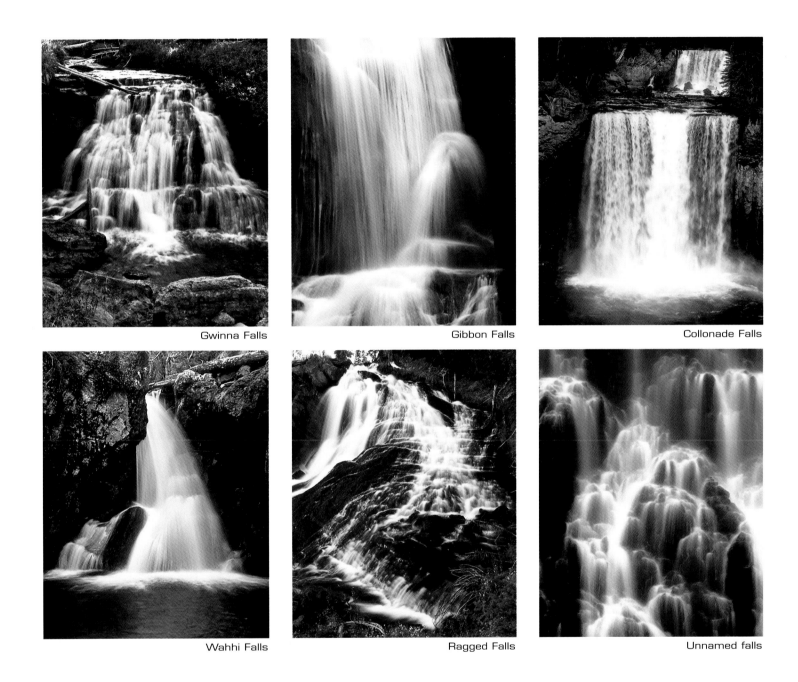

Gwinna Falls

Gibbon Falls

Collonade Falls

Wahhi Falls

Ragged Falls

Unnamed falls

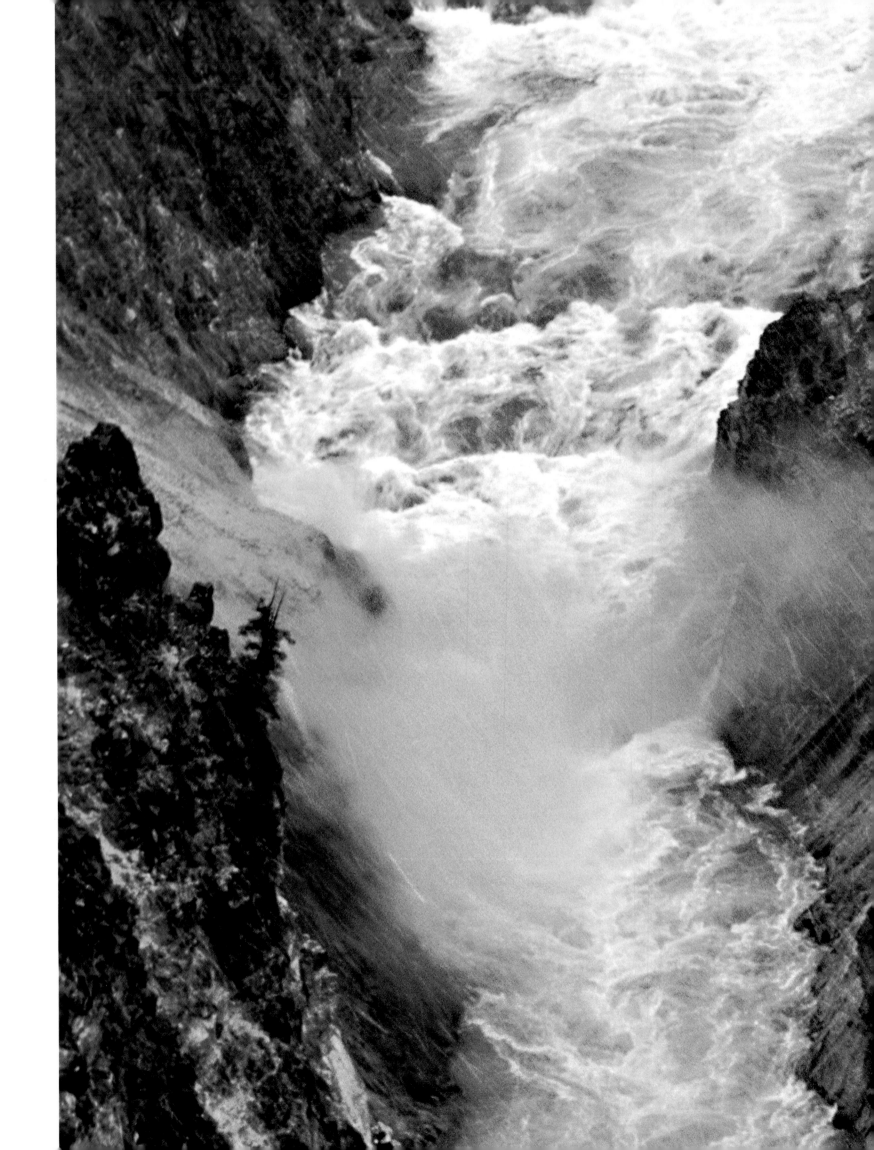

The Yellowstone
River tumbles and
roars at the bottom of
the canyon, eroding
through the softened
and fractured rhyolite.

In June, during a late snow shower,
a thermal feature steams at the edge
of the river, below steep colorful walls.

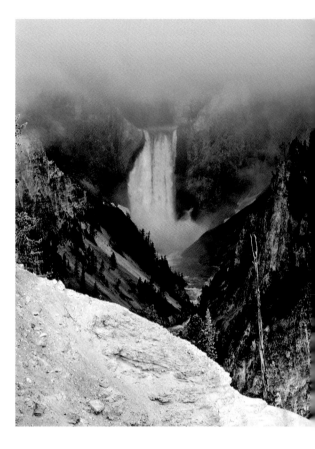

The morning fog
moved slowly down
the river, hanging
silently in the air
above the Lower Falls.

Soft, diffuse light illuminated the yellow
rock ridge which buttressed the south
rim near Artist's Point. This is one of
the most beautiful canyons in the world,
and fortunately, it is protected in the
first national park.

Western tanager.

47

Waterlily.

Near the mouth of Chipmunk Creek, large boggy meadows are remnants of lacustrine features formed when Yellowstone Lake levels were higher.

During wet summers water may stand in the deeper channels twisting through the high grass. Yellow pond lilies thrive in the rich water. Their round leaves and waxy four-inch blossoms float and provide cover and shade to fish and other aquatic life.

The ruddy duck is a chunky, small diving duck which nests on ponds in the Park. The male has a china blue beak. Courtship vocalizations are a curious combination of sound and motion. The drake puffs up his breast and cocks his tail forward. Tipping his head back, he pops his bill down on the base of his neck, tapping out a quick rhythm while calling "chuck-chuck-chuck-chuck-churr," usually pushing himself backwards on the water for a foot or so.

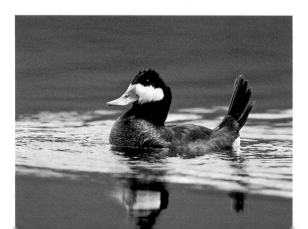

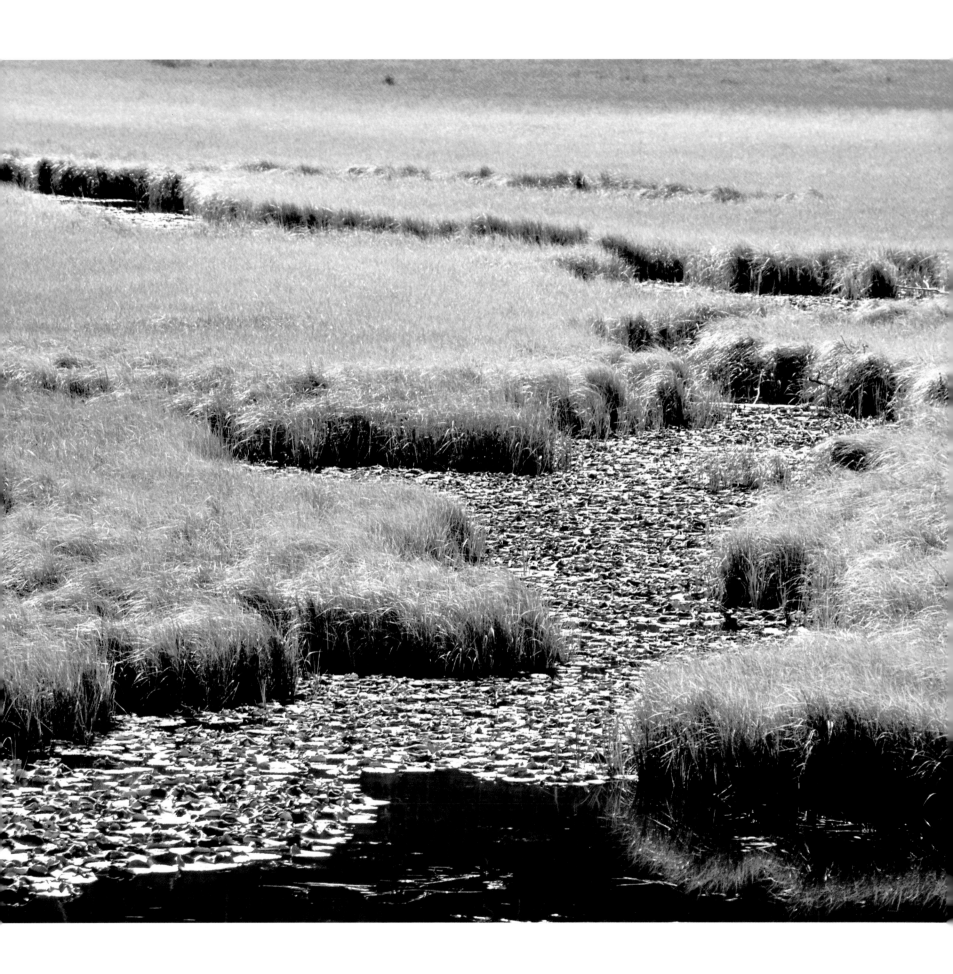

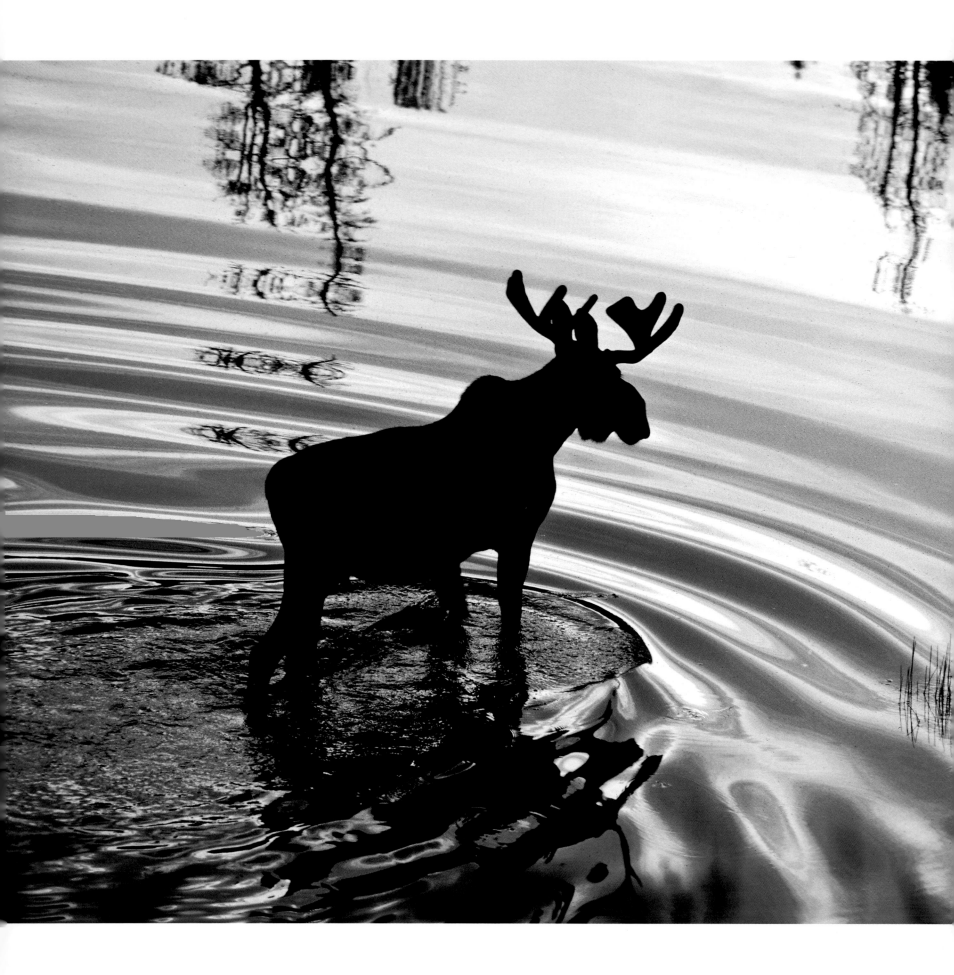

In a shallow pond along the shore of Yellowstone Lake this bull moose fed on the abundant sedges and forbs.

When he started to wade to the right, he pushed smooth ripples out on the water surface in front of him. This is primarily a waterscape, with a moose for scale.

A rain shower briefly moved up the Thorofare over the Yellowstone River and the Beaverdam Creek marsh about an hour before sunset. Two bull moose had spent all afternoon browsing the willow leaves and other lush riparian vegetation here. The faint rainbow hovering above the moose accentuated the extravagant beauty of this remote and wild place.

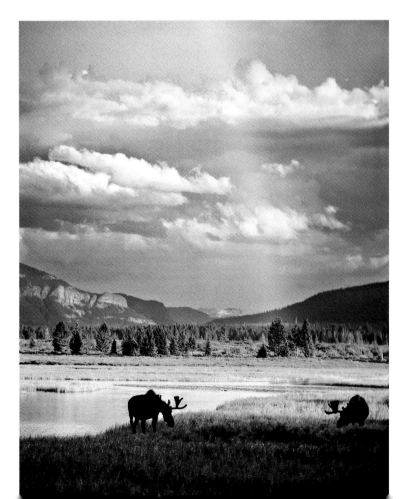

Stream surface.

Tower Creek shattered in the hiss and thunder at the base of Tower Fall.

The resulting cold mist blew out to the sides of the canyon and downstream. An early morning sun illuminated the pulsing cloud and created a wide band of rainbow colors which fluttered and shimmered, suspended above the rocks.

After hunting in the nearby stream and getting its head wet stabbing for fish, this great blue heron hopped up on a dry stick and groomed itself.

The cleanup included delicately scratching its soggy bedraggled head with one foot while balancing on its other foot. Even professional ballet dancers cannot do this.

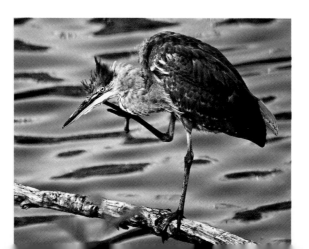

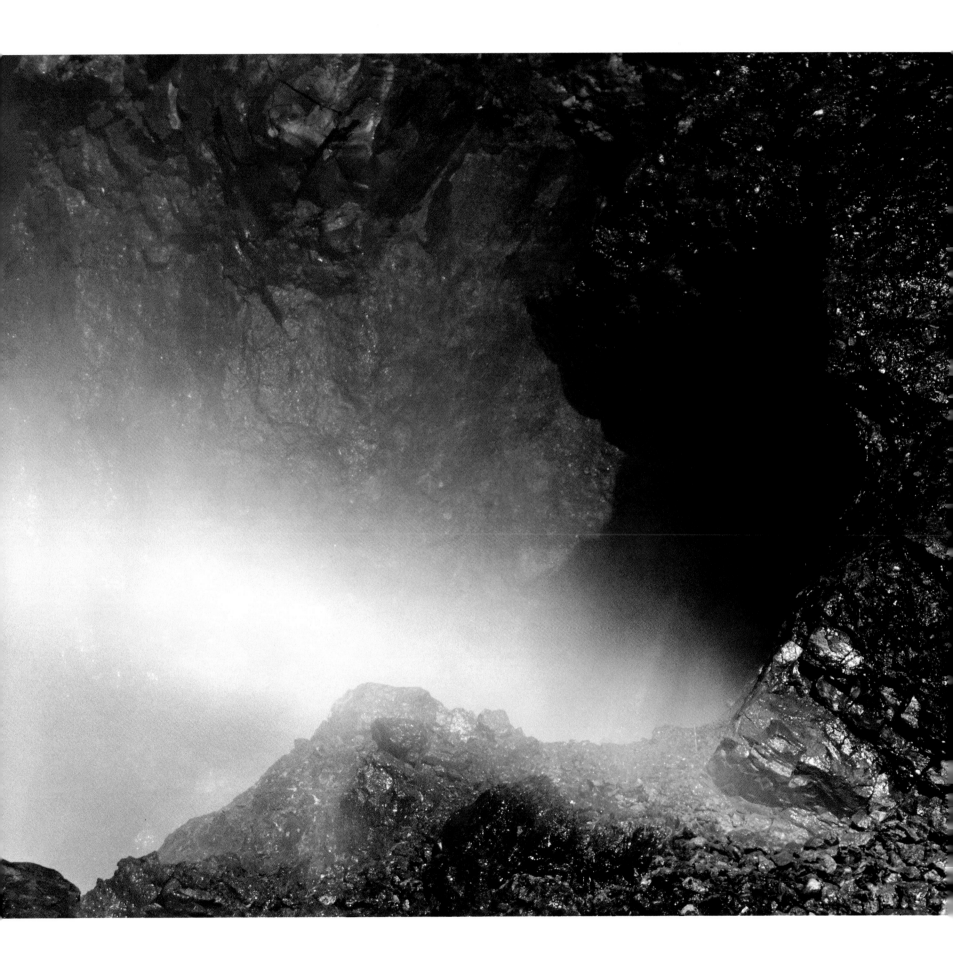

Grand Prismatic Spring is one of the largest and most beautiful examples of a common hydrothermal feature in Yellowstone.

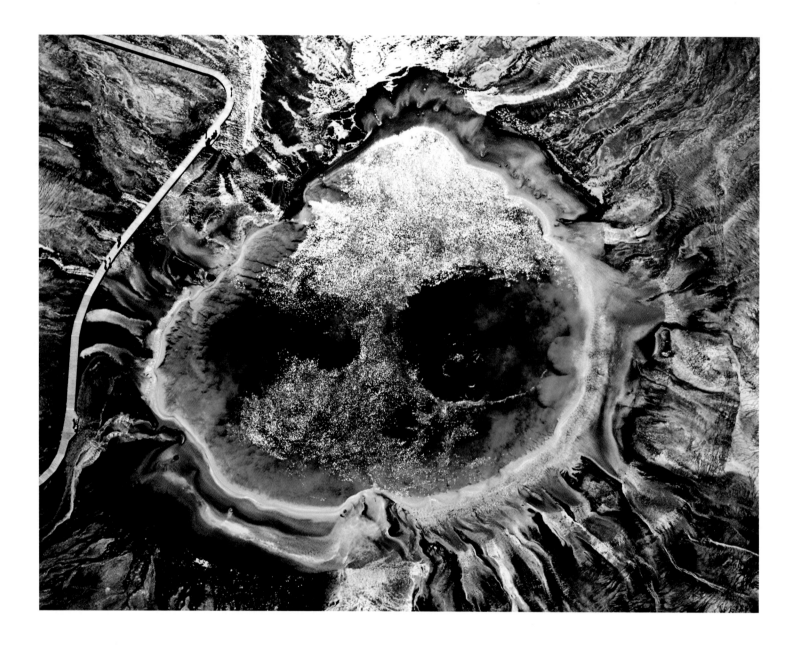

The prismatic or colorful features in springs come from several sources. The deep blue in the center is the clear super-heated water circulating up from the subterranean heat source under the Park. As the water cools at the surface, some of it sinks back down, and some of it runs off in shallow rivulets in all directions. As the water cools at the edges of the pool and on the sinter terraces, bacteria and algae live and prosper producing a rainbow of colors. From this aerial perspective, a pair of convection currents, like a pair of eyes, is visible where the water boils up from the immense heat source below. This hot spring was specifically mentioned as "Boiling Lake" in Osborne Russell's *Journal of a Trapper,* a name apparently coined by Rocky Mountain fur trappers in the 1830s.

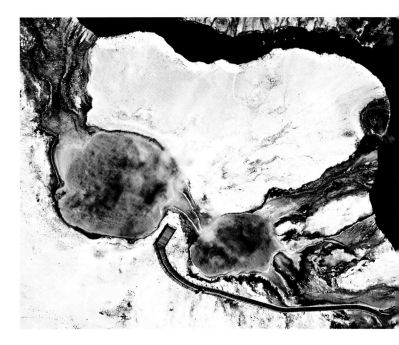

As I looked nearly straight down while hanging out of the left side of a helicopter, the two main hot springs of Black Sand Basin became visible.

Iron Creek extends from the lower right corner of this photograph to the upper left. Boardwalks are visible, too. The spring basins' deep blue is seen from the boardwalks, but the deep cone-shaped bottoms are clearly visible only from the air.

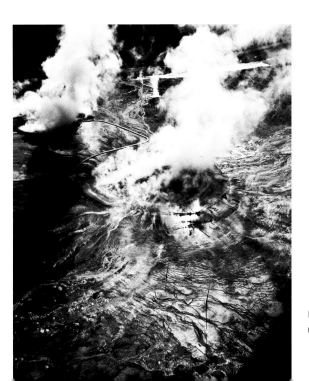

Runoff terraces,
Grand Prismatic Spring.

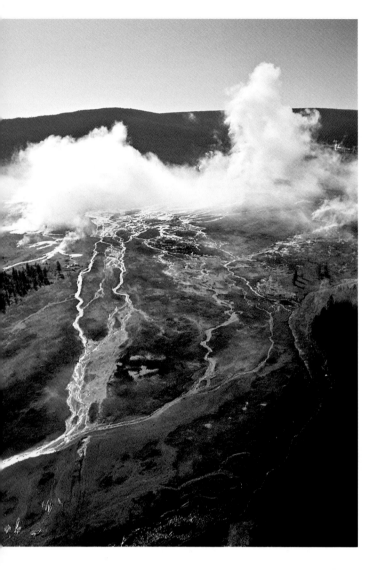

In this aerial view of the Lower Geyser Basin, it is clear that much water is released from these hot springs and geysers.

The numerous runoff channels drain north-ward along the Firehole River. Yellowstone has the largest geyser complex in the world with thousands of other thermal features. Nearly half of all the geysers in existence are within fifteen miles of the Firehole River. The two columns of steam in the still, early morning air rise from the area around Great Fountain Geyser and Fountain Paint Pots.

Sawmill Geyser in the Upper Geyser Basin erupts intermittently, sometimes for hours at a time.

It is a fountain-type geyser, erupting up through a pool of water. Pulses of hot water punch up 20 feet or more in the air with deep "thump" and "whoosh" sounds. The tinkle of glassy round drops of water falling back onto the surrounding rock creates a second song. These eruptions spin and scatter water all around and regularly wet the nearby boardwalk.

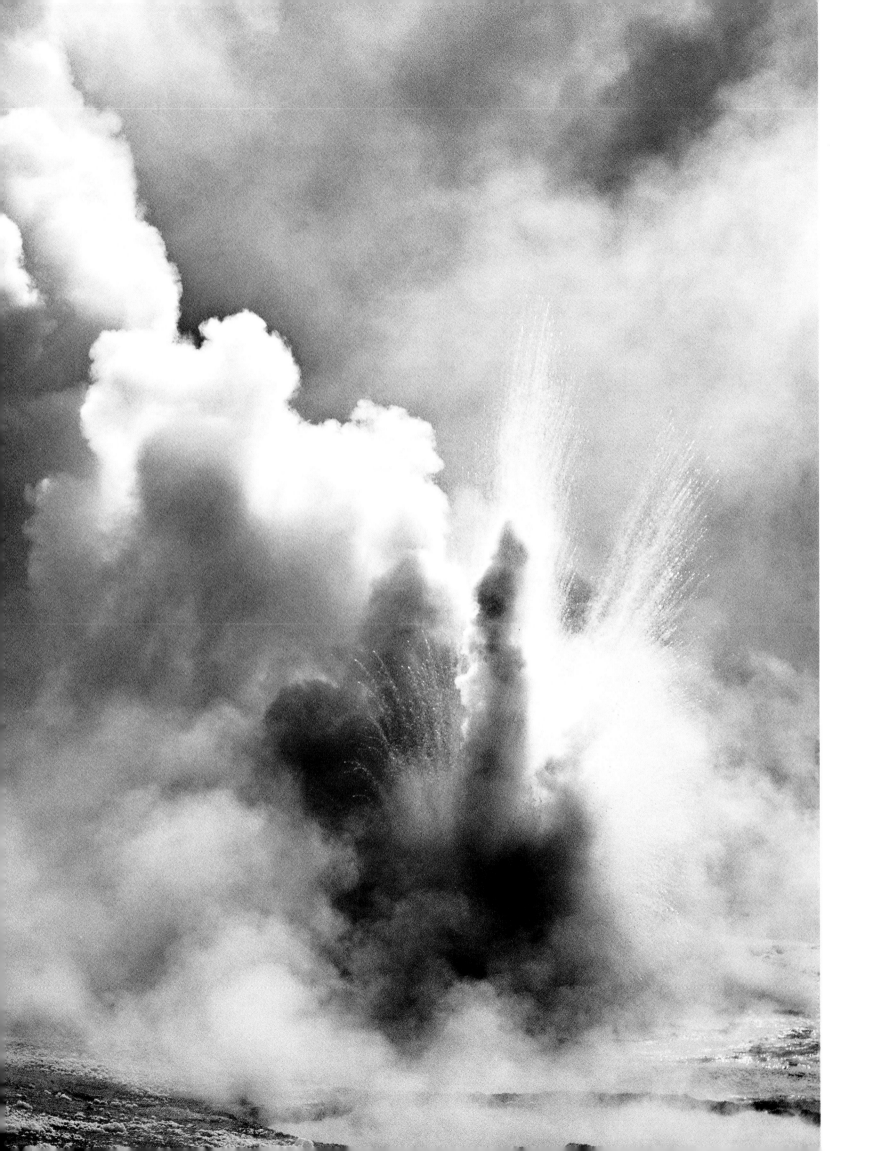

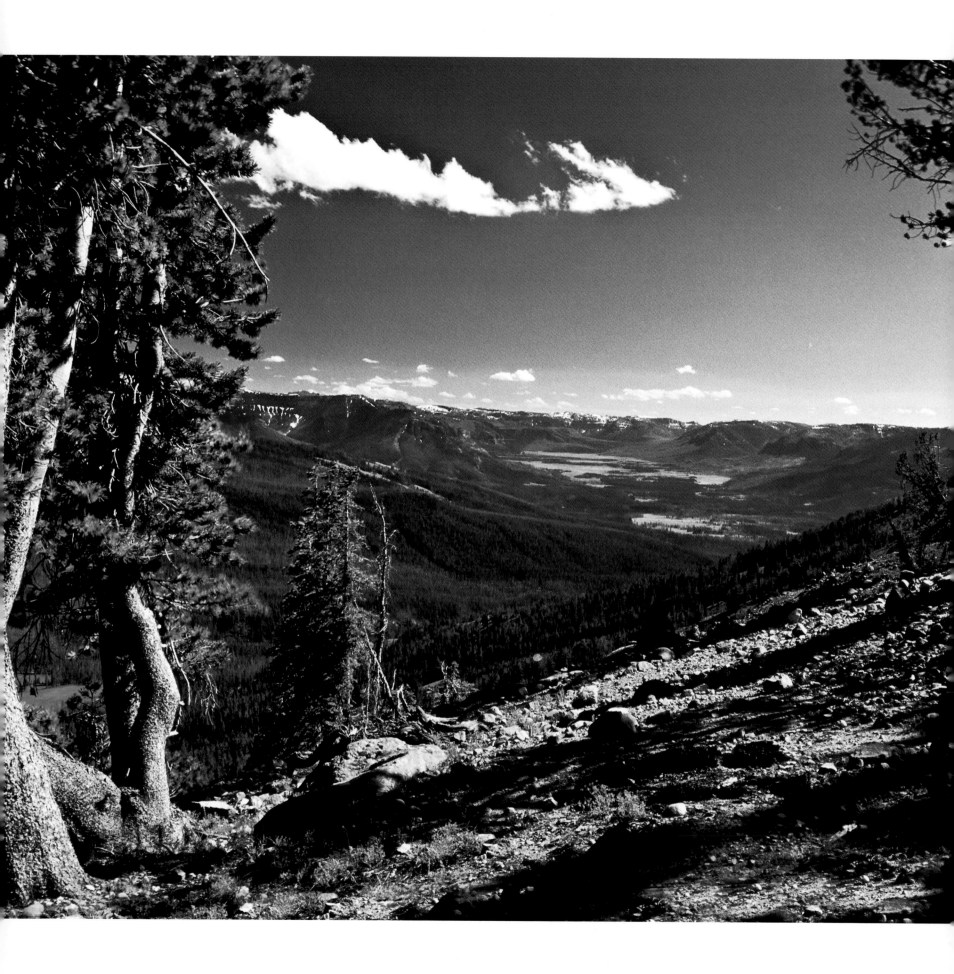

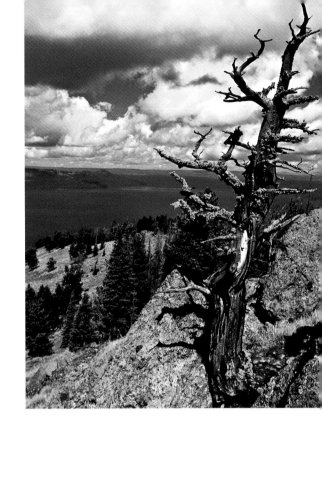

From the east side of Colter Peak, one sees the broad flat valley of the upper Yellowstone River to the south.

The mountains in the far distance are outside of the Park in the Bridger Teton Wilderness. The flat-topped mountain in the center left is the Trident. The name, Thorofare, came from the fur trappers' description of an easy travel route from the Teton Valley over the Continental Divide and down the Yellowstone River to the plains of present day Montana.

Tamias, the genus name for chipmunks, is a Greek word meaning "steward" or "treasurer" and is inspired by their food-storing traits.

This smallest member of the squirrel family stores seeds for winter food. Gathering seeds in its flexible cheek pouches, this least chipmunk paused briefly on a rock to look around before leaping to the ground and disappearing into a small burrow.

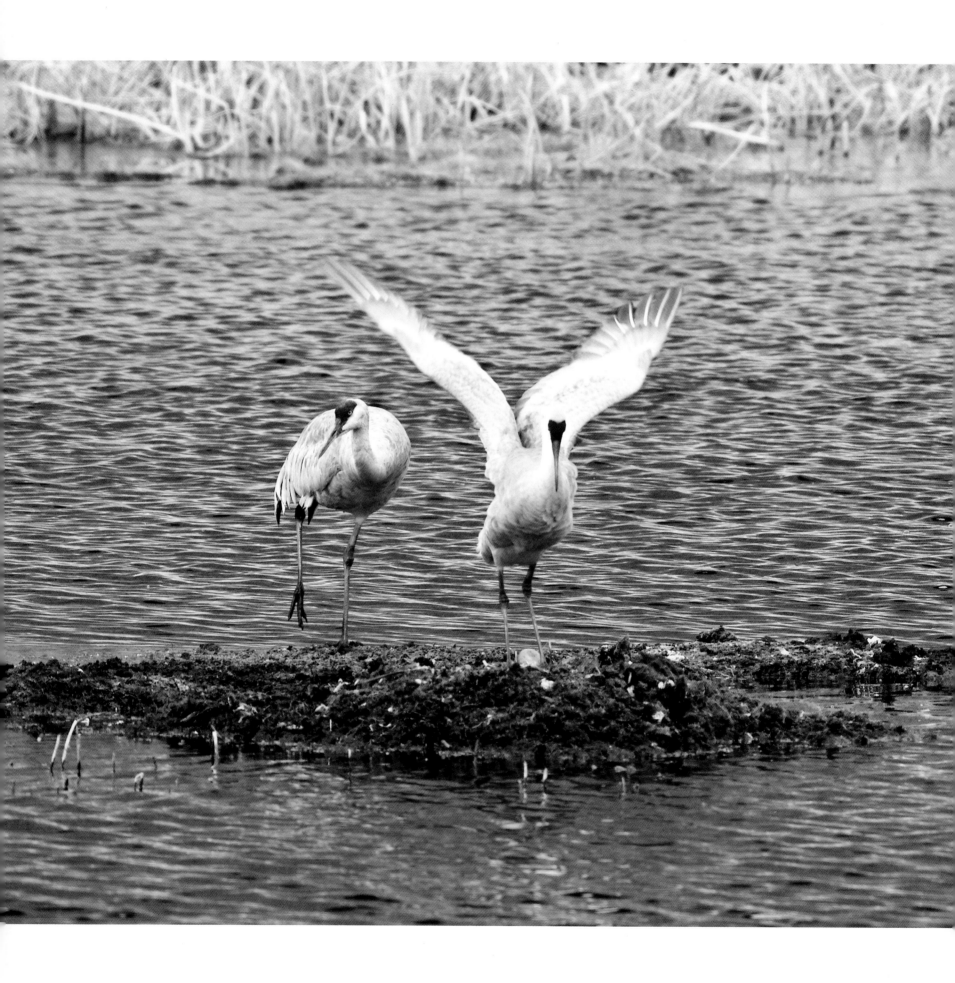

There is a muddy grassy bump on the floor of Floating Island Lake near the west shore. A pair of sandhill cranes built a nest on this boggy lump, pulling tule reeds and grasses up onto the mound about a foot above the water surface.

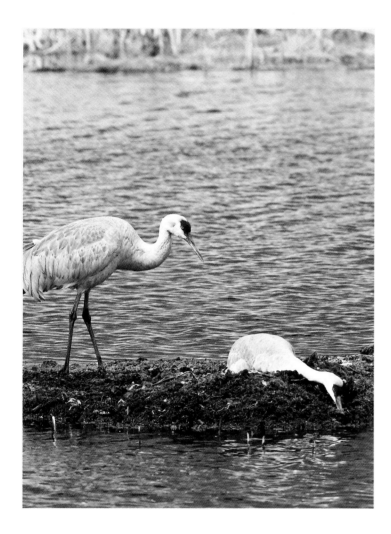 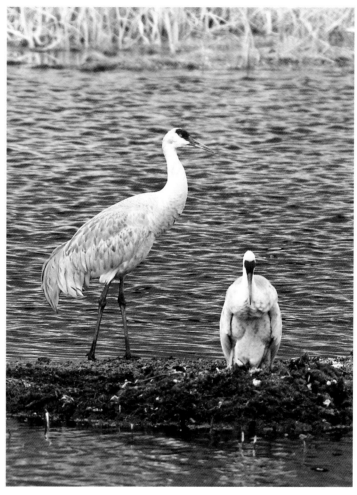

The cranes had been defending this spot for over two weeks. The one on the right was sitting on the empty nest while the other stood watch. When the one on the right stood up, I wondered which was the male and which was the female since they look the same to me. The one on the right squatted down in an odd posture for nearly a minute, stood up tall, threw back her head and let loose a wonderful prehistoric rattling call. Then I noticed the large, light brown egg below her. She might have been saying "Look what I just did," or maybe, "Wow, I'm glad that's over."

Harlequin ducks are rare breeding residents of Yellowstone and are found in only a few places in the early summer. Le Hardy Rapids is the most accessible place to see them. They are attracted to this rough water where they repeatedly fly to the top of the cascades and float and bounce down through foaming waves. Their name comes from the coloration of wild patterns like the paint of the clowns and pantomimes of the stage. They often dive to feed, turning over stones looking for aquatic insects and small fish.

Yellowstone Lake was imaginatively described as shaped like a hand; the western part is called a "thumb," perhaps a large one with severe swelling.

In the early morning here at the west end of West Thumb, fog and steam are usually visible from the active thermal basin which extends out under the water.

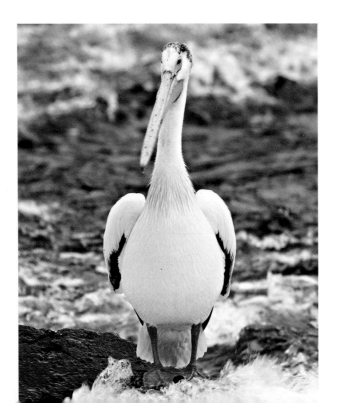

Standing patiently on a rock at the edge of LeHardy Rapids, this white pelican was watching for the spawning cutthroat trout which move up the Yellowstone River in early summer.

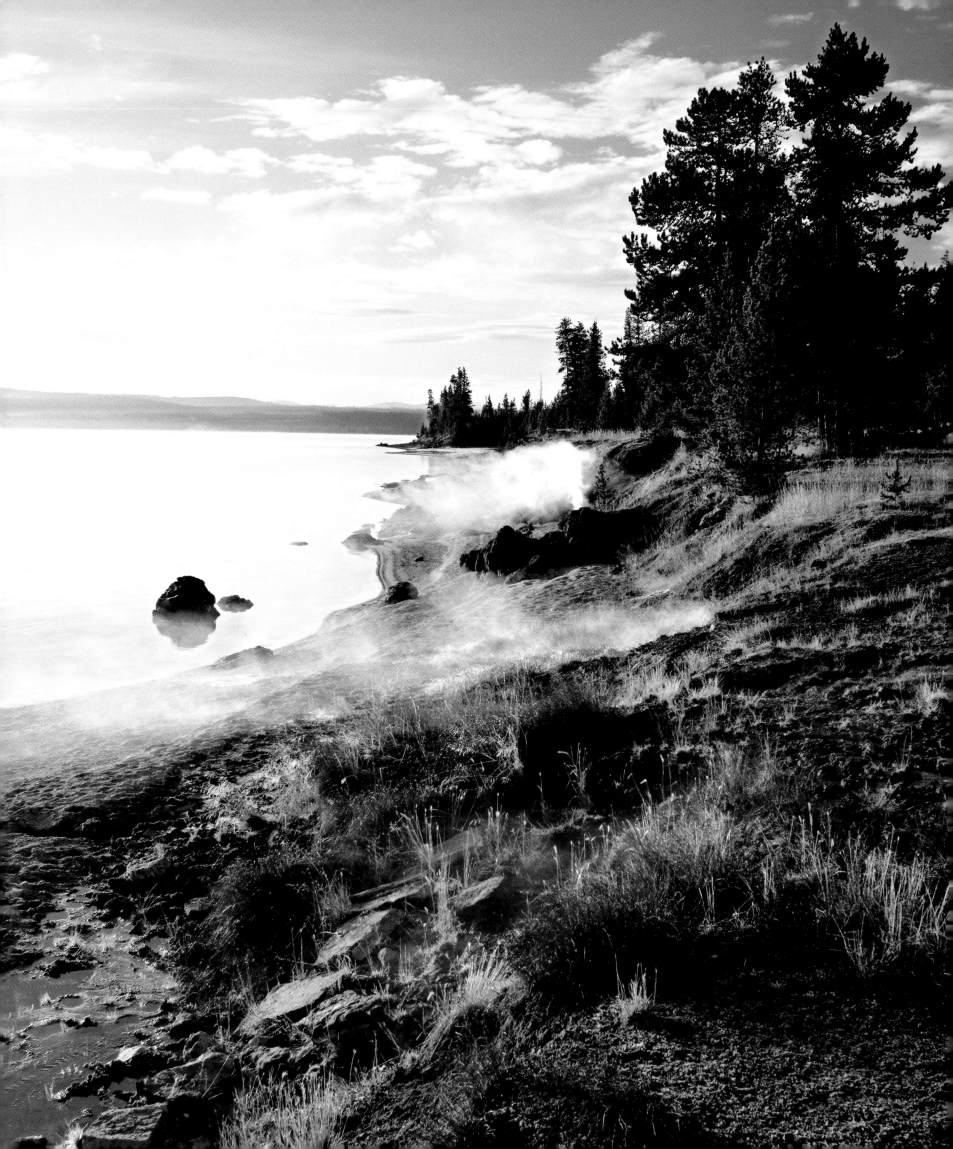

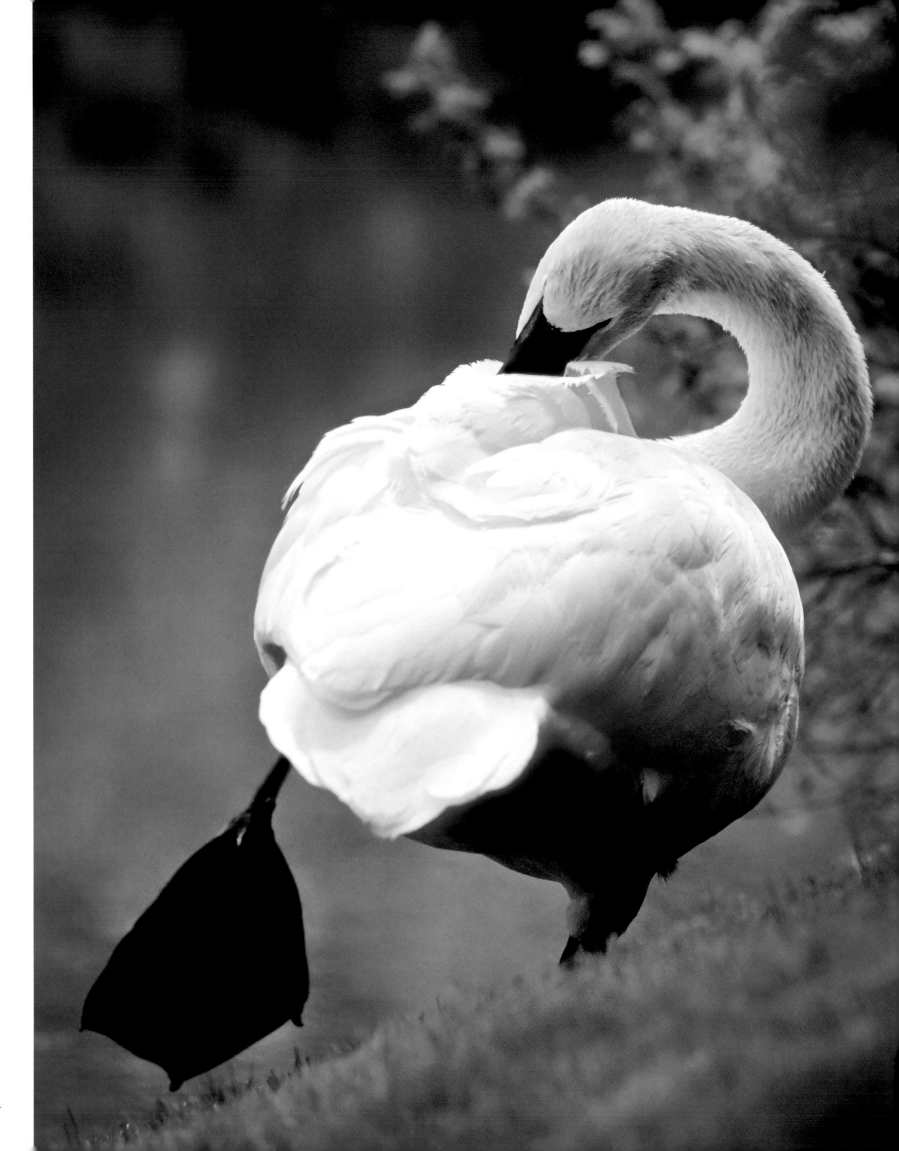

Trumpeter swans stand on one foot with powerful grace for extended periods of time.

They preen, sleep, and watch everything around them. Stretching their long necks and long wings, and twisting their heads back and around to touch oil glands at the base of their tails, they pull the oil through and under their wings while carefully cleaning and smoothing their silky feathers.

A pair of adult trumpeter swans cared for their newly hatched cygnets.

While feeding themselves, they pulled vegetation for their cygnets off the shore into the water and stirred up the shallow mud with their bills and feet bringing other food to the surface for them. While they went about the steady job of caring for these beautiful cygnets, they protected them so they would live to fly within three months.

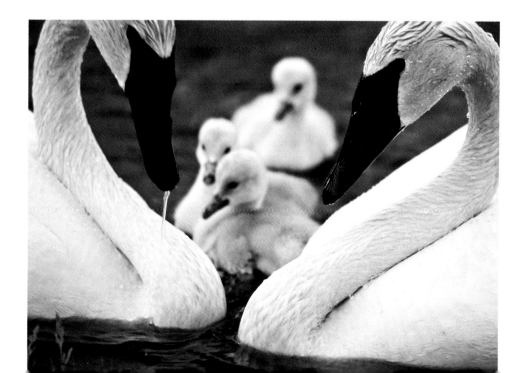

Trumpeter swans have successfully raised cygnets on this two acre pond for most of the past 15 years.

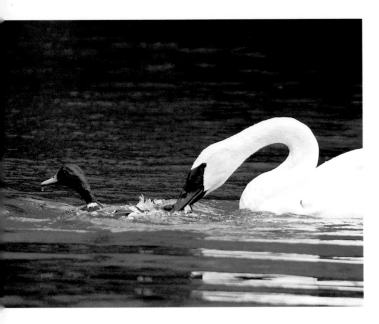 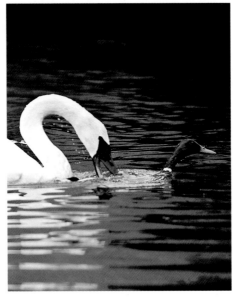 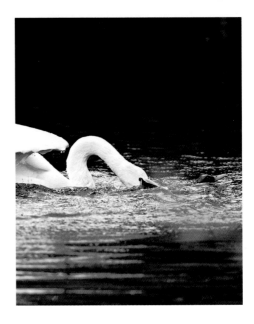

There are many threats to the little cygnets. Raptors could fly down and take them. Coyotes, foxes, and other land predators could kill them when the cygnets are roosting on shore. There are also threats from underwater. Large fish can eat the smallest cygnets, and otter and mink can catch them in the water. As soon as the cygnets hatch, the adult swans chase off any Canada geese, but they mostly ignore ducks, even allowing them to come within a few feet while feeding.

A mallard drake swam to within six feet or so, a common event, but this time one of the adult swans pounded the water with its wings and lunged at the duck. Even though the duck is more agile and quick, it was caught off guard. The swan

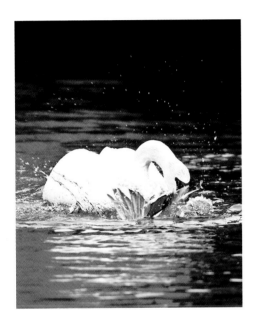 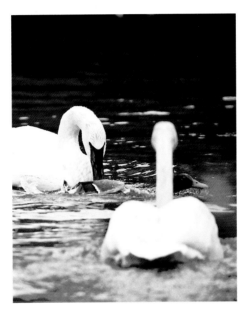 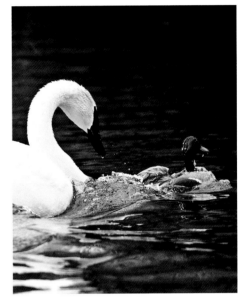

grabbed the duck by the tail and pushed it under water. The duck was thrashing and struggling to get away and get its breath. The swan needed to breathe too and finally let go of the duck. The duck popped up gasping and tried to flop away, but each time the swan reached out and grabbed the duck again and held it under water. The duck almost got away once by struggling over to an over-hanging bank, where the swan lost sight of it for a moment. This battle went on for about three minutes before the duck finally got past the reach of the swan's neck and frantically swam off. I suppose the swan was being overly cautious and protective since a duck would not be a threat to a cygnet.

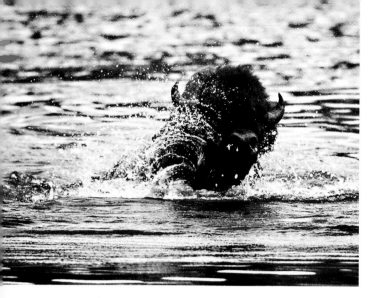

At the north end of the
Hayden Valley there is a
favored spot for wildlife to
cross the Yellowstone River.

Paths lead up to it, and the nearby trees
hold scars from all the extra rubbing and
scratching by wet bison. During the rut,
bison travel back and forth across the
river almost daily. Half of the crossing is
shallow, and as they wade across, they
eventually step into deep water and must
swim. When they swim, they are nearly
submerged with just their faces above
the water pointing up at the sky. They
move quickly and eventually hit the
shallower river bottom on the far side.
As this bull rose out of the deeper water,
he swung his head back and forth,
getting his balance on the uneven river
bottom and flinging water off his head.

After swimming the
Yellowstone River, bison
usually stop to shake their
heads before continuing.

If they are in a hurry like this bull,
they will walk along dripping like
a saturated rug, leaving a peculiar
trail of sprinkled dirt.

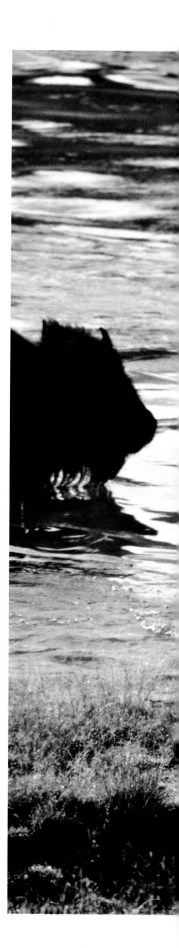

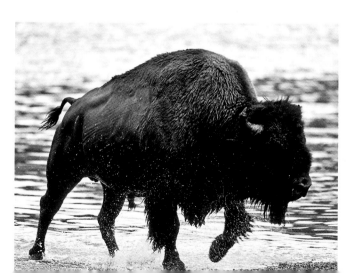

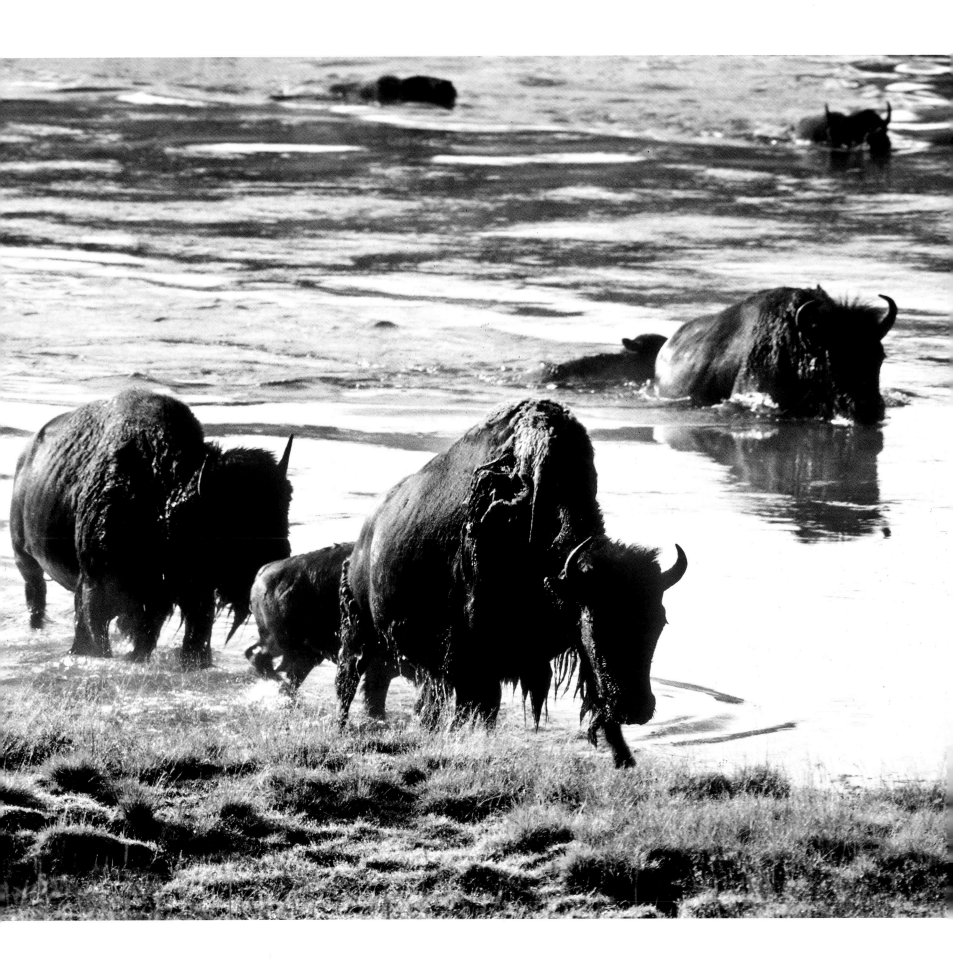

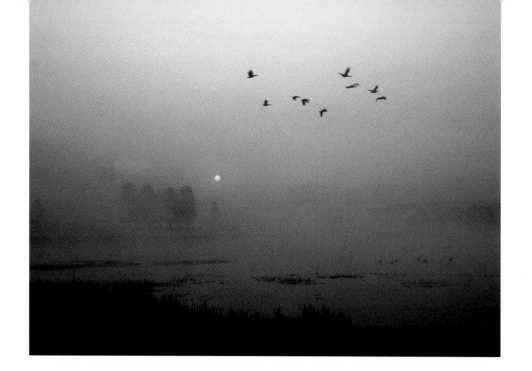

The mouth of Alum Creek is a nice place to wait for a sunrise. The sun usually breaks clear over the low timbered ridge to the east and lights up fog banks moving down the Yellowstone River and Alum Creek. Birds such as these Canada geese often get up and move at this time of day from their night-time roosting sites to feeding sites.

The American avocet is a summer transient in Yellowstone.

These six birds rested on a rock in a kettle lake in Lamar Valley. They were there for just a few days, feeding and relaxing in the sun. They use their slender upturned bills to sweep back and forth in shallow water to catch insects, shrimp and other aquatic invertebrates.

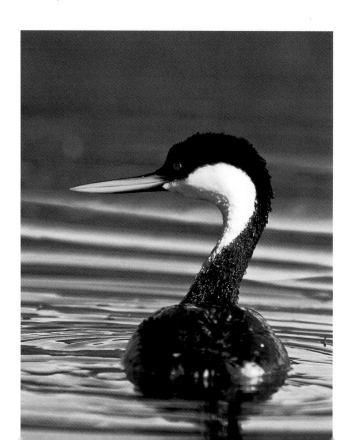

Western grebes are small diving birds with narrow pointed bills and striking ruby red eyes. They dive either by appearing to deflate and submerge or by rising up out of the water spearing their heads in and dropping below the surface. After they stay under water pursuing fish for a half a minute or so, they often pop up quite a long way from where they disappeared.

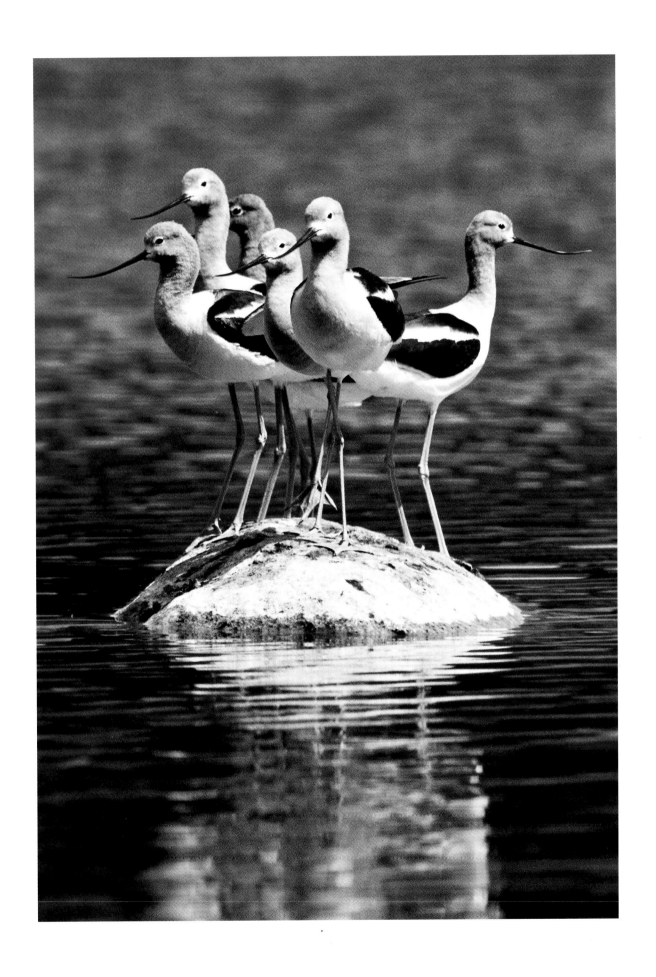

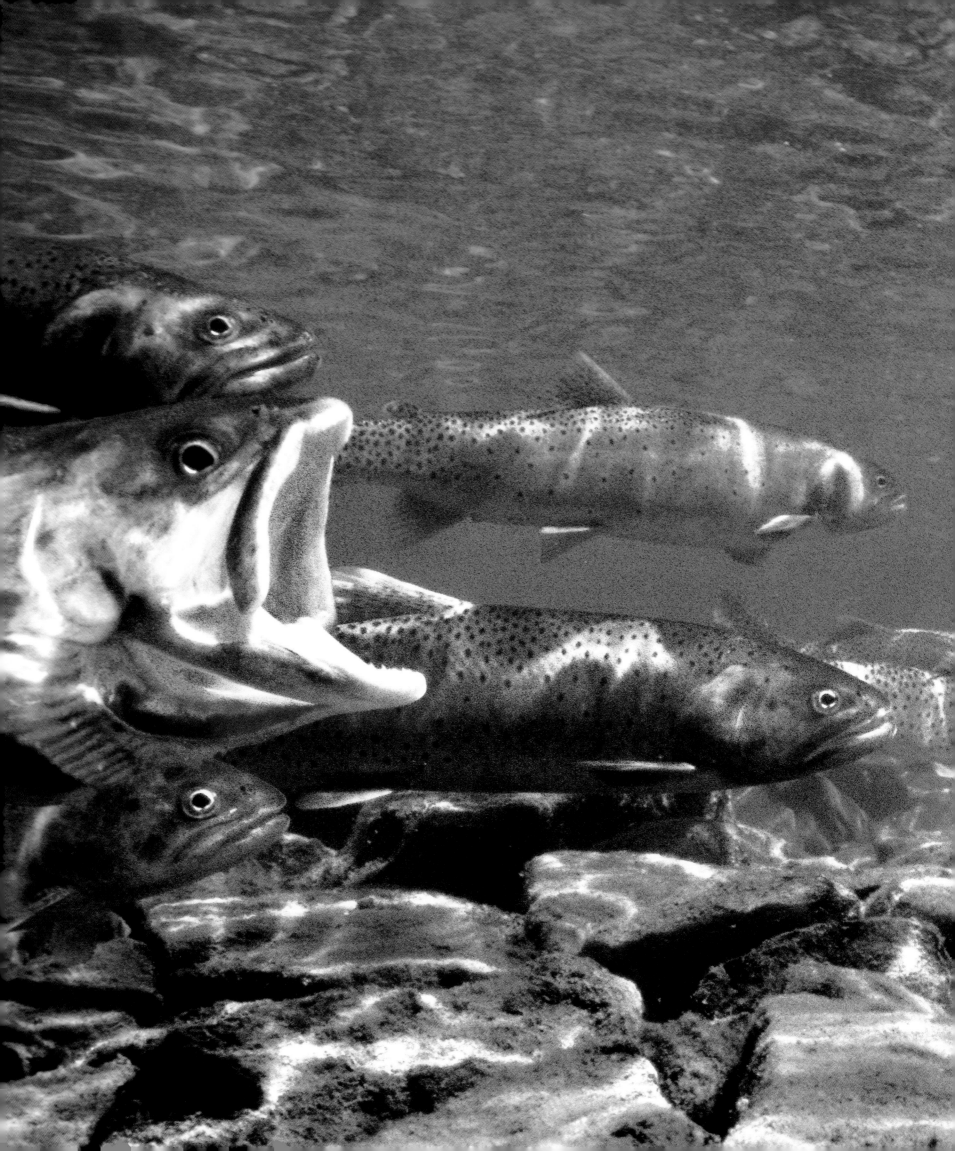

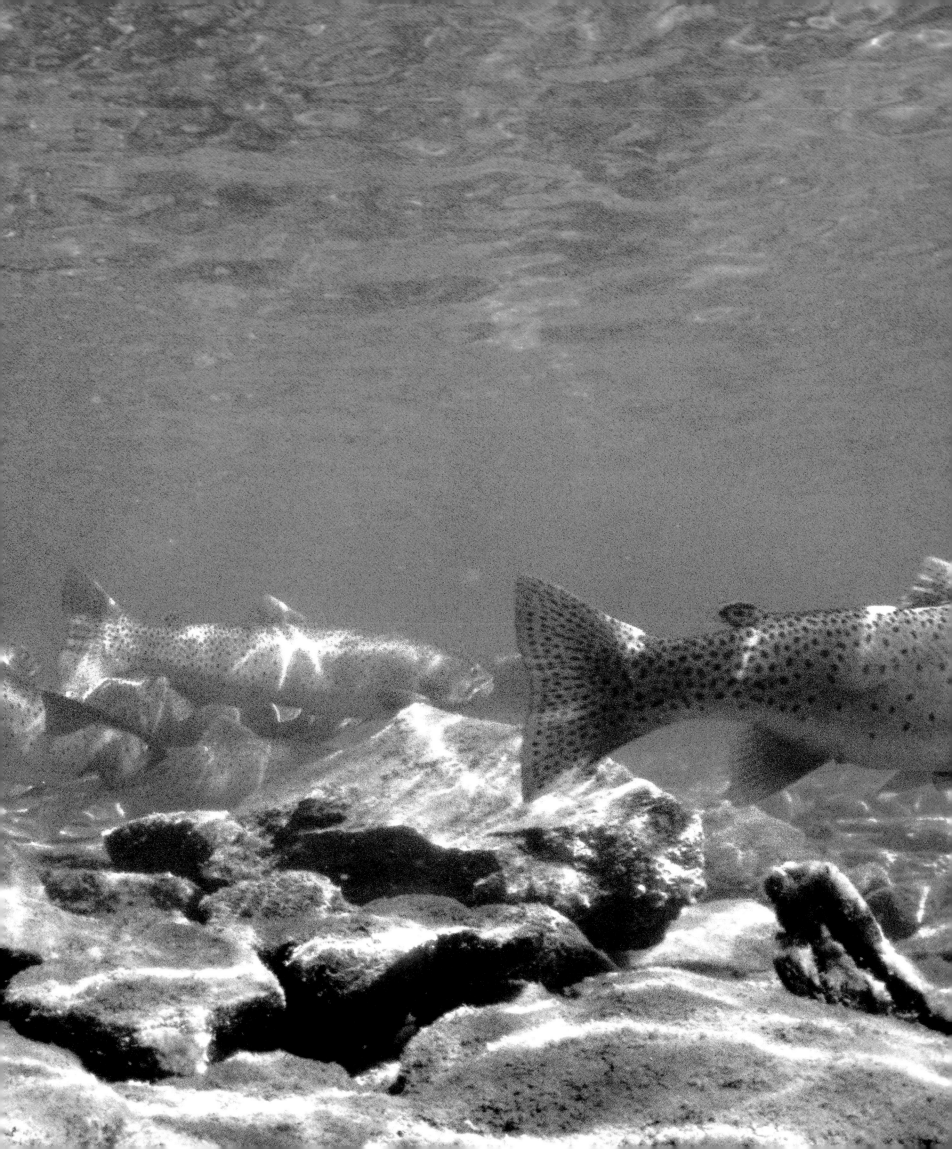

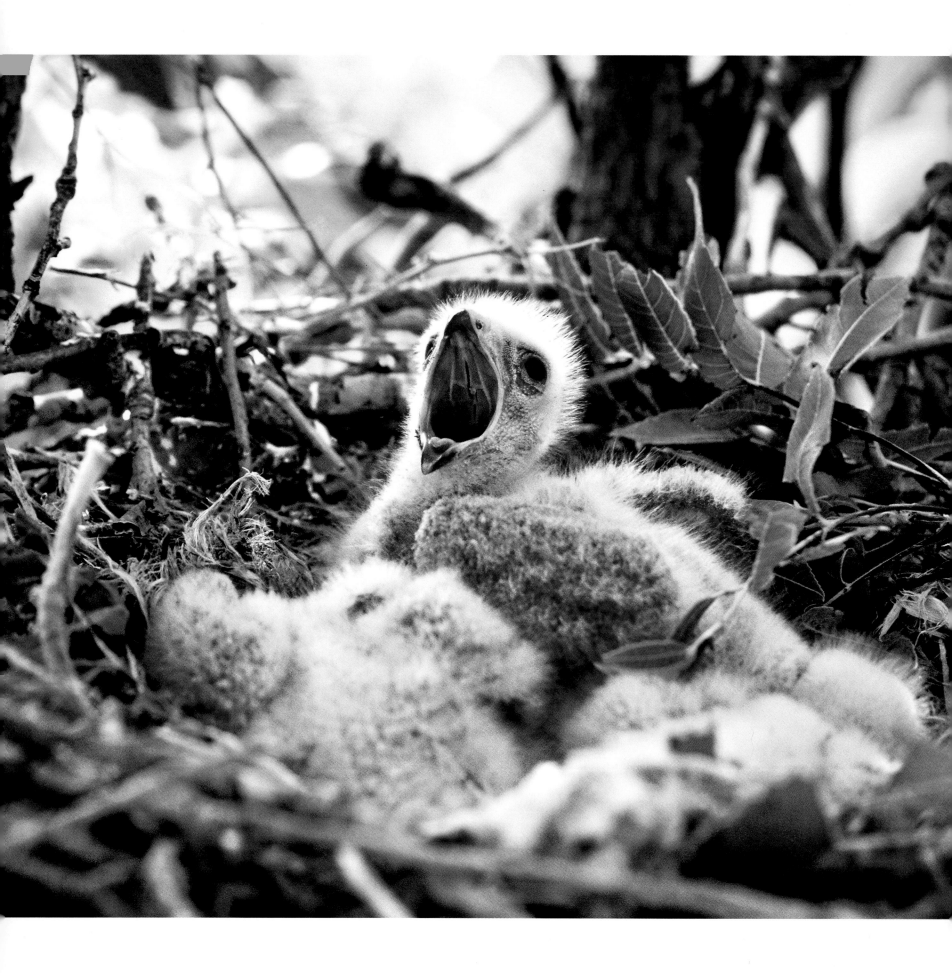

Three downy
Swainson's hawk chicks
slept and waited for
their parents to return
from foraging.

One sat upright and briefly yawned,
then dropped back to sleep with its
nest mates. Swainson's hawks are large
buteos that migrate over 12,000 miles
per year from western North America
to Argentina.

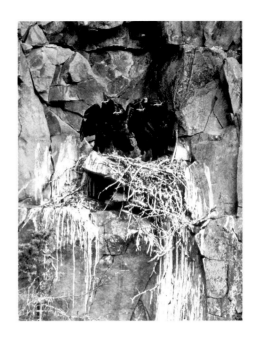

This brood of four ravens
and the sparrow chick (below)
are expecting food.

Motion above them seems to trigger
a response to open their mouths wide
for food

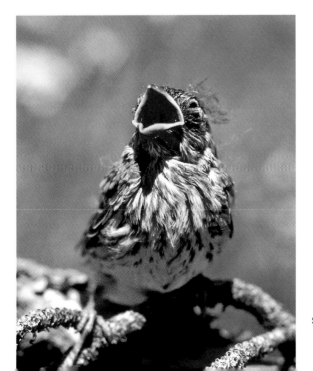

Sparrow chick.

(pages 72-73)
Cutthroat trout congregate in the
shallow pools of small streams during
the spawning season in June and
July. Facing upstream into the gentle
current, the one on the left opened
its mouth extra wide, making it
appear to be laughing or yawning.

75

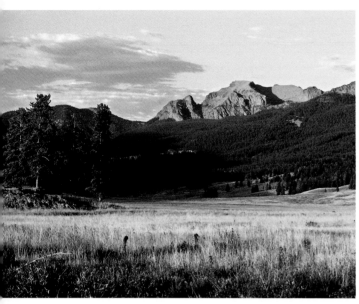

Cutoff Mountain from
Slough Creek Valley.

A five month old calf,
like this one drinking
beside its mother,
has changed color
from the light brown
of its first two months
and is starting to grow
the distinctive hump
that adults have.

Bison travel a lot while feeding. Stopping at
this kettle lake in the Lamar Valley, the herd
did not linger in the green grass nearby but
continued to move on selectively grazing on
the curing summer grasses and putting on
weight for the upcoming winter.

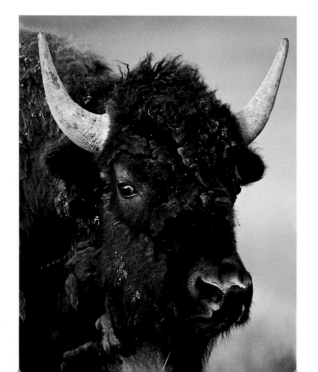

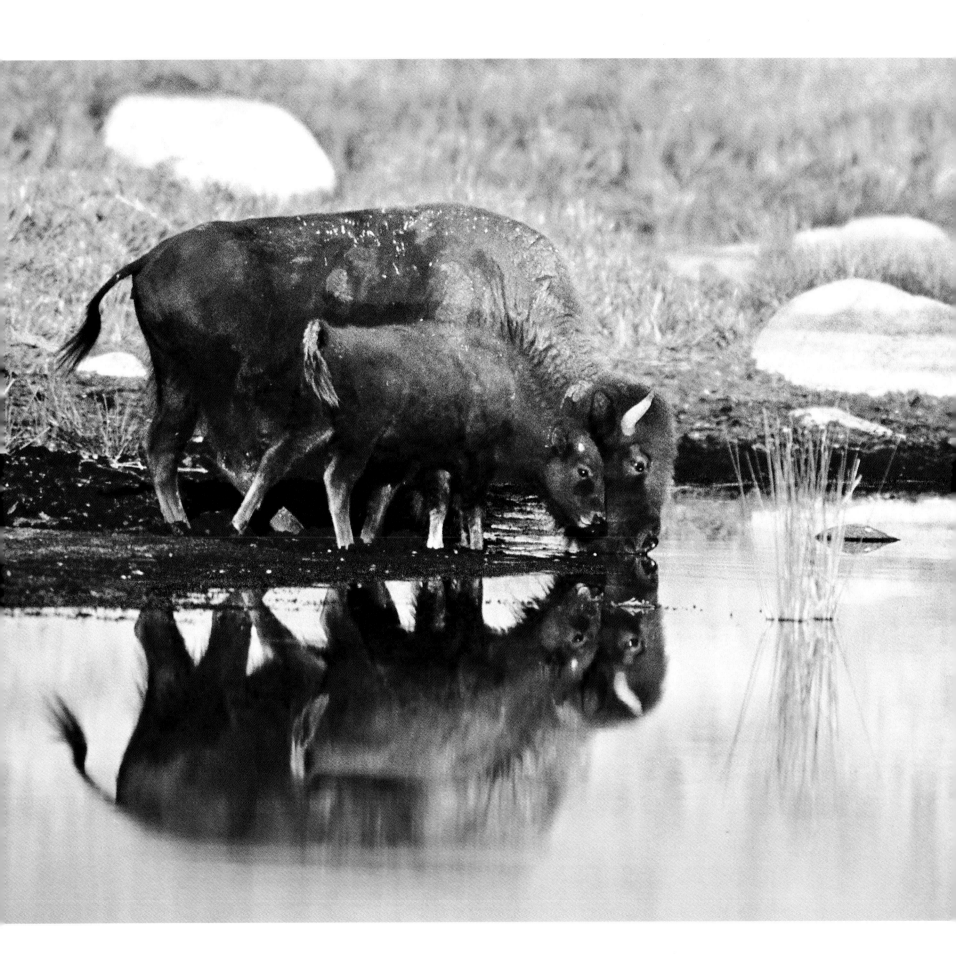

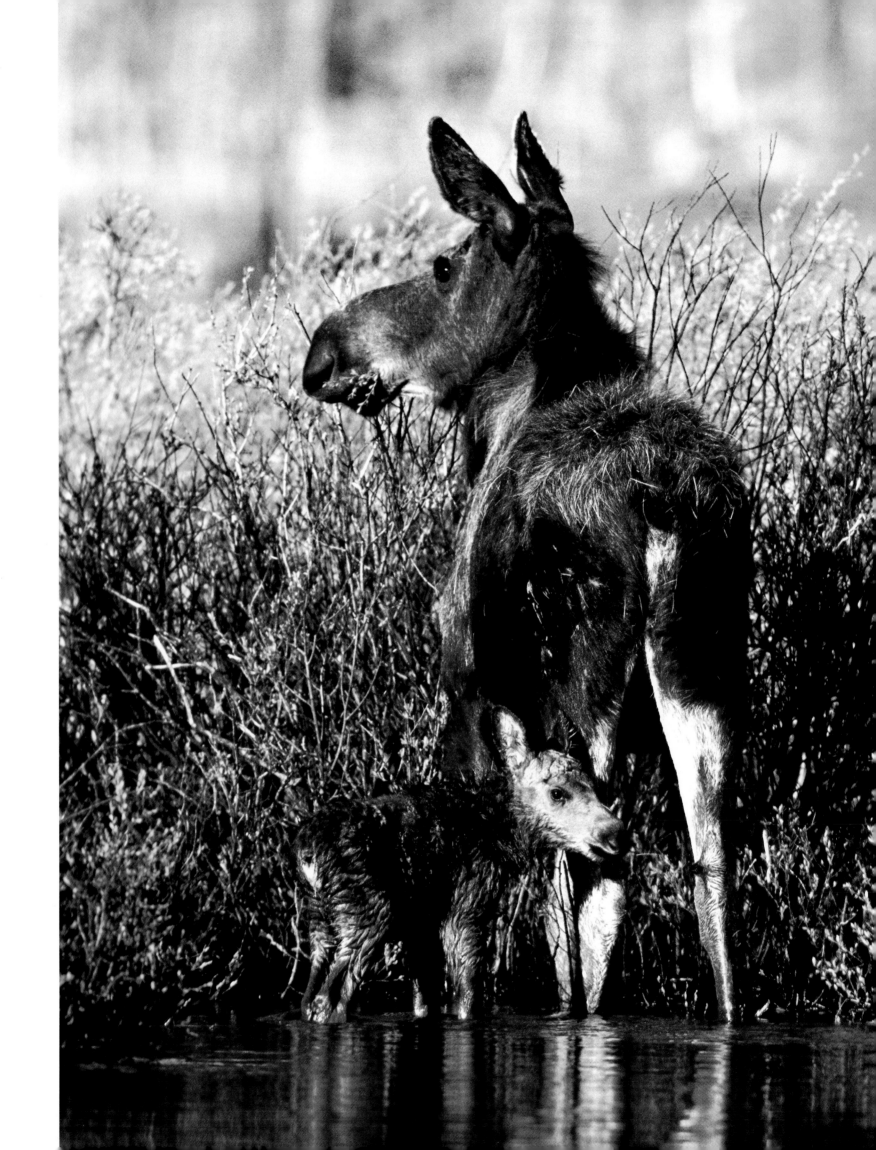

Less than one day old, this moose calf walked out on wobbly little legs into the shallow water where her mother was browsing the new willow leaves.

The cow was busy feeding, watching for threats to her helpless young calf, and making sure the calf didn't wander into deep water or get tangled in the brush.

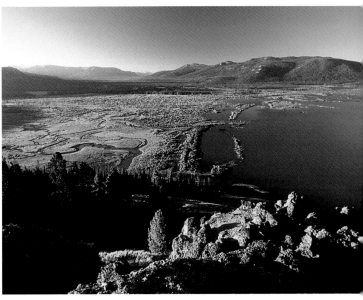
Southeast Arm of Yellowstone Lake.

Yellow-headed blackbirds are related to meadowlarks and nest in colonies in marshes.

They weave grass nests near the bases of reeds and cattails just above the water's surface and raise their chicks on insects. Males spend a lot of time defending their territory from their neighbors. Part of the male's territorial display is a clacking, raucous, non-musical call sometimes compared to a rusty gate hinge. The birds climb and perch on the round-stemmed tule reeds. It takes some time to learn how to balance on the flexible, tall green stalks. The adult male in the upper left has learned to fly in and grab three or four stems and let them bend under his weight to give him a stable, flat base on which to perch. The juvenile fledgling has not figured this out yet. It flew into the reeds and grabbed one stem on the left and one on the right to cling spraddle-legged between the two. This was okay unless the wind was blowing. The breeze that day created a problem for this juvenile because the two stems were swaying back and forth, sometimes spreading too far apart for its spindly little legs. Like having one foot on the dock and one in the boat, when the two stems spread apart, the chick fell into the water three times while I watched.

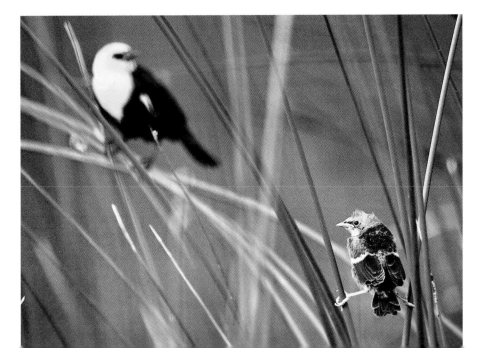

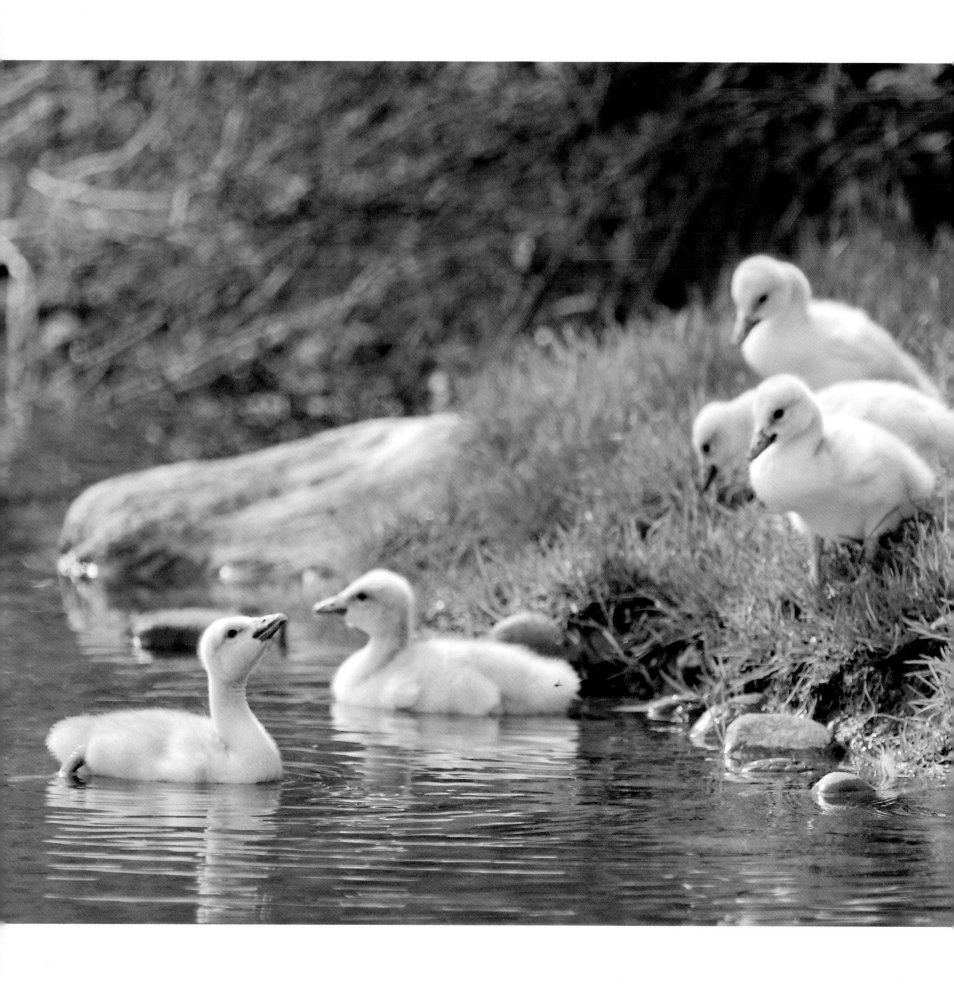

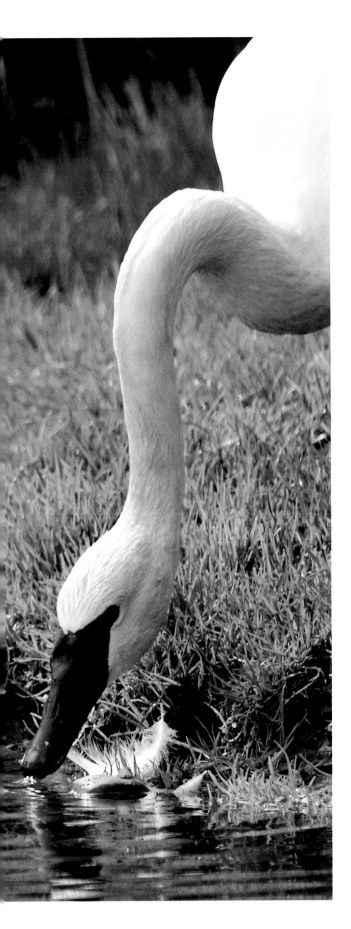

After spending about
half an hour feeding
in the water, the adult
trumpeter swans brought
everyone to shore.

The five cygnets moved out of the water
onto the grass, taking a last drink. Just
before walking up the bank to rest,
the adult reached back to the water for
a little sip, too.

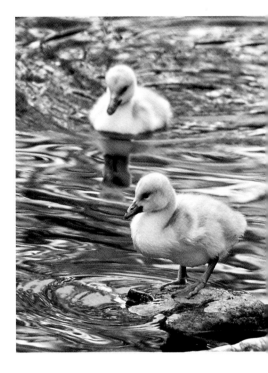

Moving off the water to
rest on the grassy bank,
these trumpeter swan
cygnets paddled in the
rippling mirrored surface.

One stood briefly on a small rock
to wait for its parent to preen
before going to rest on the bank
for a couple of hours.

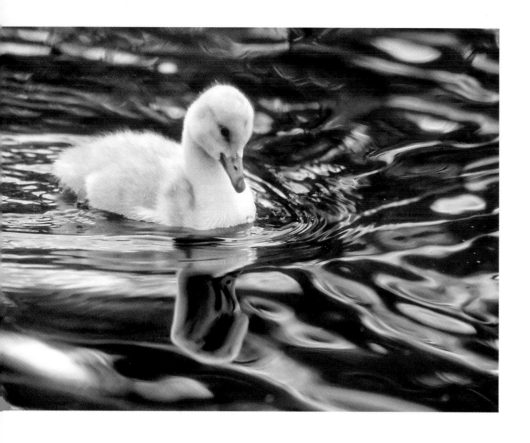

Trumpeter swan cygnets feed busily all around and between the adults who provide protection from predators.

The first food of the cygnets is brought up to the surface of the water by the adults and consists primarily of beetles, insects, and crustaceans. After three weeks or so the diet shifts to plant material such as sedge, pond weed, and rushes.

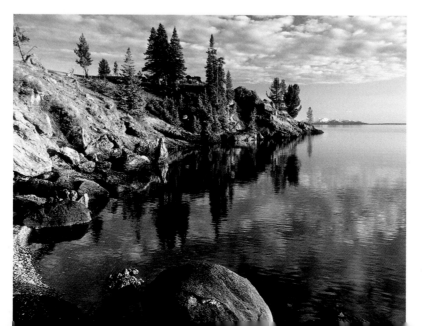

East shore, Yellowstone Lake.

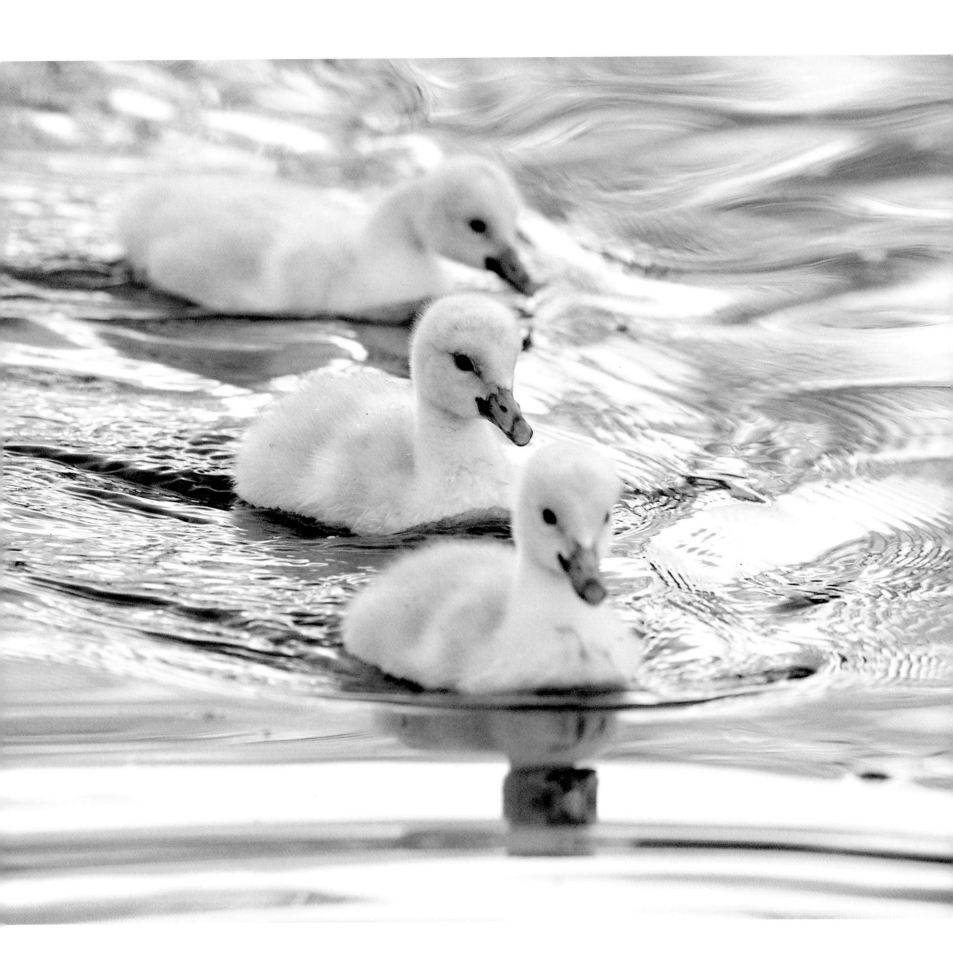

Standing on a small, nearly submerged log, this American coot chick watched its parents diving for food, dabbling, and picking insects and vegetation off the surface.

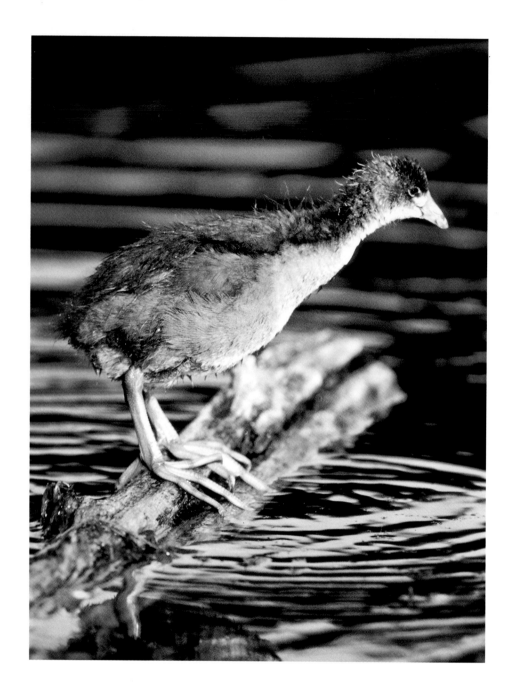

It did not stay on the log for more than 15 seconds before it stepped into the water and began feeding near the adults. It will be able to fly at a month and a half.

Killdeer are one of the most familiar shorebirds in North America.

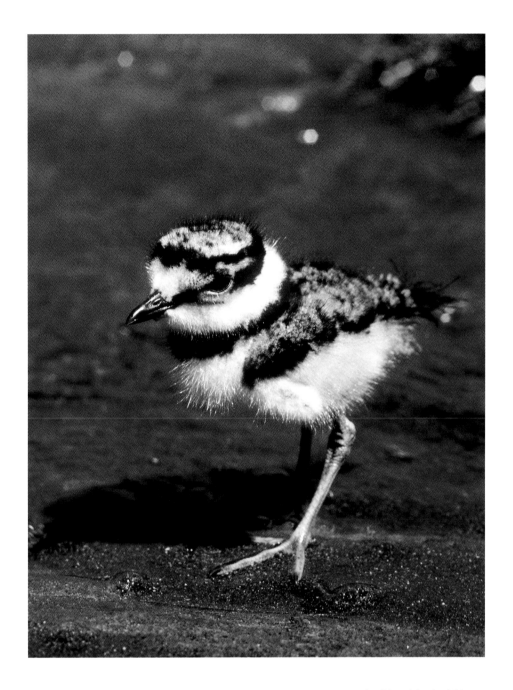

Their name comes from their loud call "kill dee" or "kill deer." The precocial young leave the nest soon after hatching and fly within three weeks. This chick was less than a week old and looked like a fuzzy black and white ping pong ball racing around on oversized legs.

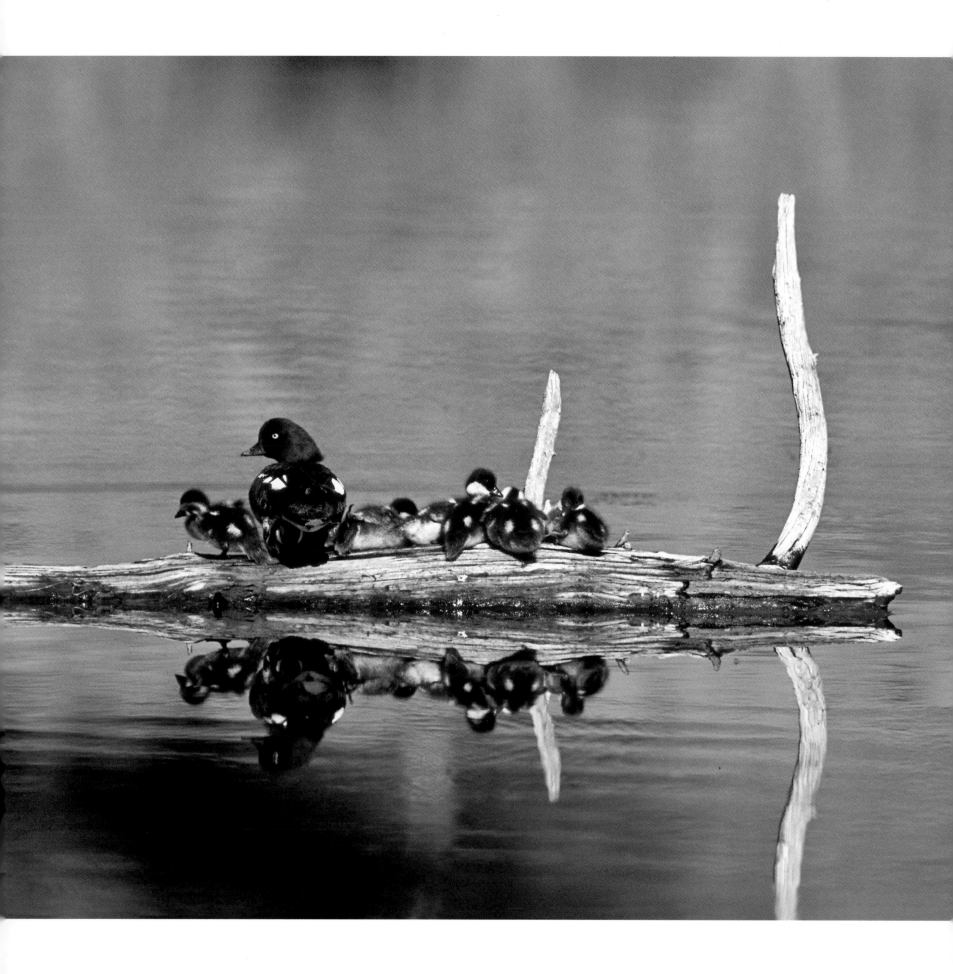

The common goldeneye duck may lay up to 20 eggs in a single nest.

The precocial young are tended by the hen. The adult duck can dive down 20 feet to feed on aquatic plants, insects, and fresh water shrimp. With their mother's protection and some luck the ducklings will fly within two months of hatching.

Blue grouse chick.

The pastel colors of weathered rhyolite are softened in the shade of the far wall of the Grand Canyon of the Yellowstone.

Lodgepole pines stand on fractured blocks of nearly sterile dry stone above the river hundreds of feet below. Many of the surviving trees on these inhospitable slopes endure with their twisted wood exposed above the eroding abyss.

While waiting for its parents to bring more food, this robin chick tipped its head back and took a quick nap on its cottonwood twig.

The adults returned about every four minutes or so with salmon flies, spiders and beetles.

A wet winter and spring produced one of the best wildflower crops of a decade.

Early in July the Lamar Valley was covered with flowering forbs. Plants in their seasonal succession produced a dynamic array of color and texture during the entire summer. Some areas had concentrations of purple, then pink, then yellow, stretching for miles, mixed with the rich greens and gold of the grasses and the blue-grays of the sage. This particular summer produced a rejuvenation of seeds and strengthened root stocks while providing an overabundance of forage for the fattening wildlife.

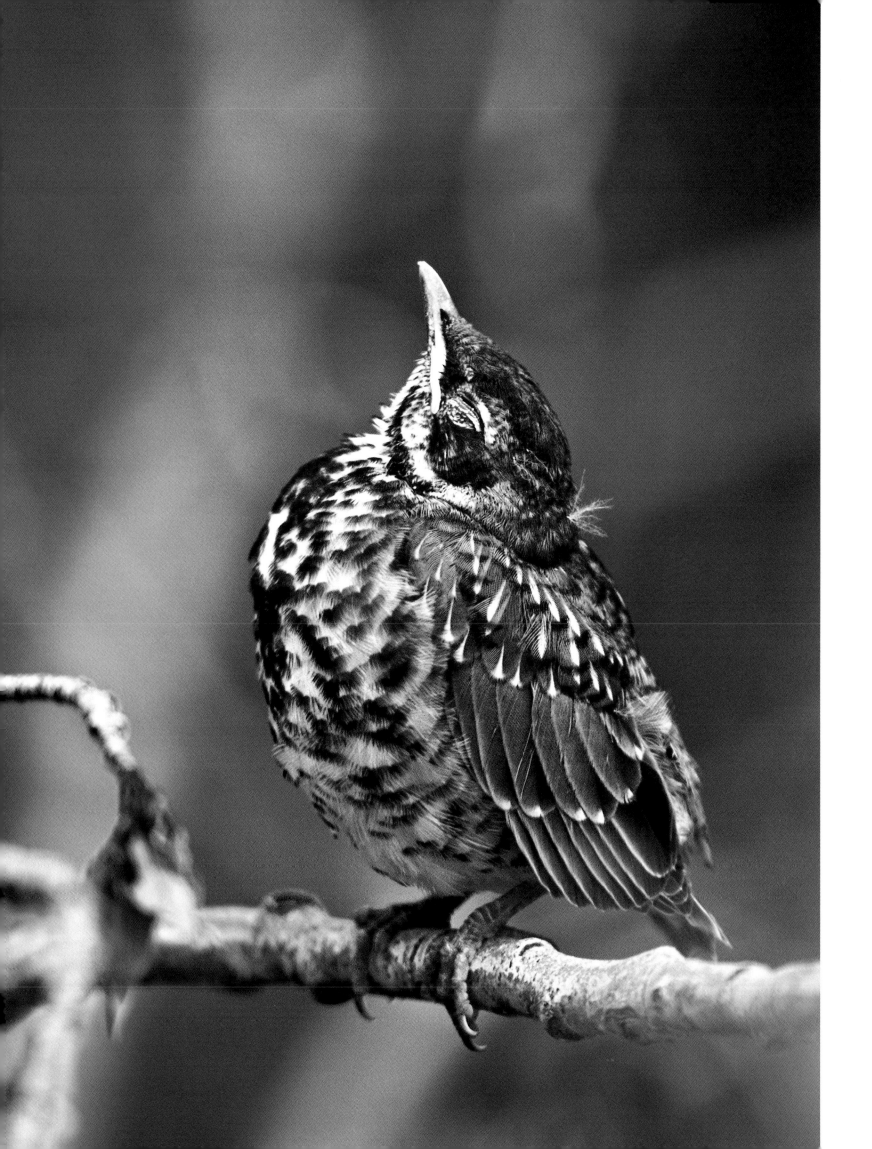

Juvenile elk with dry reed.

Pronghorn antelope can outrun every animal in the western hemisphere. When a young pronghorn runs, its tiny, thin legs move so fast they blur, and you see only the little compact body floating along above the grass, as if it had invisible wings or invisible wires carrying it along. I wouldn't be too surprised someday to see one take off and fly.

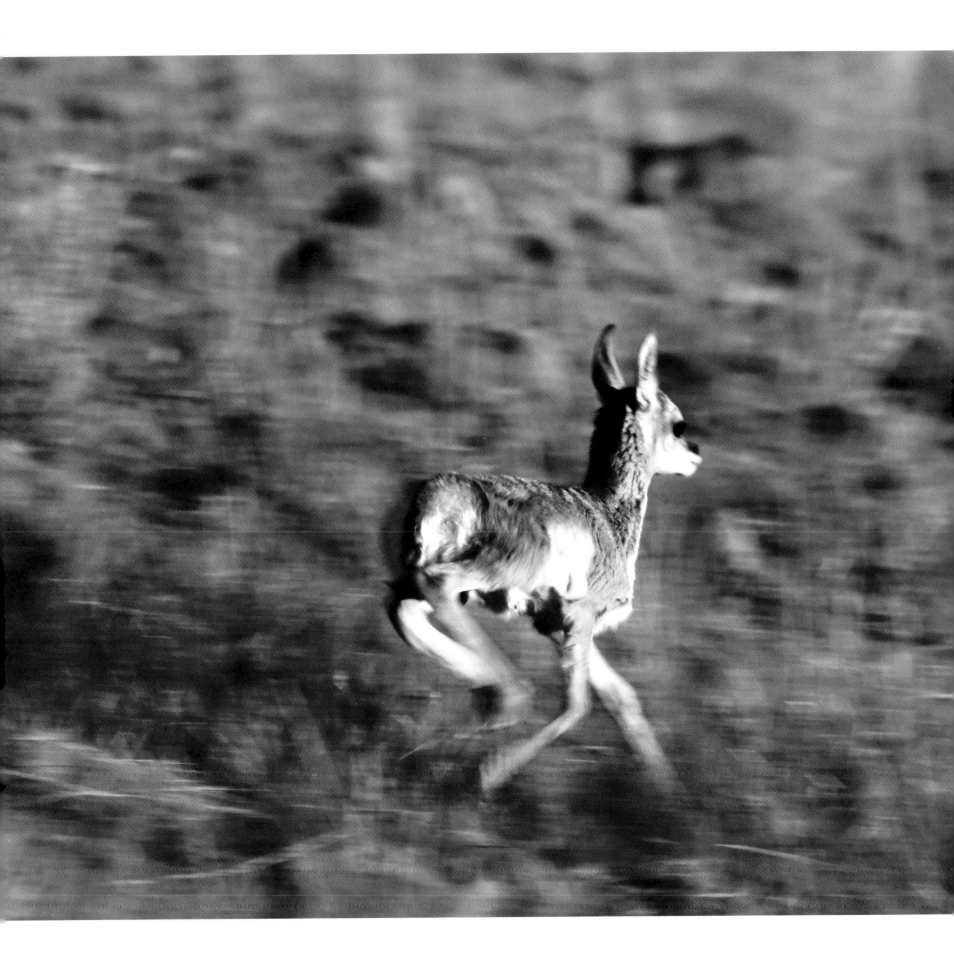

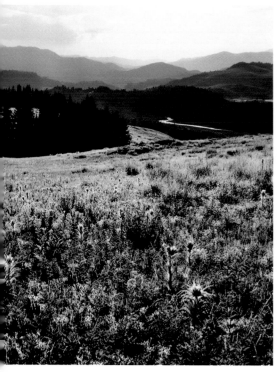

Lamar River.

Bighorn sheep give birth in June after a six month gestation period.

A big part of their survival strategy depends on their ability to occupy steep cliffs that predators cannot. They must travel out to flatter benches and valleys at times to forage but are always alert and retreat to the cliffs if threatened. This month-old lamb seemed to be just running around the meadow for exercise or amusement, and his mom followed him briefly.

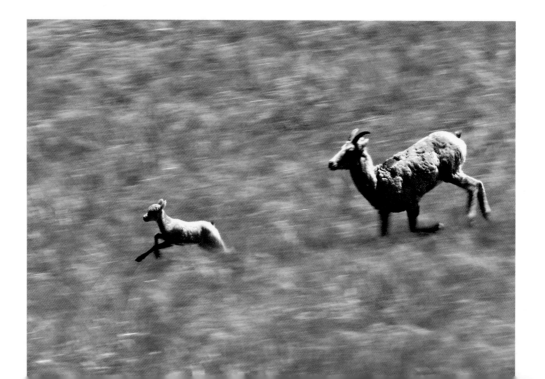

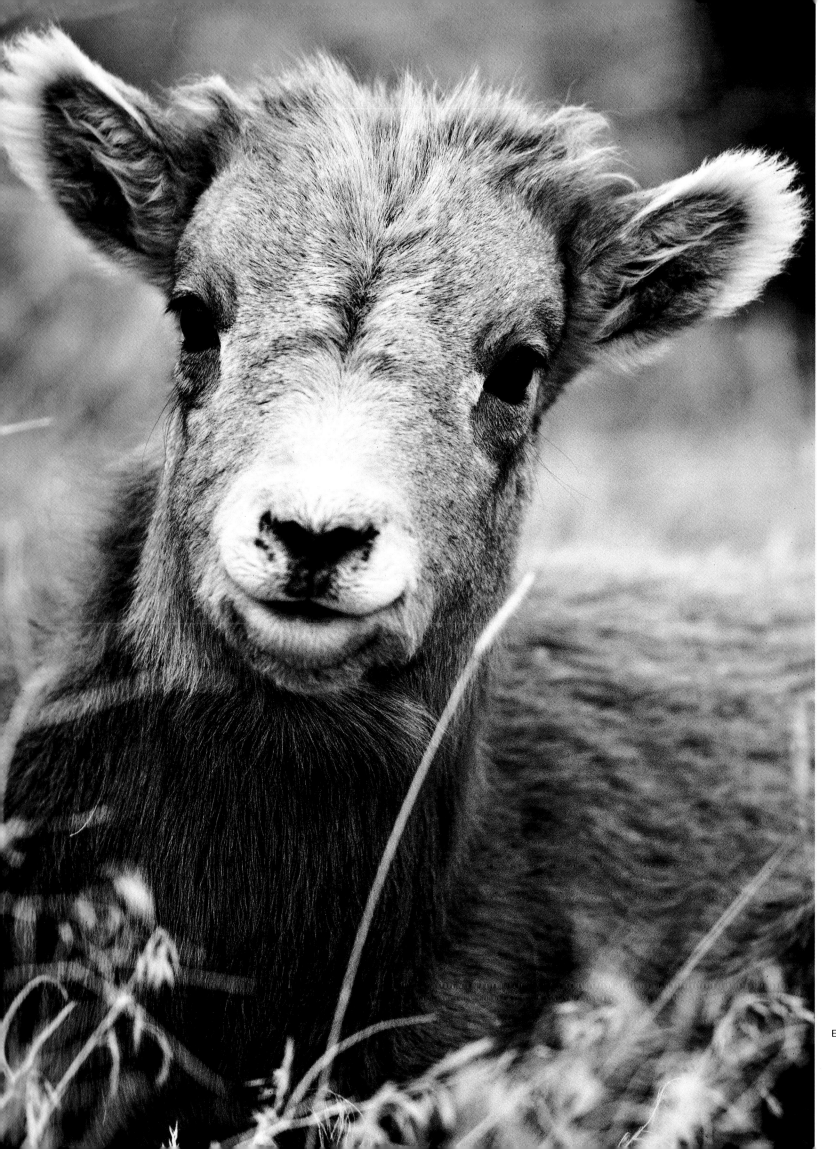

Bighorn lamb.

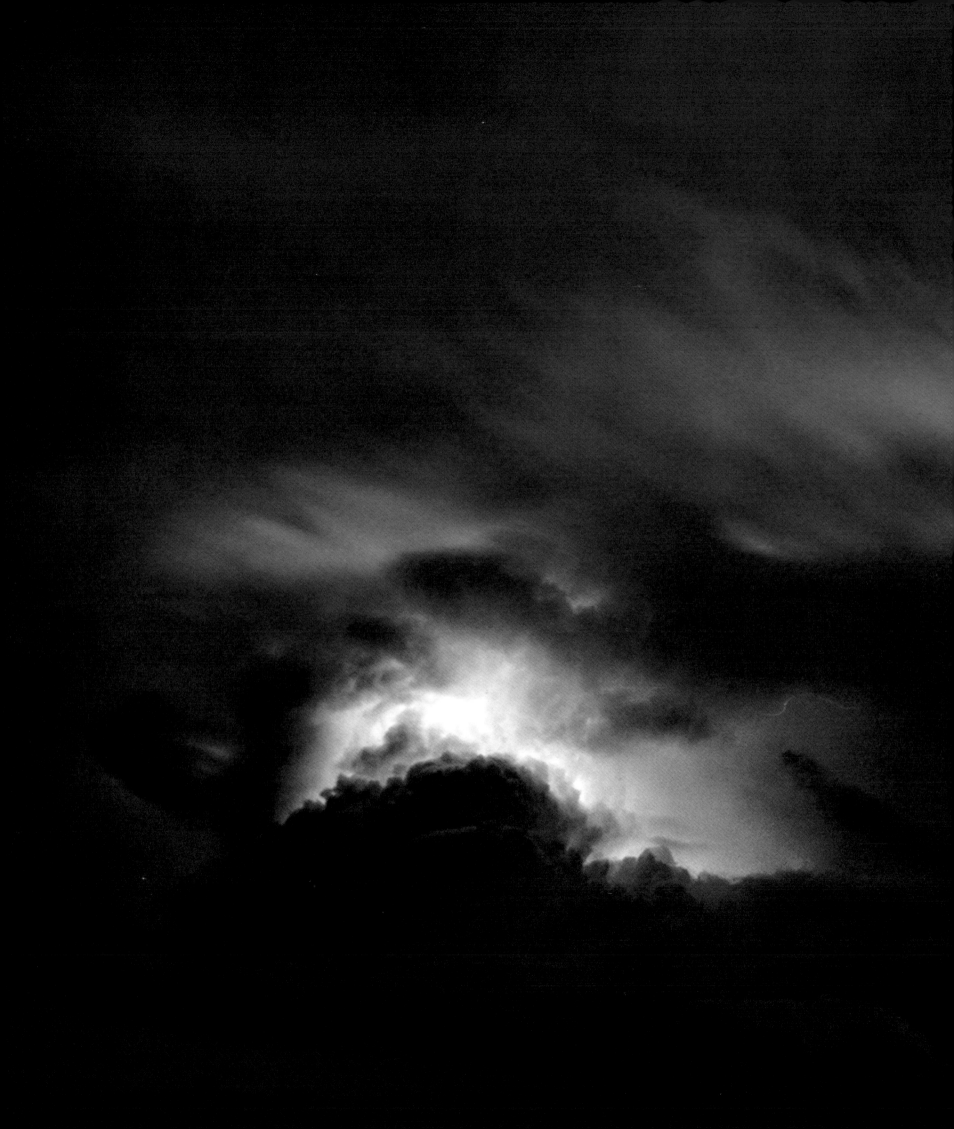

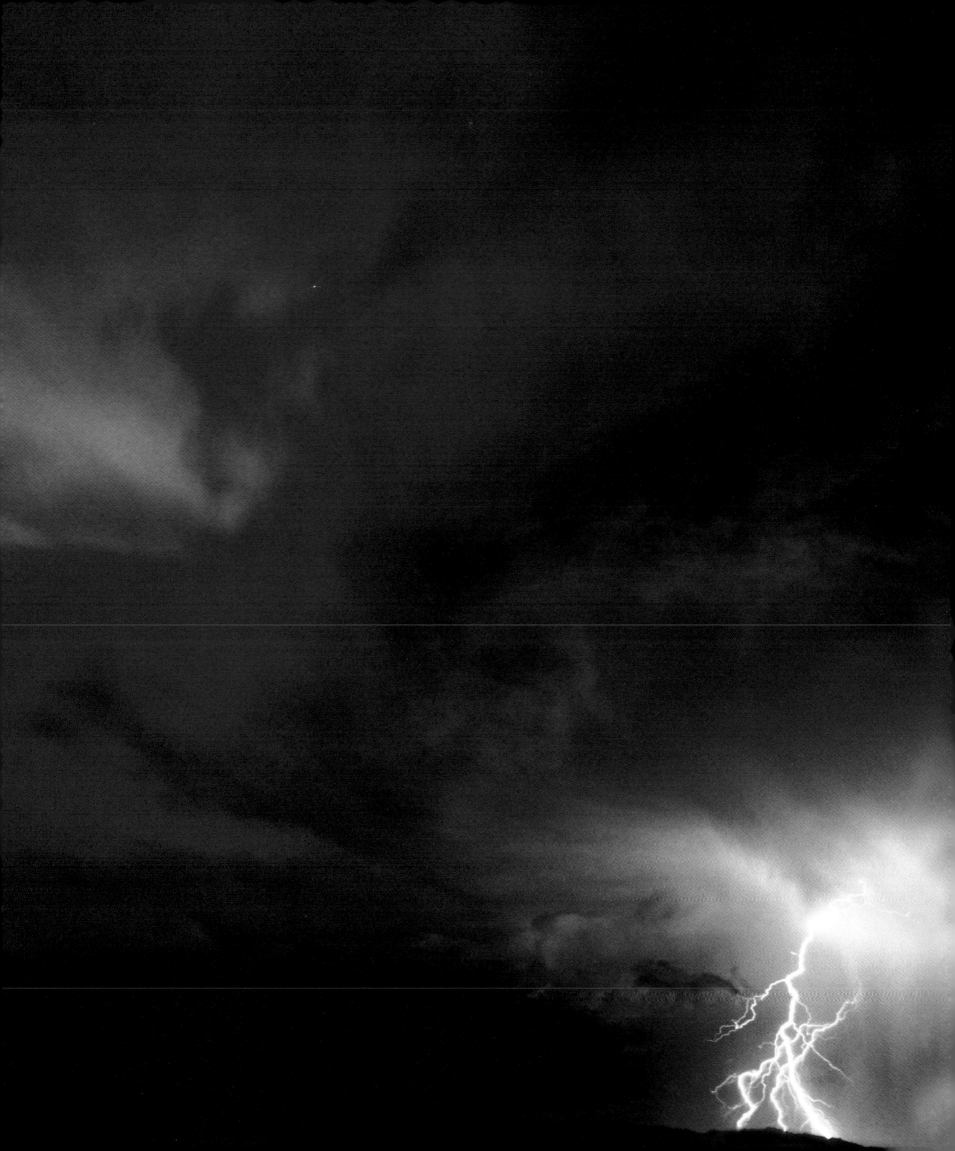

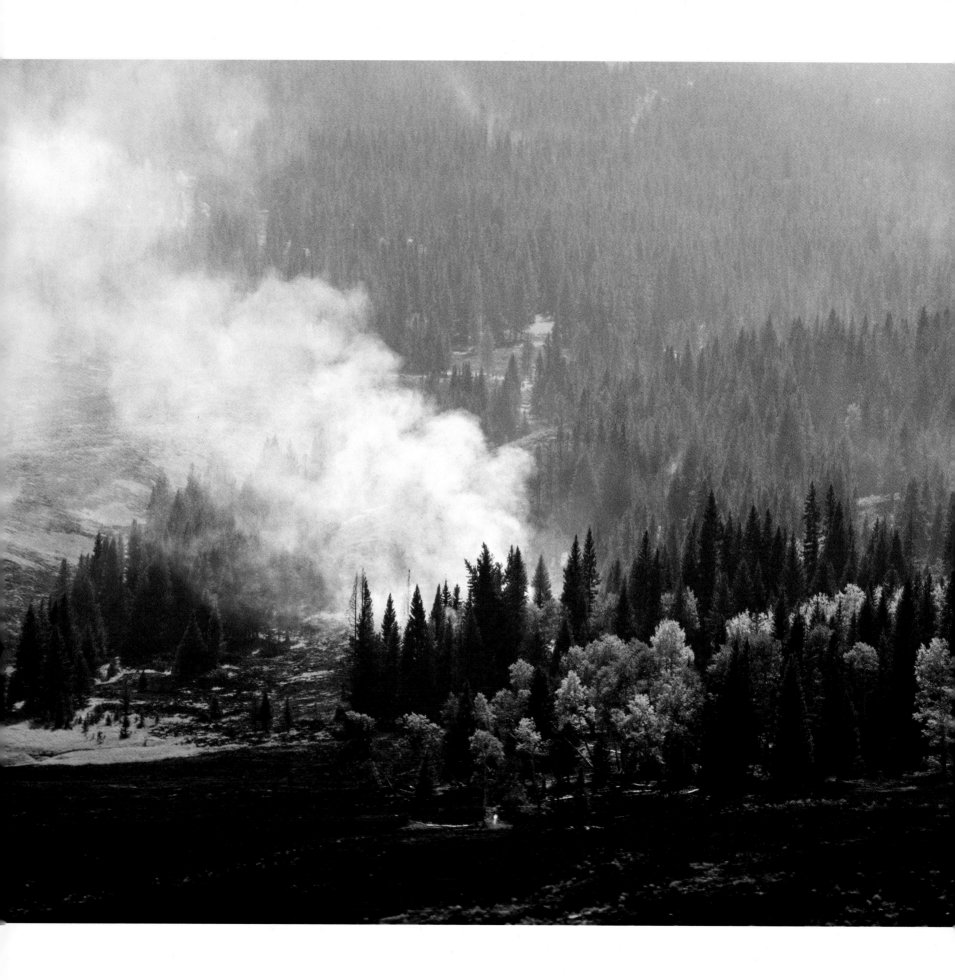

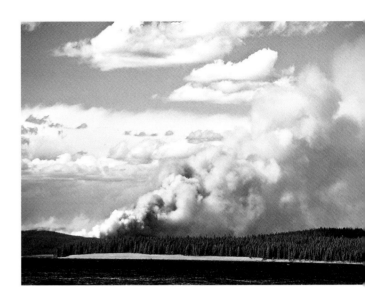

A natural, necessary and powerful process, wildland fire has shaped Yellowstone's ecosystem for thousands of years.

Reinvigoration of vegetation communities, wildlife densities, soil formation, insect and disease control, changes in stream channels plus other consequences of fires will continue to help make Yellowstone a wild, healthy, and vibrant place.

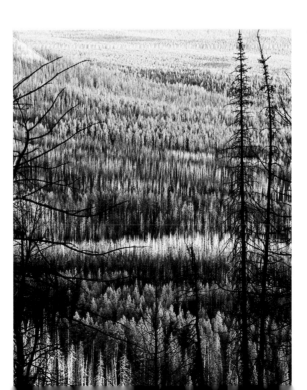

(pages 94-95)

Lightning flashes are startling, loud, and only last about one-quarter of a second. At temperatures up to 50,000 degrees F, which is five times hotter than the surface of the sun, the three or four discharges in each flash travel up and down an ionized path at speeds going down to the ground at 500 miles per hour and return along the same path to the cloud at ten times that speed. The super-heated air along the ionized path of the strike expands and contracts drastically producing a shock wave of thunder.

Over a hundred naturally occurring forest fires a year may start in Yellowstone; yet rarely does a fire burn more than a fraction of an acre.

These lightning-caused fires usually burn only the one tree where the fire started. It takes a combination of low relative humidity and hot, dry wind to carry a fire beyond its origin. This is a night photograph of a small backcountry fire in the Thorofare region which burned a few hundred acres during the summer of 2002. During the day there was a bank of smoke in the Yellowstone Valley, but at night individual trees became visible when they exploded briefly and burned brightly and spots of coals from large fallen trees cast a red glow into the midnight smoke.

The early sun shone under a heavy finger of fog above the Yellowstone River.

Thin wisps of water vapor rose off the water and re-condensed into the fog above. The light of the sunrise glowed in the thin fog and on the surface of the water, making it look like the river was on fire behind the sage and trees.

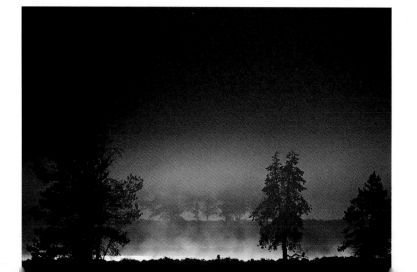

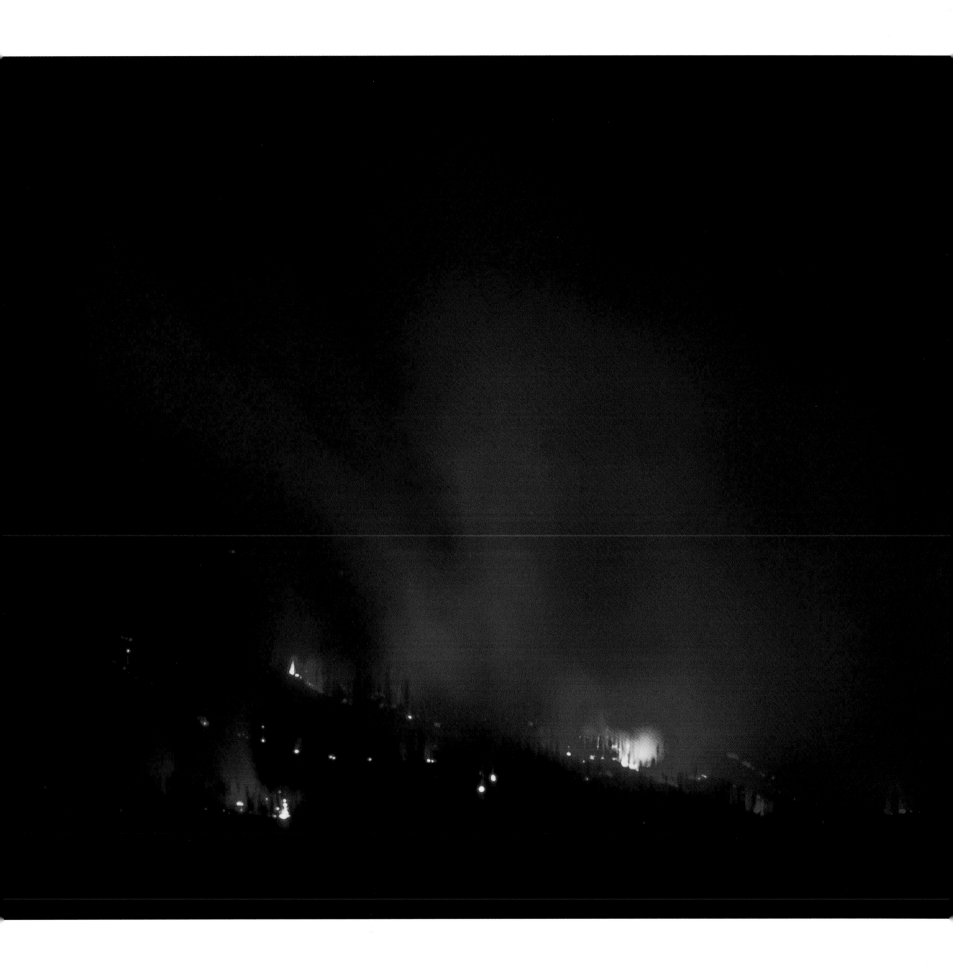

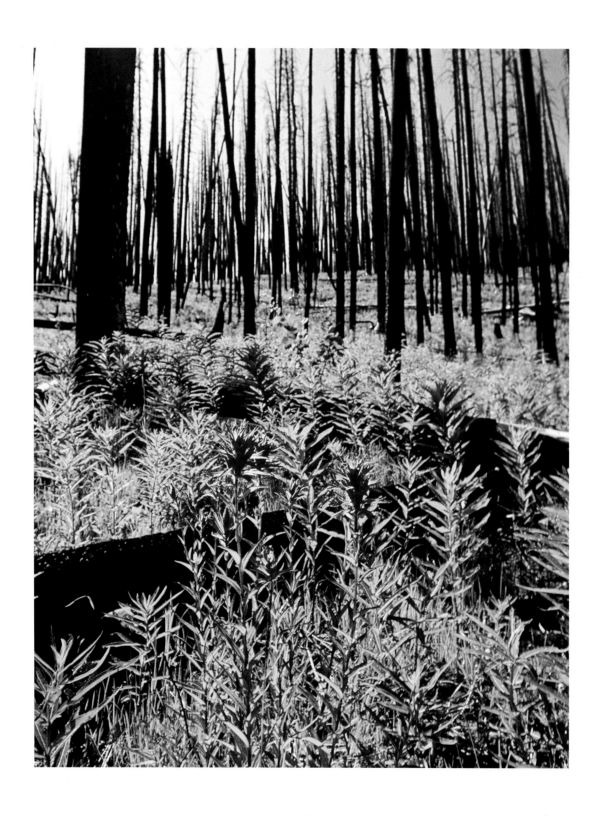

Five years after the 1988 fires, the burned lodgepole pine trunks were still black and mostly standing.

Grasses and forbs had grown densely among the downed logs along with billions of lodgepole seedlings. Indian paintbrush is a perennial semi-parasitic plant that steals nutrients from the roots of other plants.

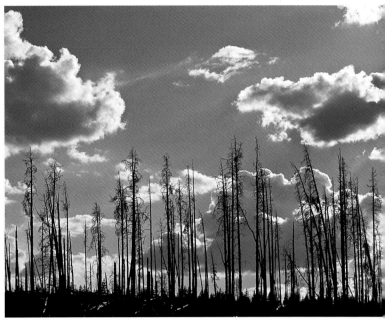
Standing burned lodgepole pine.

Fireweed is a member of the evening primrose family.

Its unattractive name comes from its behavior as a pioneer species in recently burned forest areas, where it has early access to newly released nutrients and can grow up to seven feet tall. Young leaves and flowers are edible, and browsers and grizzly bears like them.

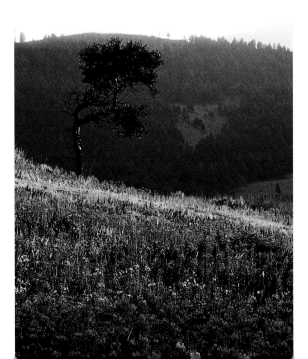

Hunting for rodents in the late afternoon this great gray owl floated silently off a nearby low branch and smacked into the deep grass.

It disappeared for several seconds behind a log, then peeked over it while steadily holding its position, checking to see if anyone else might want its meal. It had a rodent in its feet and was squeezing the life out of it. Then it bent down and untangled the now dead mouse from the grass and its toes, and swallowed it quickly with its beak pointed in the air.

The Lepidoptera order of insects includes moths and butterflies which metamorphose from larval worms to four-winged creatures as colorful as flowers.

This Rocky Mountain Parnassius butterfly rested near Atlantic Creek in the Thorofare.

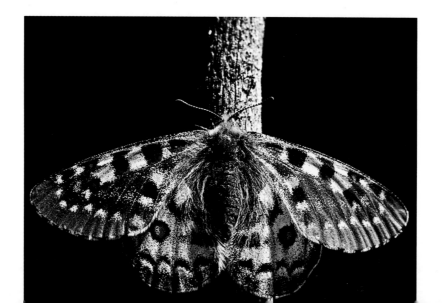

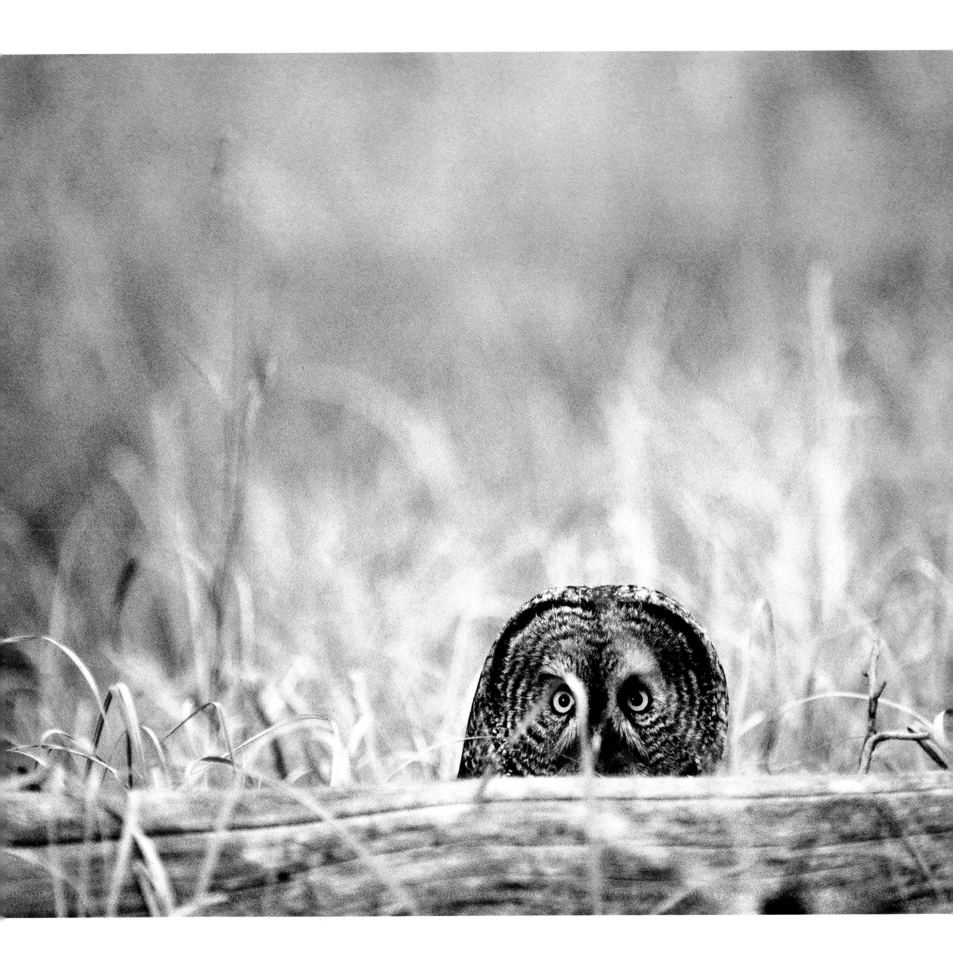

Perched on a low branch in a spruce tree, this song sparrow faced a small pond and sang for a few minutes.

Most bird songs are related to territorial claims; so its grass cup nest was probably nearby on the ground or low in a bush. Song sparrows can be found year-round in the Yellowstone ecosystem.

Soda Butte Creek runs southwesterly through dry sagebrush and grassland on its way to the Lamar River. Scattered mature cottonwoods grow along old flood plains after they sprouted in the new, rich mud banks deposited during spring floods. Trees and grasses absorb moisture from the morning fog through their leaves, which refreshes them without rain.

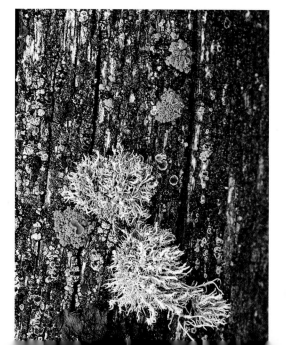

Lichen on wood.

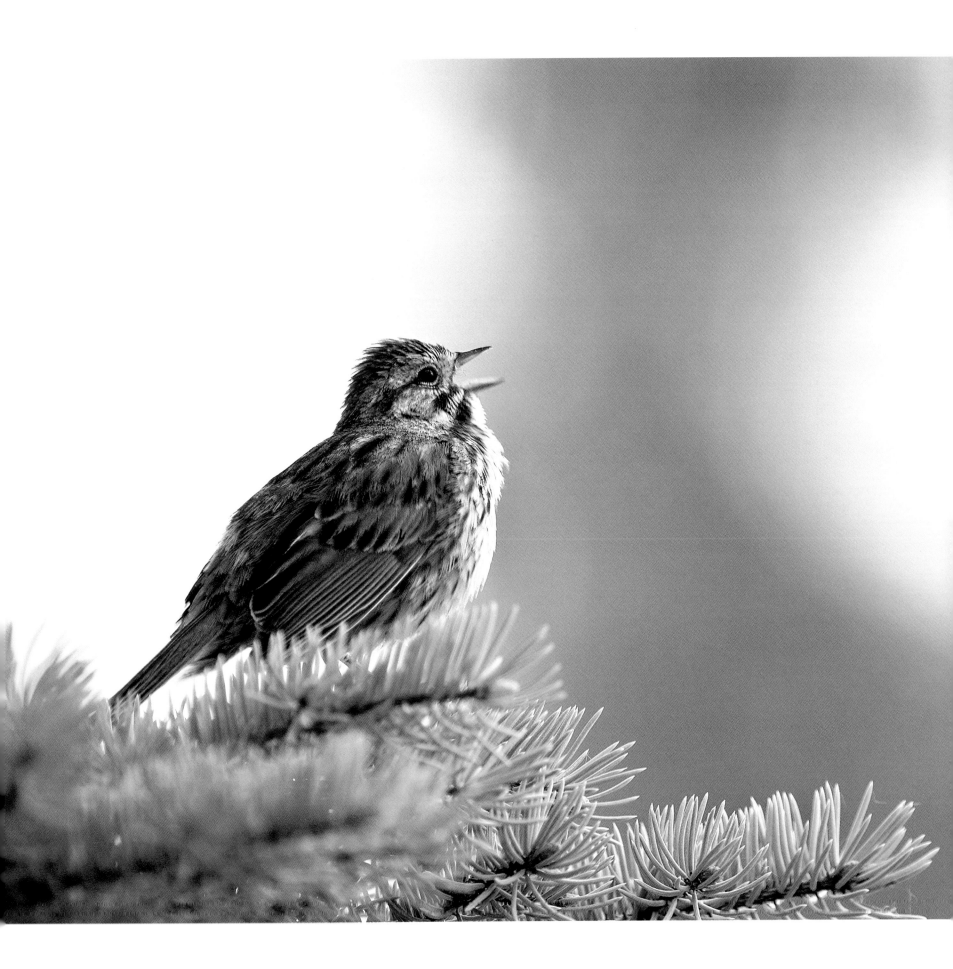

Passerines are perching birds with four toes, one of which always

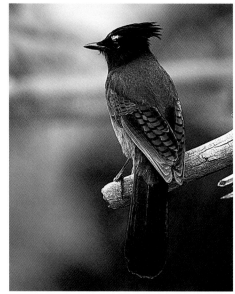

Stellar's jay

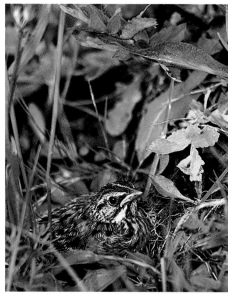

Savannah sparrow

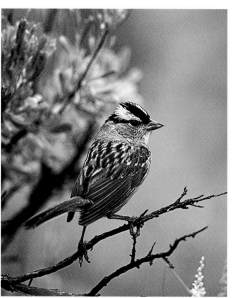

White-crowned sparrow

More than half of all the birds in the world are passerines; there are nearly six thousand species worldwide, almost 400 in North America. Most families of passerines are represented in Yellowstone and include species of flycatchers, ravens and jays, swallows, nuthatches, wrens, warblers, thrushes, waxwings, tanagers, finches,

points backwards and allows individuals to firmly grasp slender perches.

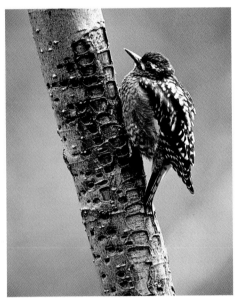
Yellow-bellied sapsucker

Green-tailed towhee

Magpie

blackbirds and sparrows. They can be insectivores, fruit eaters, or scavengers. Plumage ranges from bright multi-colored individuals like warblers and tanagers to solid black like the raven. They will nest on the ground like the vesper sparrow, and in trees and bushes at various heights (the most common nesting choice of most passerines), in the spray at the bases of waterfalls like the dipper, and in globu-lar structures made from pellets of mud plastered to cliffs like the swallow.

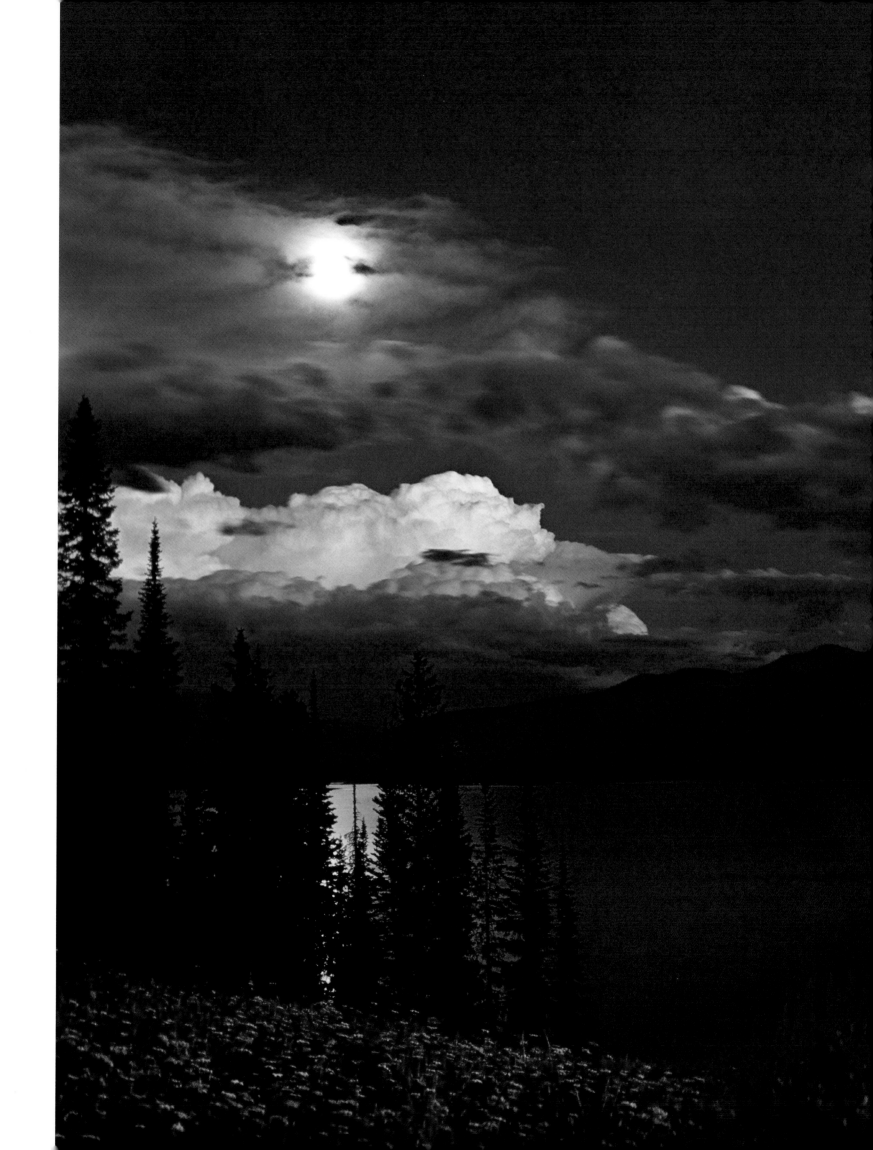

Out of the order of mammals called Chiroptera, which contains over 800 species world wide, there are at least eight species of bats living in Yellowstone.

This little brown bat is common in Yellowstone. All Yellowstone bats are insectivores, and most of their prey is caught in flight using echolocation. Echolocation allows the bat to avoid obstacles and to find flying insects. A little brown bat catches insects in its interfemoral or tail membrane or in its mouth. It will often grab the insect in its mouth and simultaneously bring its tail membrane forward to hold the insect for a moment to get a better grip, swallow the insect, then fly on, all within one wing cycle. This maneuver makes it almost turn a backward somersault. Bats leave their roosts in buildings, caves, or trees at dusk to forage for several hours traveling over water, along the edges of wooded areas, and over open grasslands, eating an average of nearly 500 insects per hour. Bats do not migrate but hibernate from late September or early October until April or May.

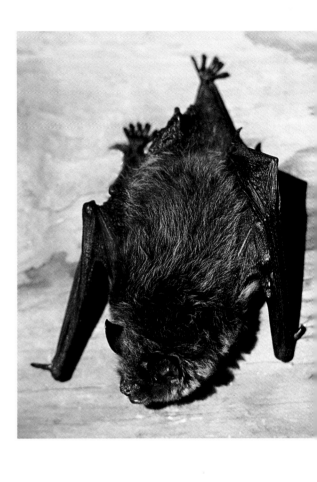

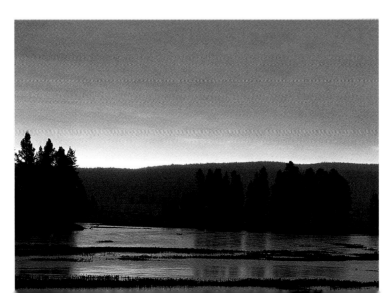

Before sunrise,
Yellowstone River.

The warmest light of the day will be at sunrise or sunset.

Puffs of steam from the Old Faithful geyser cone moved up and covered the early gold sun rising above the distant ridge. The geyser had erupted a few minutes earlier and the runoff channels were still steaming too.

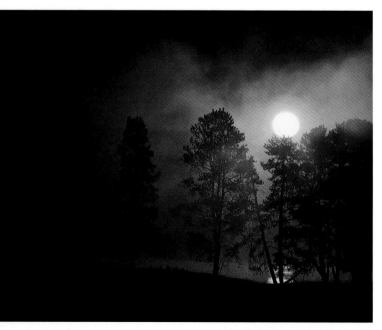

Sunrise, fog, Hayden Valley.

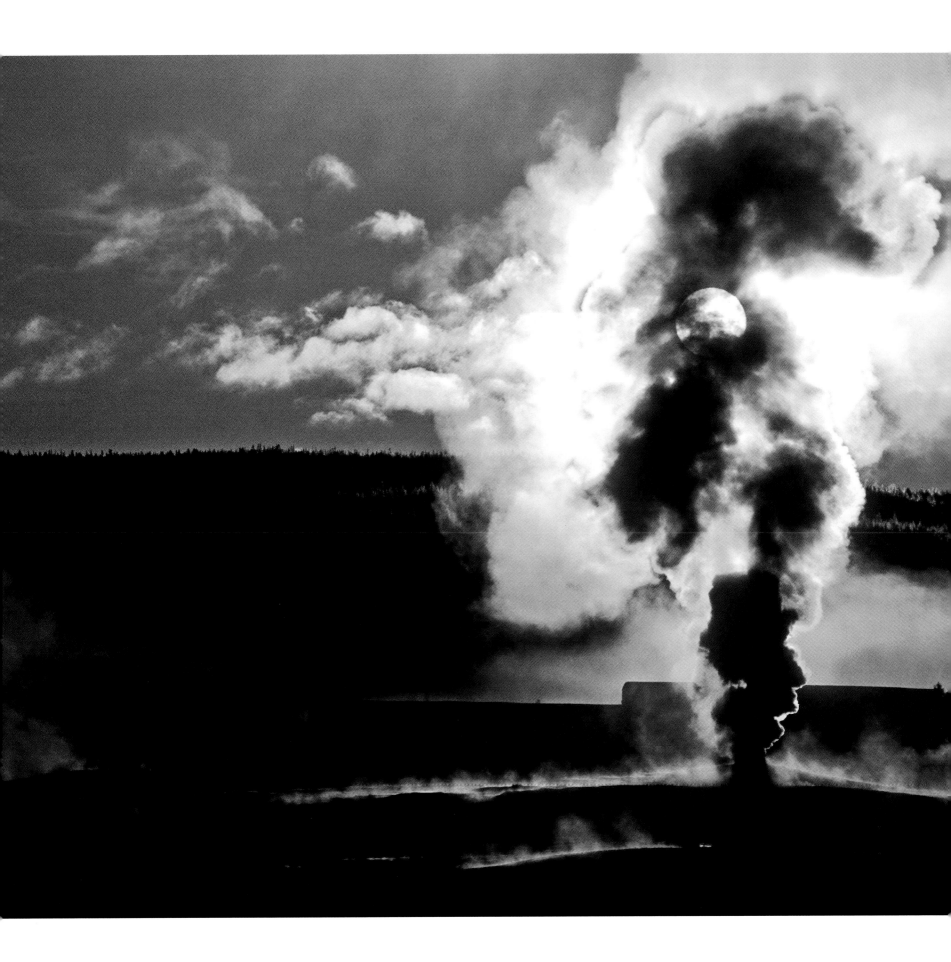

Abstracts.

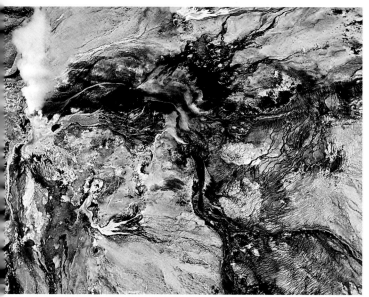

Aerial Clepsydra Geyser

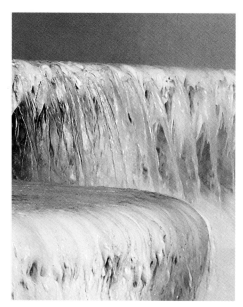

Canary Spring

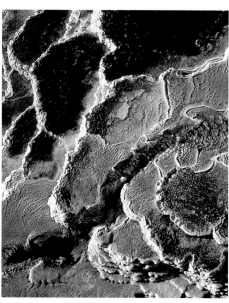

Travertine

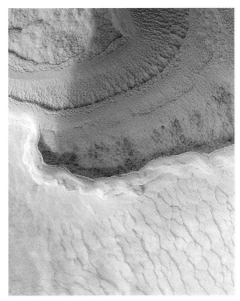

White travertine loops

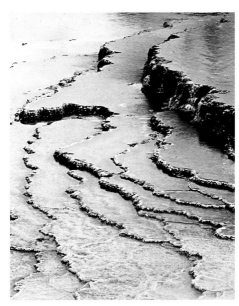

Travertine

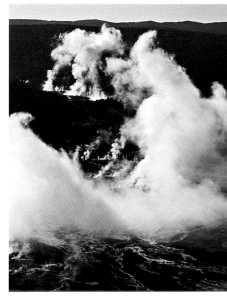

Lower Geyser Basin steam columns

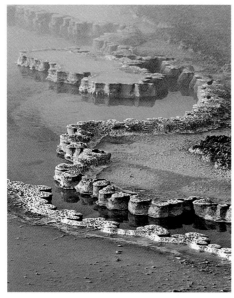

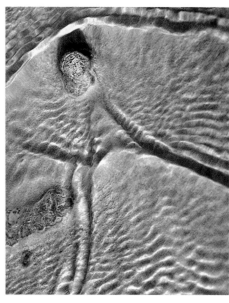

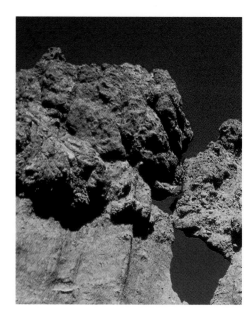

Doublet Pool Sinter Hoodoos

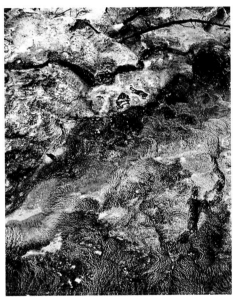

Algae and bacteria

Red bacteria filaments

Fountain Paint Pots

Salsify detail.

Skunk cabbage
has a thick
conspicuous stalk
bearing hundreds
of minute flowers.

The bright yellow concave bract, called

a spathe, wraps around the blossoms.

Bears eat the entire plant. If we cook it,

we can eat it, too.

Elk Thistle is a common
plant in open meadows.

In 1870 Truman Everts, separated and

lost from the Langford-Washburn

exploratory party, mostly subsisted on

this plant. The roots and fleshy stems

have a delicate taste, sort of like celery.

Some Flowers of Yellowstone summer.

Spotted coralroot

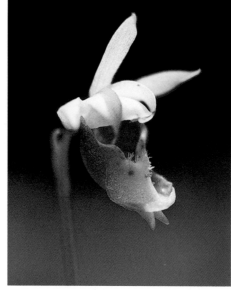

Fairyslipper

Pasqueflower

Blue flax

Bitterroot

Prickley pear

Wildflowers present every color, hue, and tint to the sun. In tiny specks or expansive meadows, these colors shift and change every day. Their shapes mimic other creatures or they entice insects and browsers with the sweet taste of nectar providing an extravagant dining table of irresistible food. A single blossom's life is short, usually less than a few days, but the cumulative array of color, texture, shape, and their delicate fluttering motion is one of the most memorable features of summer. Flowers are a driving force

Globeflower

Indian paintbrush

Forget-me-nots

Prairie smoke

Purple asters

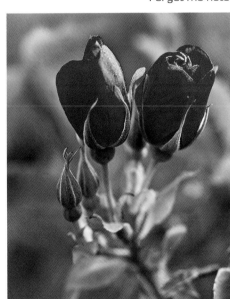

Rose buds

of evolution. Plants use insects and almost every other form of flying and terrestrial animal to help in their own reproduction. By providing food, shelter, or camouflage as a "trade," a flower uses visitors to help produce seeds. In this symbiotic relationship, most root-bound, stationary plants also get their fruit and seeds dispersed. Wind and rain are also exploited by these clever plants to scatter and move their seeds. Flowers probably created things like honey bees and hummingbirds.

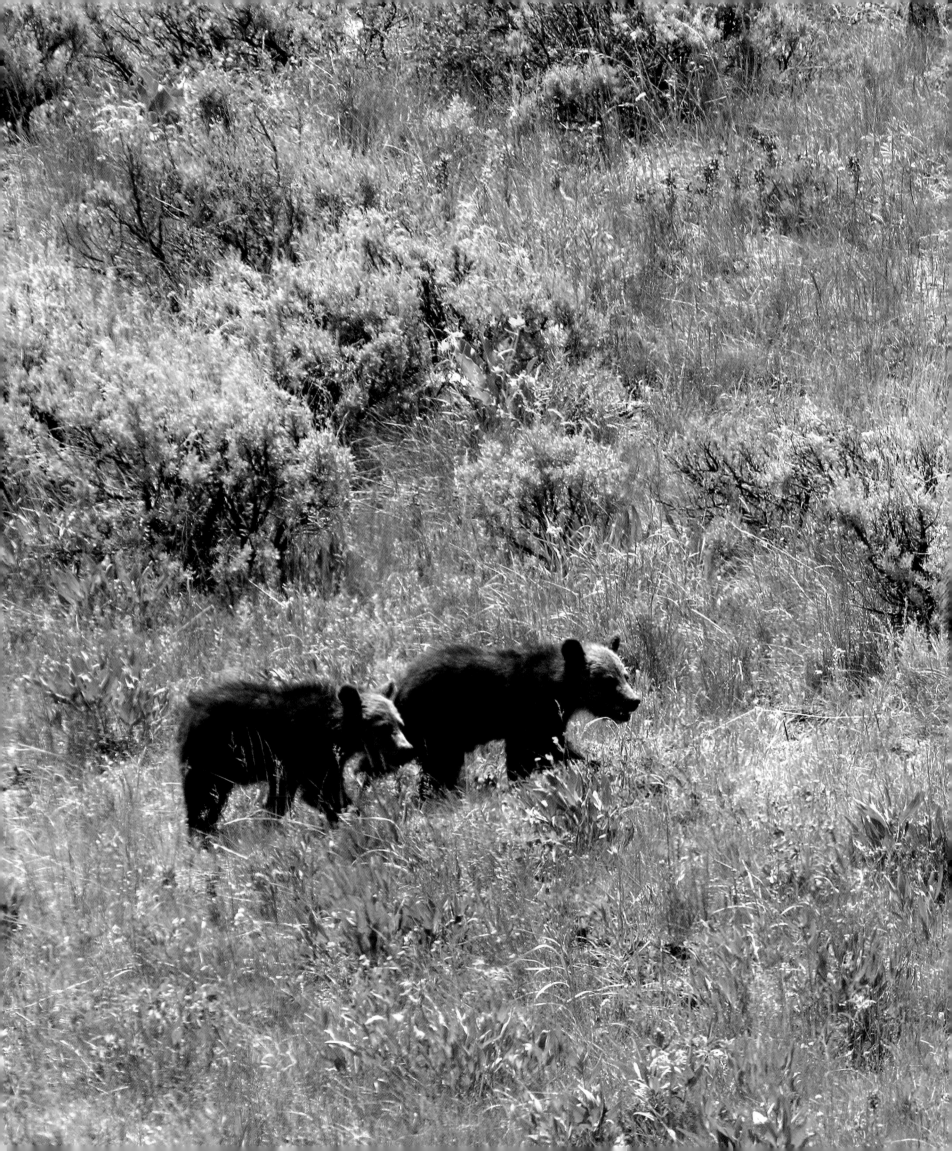

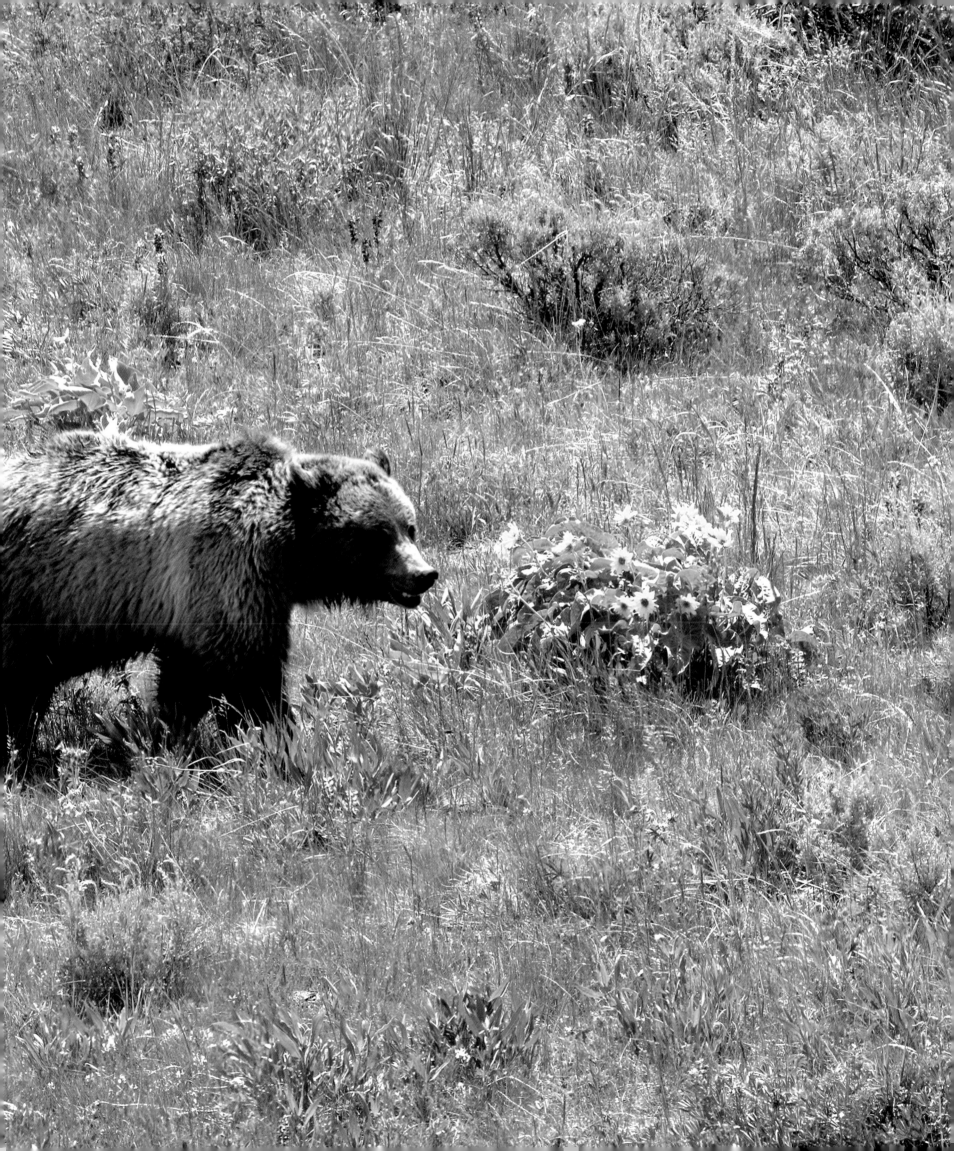

Summer grasses and wildflowers.

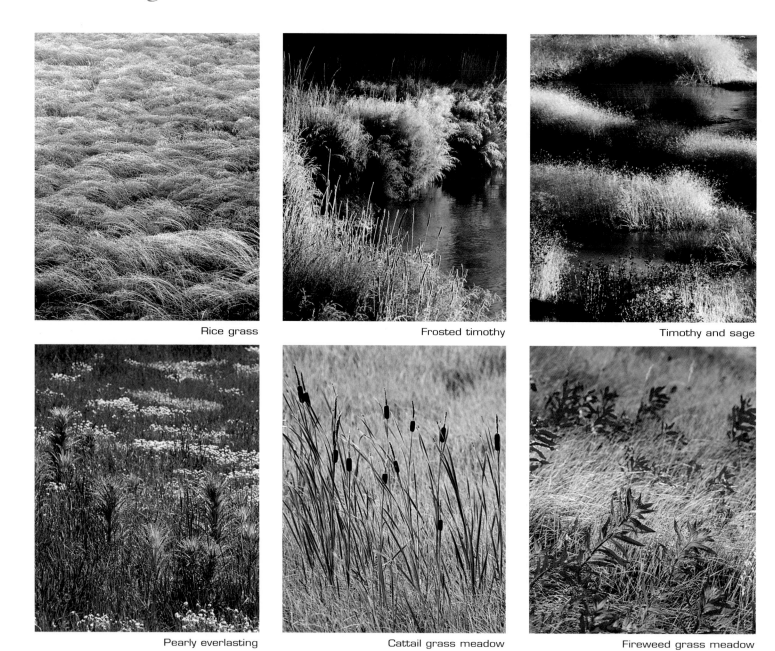

Rice grass

Frosted timothy

Timothy and sage

Pearly everlasting

Cattail grass meadow

Fireweed grass meadow

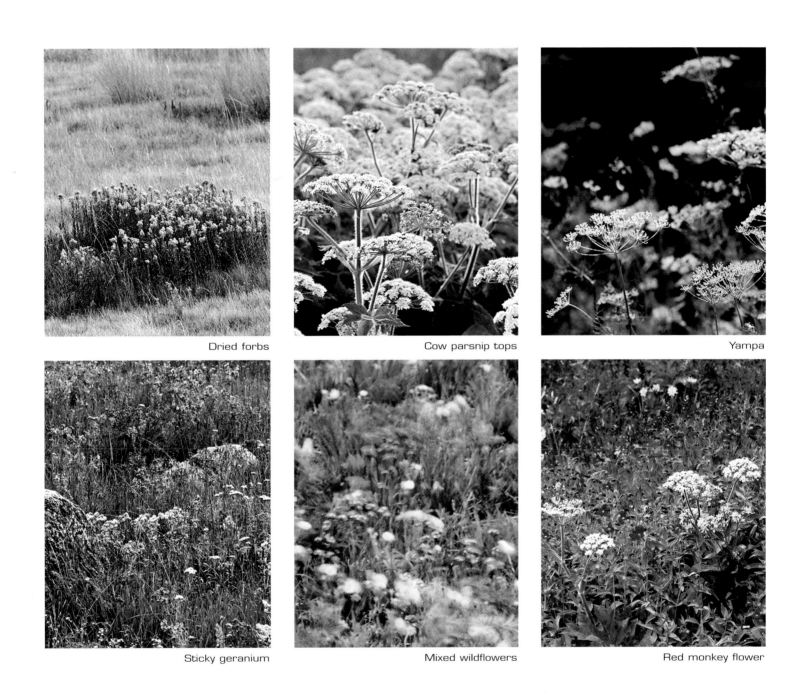

Dried forbs

Cow parsnip tops

Yampa

Sticky geranium

Mixed wildflowers

Red monkey flower

(pages 120-121)

A grizzly bear mother is very attentive to her cubs. She has cubs about every three years and usually just one or two at a time. During her lifetime she will probably have no more than five litters of cubs.

Feeding.

In August and September of 1988 there were thousands of acres of recently burned grassland in Yellowstone. The grass fires apparently did not kill many of the rodents occupying this ecosystem, but after the fires died out, the rodents suffered from a loss of cover. Moving along in their pathways between their burrows and feeding areas, they found that their protective jumble of grass was gone, and they had become much easier prey for hawks, owls, foxes, and coyotes. Watching this coyote for several hours, I saw a much higher capture rate of voles and mice than I had ever seen before

or since. The coyote seemed to hunt by sight and ran here and there collecting rodents, unlike the usual listen and pounce method he used in tall grass.

<p style="text-align:center">★ ★ ★</p>

Typical habitat for a harem of yellow-bellied marmots is a rocky outcropping or talus slope in a meadow. They burrow up to 15 feet horizontally into a hillside to make their nest chamber under a large rock. They hibernate for about eight months a year. This adult made a couple of trips into its burrow with large mouthfuls of grass. Since they do not store food, the

grass was probably used as nesting material. Marmots lose about 50% of their body weight during the winter, so they must accumulate sufficient fat reserves before going into hibernation in early September.

<p style="text-align:center">★ ★ ★</p>

This cow elk near Roaring Mountain must have had a mineral deficiency. She licked the white coloration at the base of the dead trees, which had been killed by overflow from the nearby hot springs. Through capillary action, minerals had been pulled up into the wood at the base of the tree. It tasted like baking soda to me.

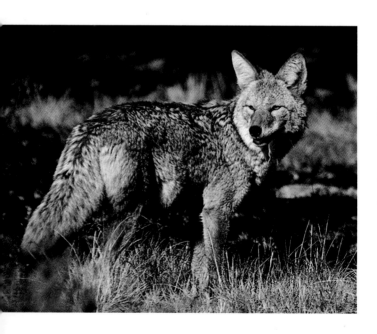
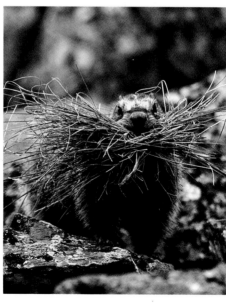
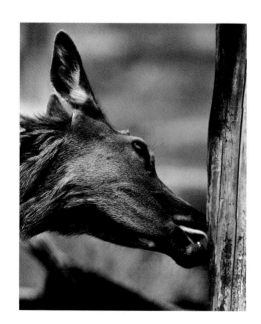

Long-tailed weasels are brown and tan in the summer and white in the winter.

They are aggressive and quick carnivores with long bodies and short legs. This individual, probably a female with young, was catching rodents and taking them to a den about 50 yards away. She was hunting, bounding along through and over the grass in flexible, spring-like movements. Several times she disappeared into the ground near a vole's dirt mound probably going down the burrow to the vole's nest. Reappearing after five minutes or so, she carried a large, dead rodent in her mouth. Raising her head high to avoid stepping on her prey, she ran along, stopping every 15 feet or so to look around. When she became concerned about some movement, she dropped the rodent and hid in the grass. After she felt safe, she retrieved the meal and proceeded toward her den which was on a steep slope with ground squirrel burrows all around. As she crossed the ground squirrels' territory, the adult squirrels chased her, chattering in alarm, and caused her to drop the rodent again and zig-zag to outrun the squirrels. After she ditched the squirrels, she went back, picked up the rodent for the last time, and dashed out of sight into her den.

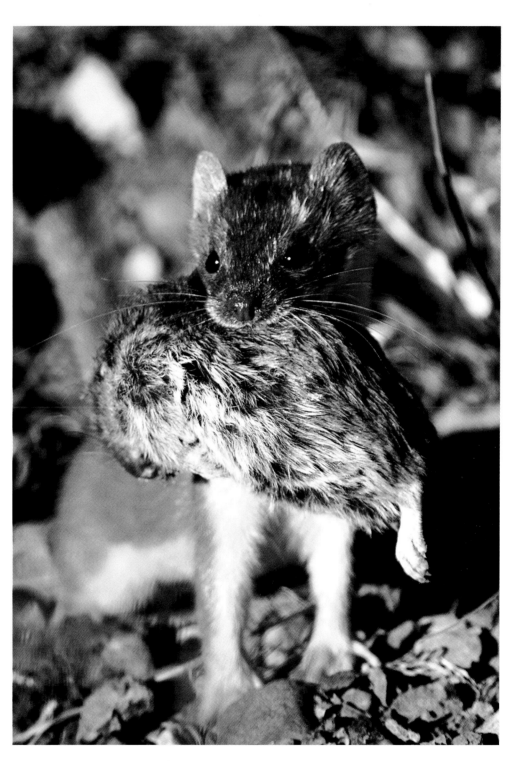

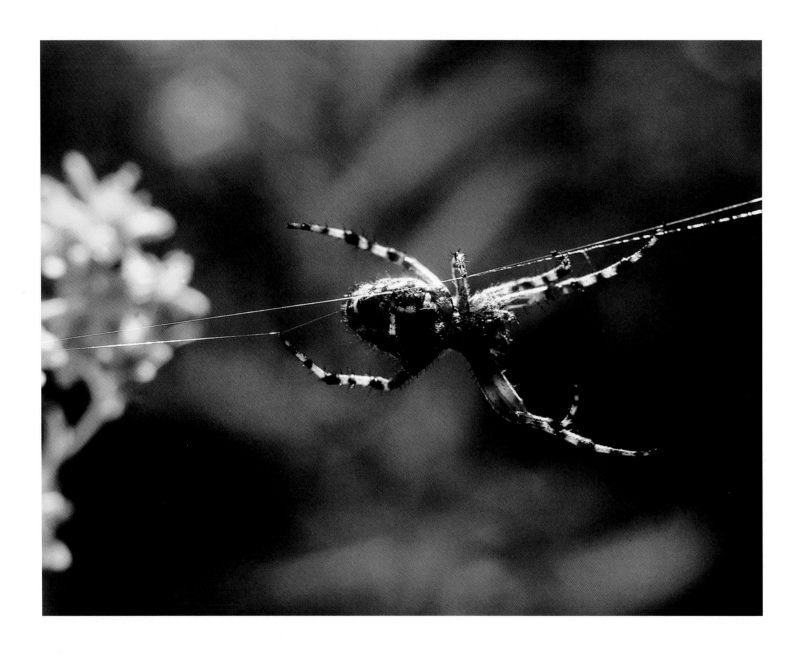

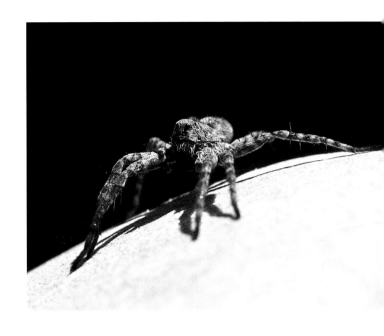

Spiders are arthropods with eight legs and un-segmented abdomens.

They build nets, webs, and/or egg sacs out of a strong fine thread called silk. Spiders have used their silk tools for millions of years to make a living as predators, eating mostly insects. Most are secretive and nocturnal to avoid their predators such as wasps and birds. The crab spider changes color to match a white or yellow flower and has pink or red spots. Crab spiders do not build a web; instead they hide in flowers and jump out and grab their prey of flies and mosquitoes, some of which may be bigger than they are.

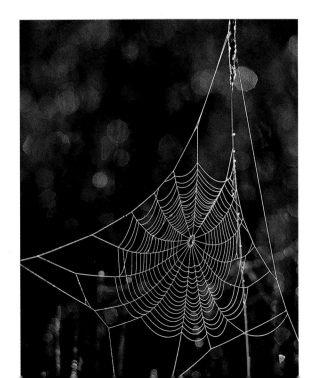

Spiders and insects in Yellowstone vegetation.

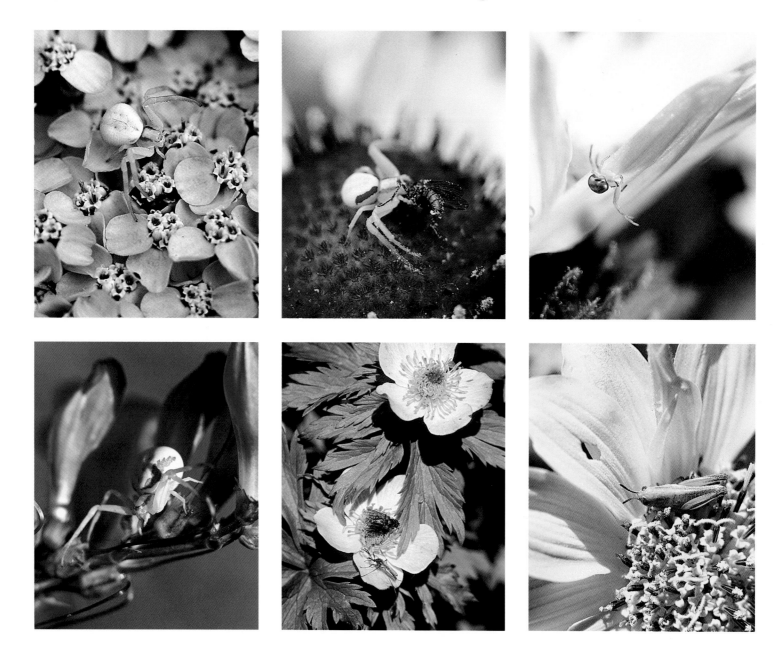

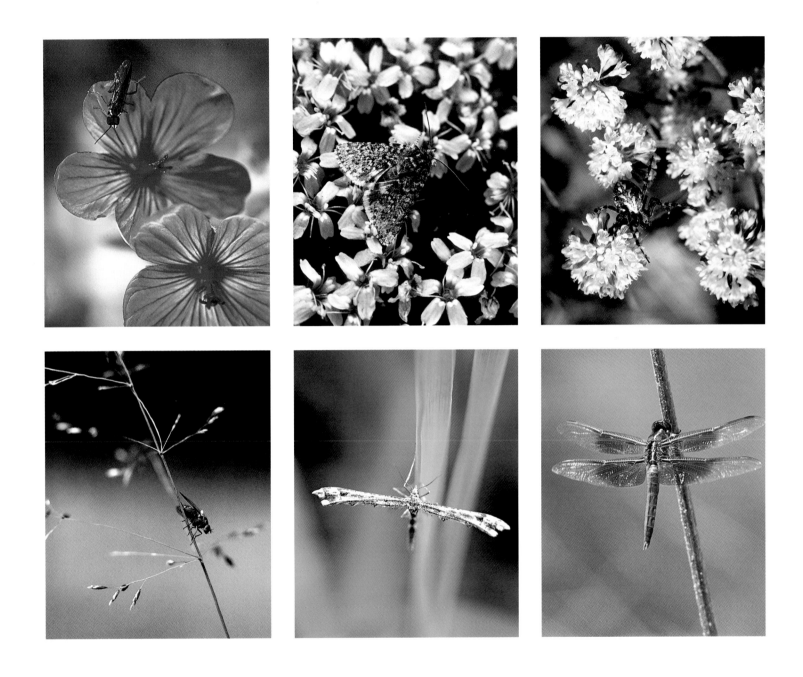

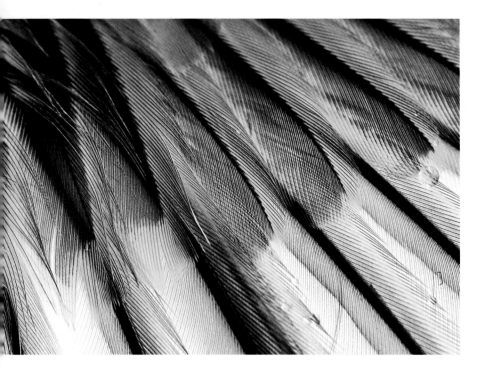

The primary wing feathers and coverts of this black-chinned sparrow have an unbelievable amount of fine detail, which is typical for all birds.

The main stem of each feather is called a rachis and tapers from the base out to the fine tip. Extending out from the rachis are two rows of hundreds of smaller stems, on the opposite sides of the main stem, called barbs. These barbs have tiny fibers called barbules that interlock with their neighbors and extend out at a shallow angle toward the end of the wing. This profoundly complex arrangement not only provides aerodynamic lift so the bird can fly thousands of miles, it also provides protection from sub-freezing temperatures, summer heat, and moisture. It carries the subtle and distinctive coloring patterns that help define the unique species and gender of the bird. The soft, faint pink on each barb lying against the overall blue-gray of each feather produces a warm cast on the wings and contrasts with the dominant blue-gray of its body. Even with this complex and elegant structure, the bird still ends up looking relatively plain.

There are twenty-eight species of gossamer-wing butterflies in Yellowstone, including 11 in the subfamily Polyommatinae called "blues."

Blues, scarcely an inch across, are butterflies that eat nectar, mud, and dung. Each species has different host plants such as sulfur buckwheat, wild rose, and lupine. This small group of blues perched on a water-saturated log next to a spring. They sipped mineral-rich water from the log in an idyllic, cool and shaded refuge.

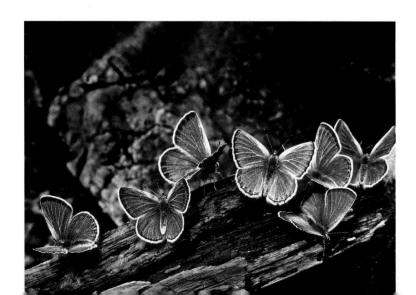

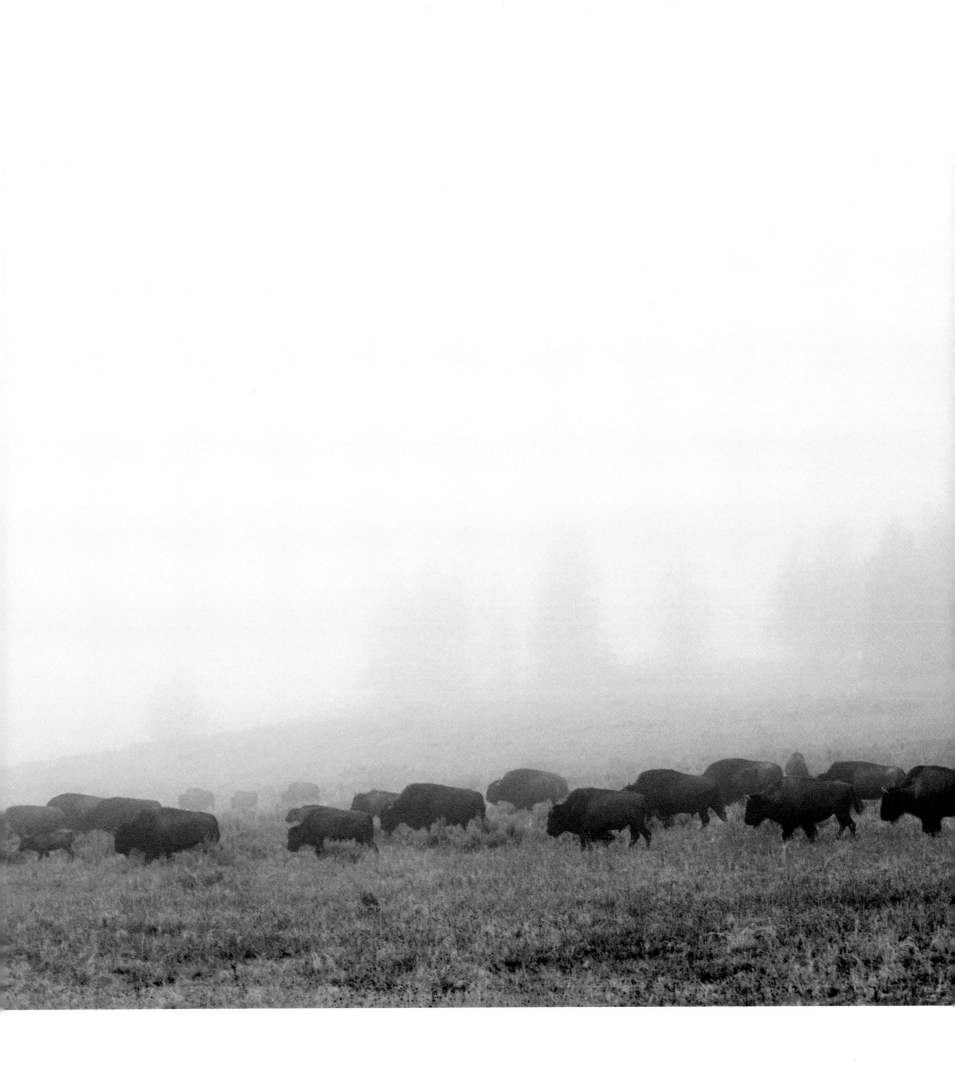

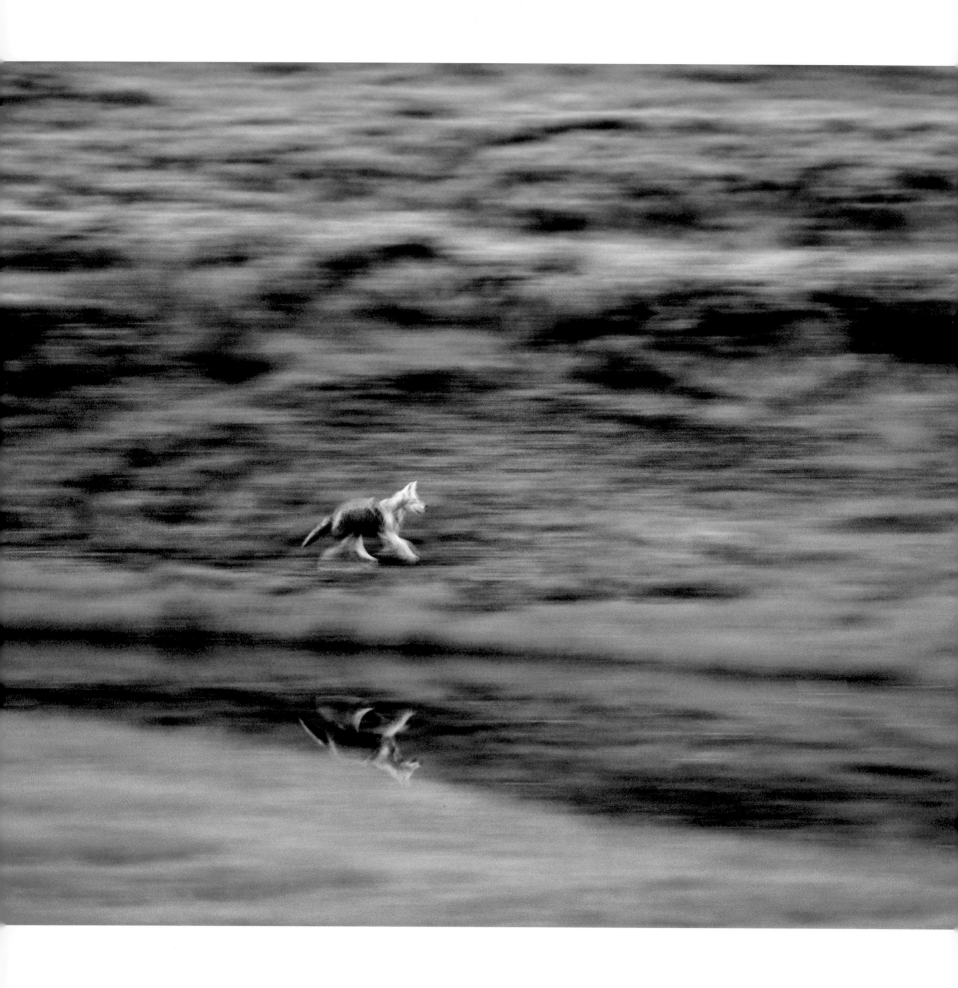

Blacktail Plateau storm.

Running along Trout Creek, this coyote was hurrying to see what another coyote was doing off to the east.

To create a sense of motion like this in a photograph, use a slow shutter speed and move the lens to match the speed of the animal while pushing the shutter button.

Ravens are possibly the smartest birds in Yellowstone Park.

There is extensive literature on the common raven, and all studies point to their strong social bonds, communication skills, memory, and sense of play. Their heavy beaks are used to adroitly manipulate objects and tear apart prey. Their grip is strong enough to hang by their beaks from perches.

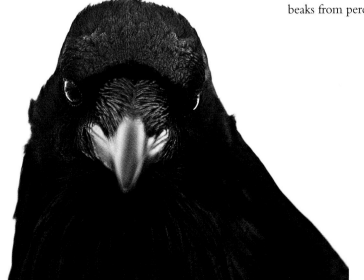

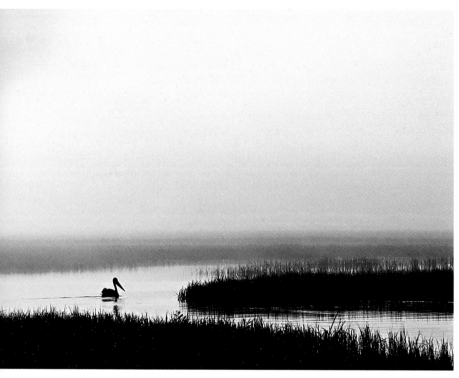

White pelican, morning fog.

Reservation Peak in the Absaroka Mountains stands just south of the East Entrance to the Park.

It rises high above the morning fog filling Middle Creek valley.

Colter Peak stands 10,683 feet high near the eastern boundary of Yellowstone.

It is one of hundreds of peaks in the Absaroka Range, which extends from Livingston Peak near Livingston, Montana, to Ramshorn Peak near Dubois, Wyoming, 150 miles to the south. The Absaroka Range was created primarily by volcanic activity during the Eocene epoch 30 to 60 million years ago. The most recent reshaping of the landscape occurred when the Pinedale glaciers covered virtually all of Yellowstone Park and extensive areas to the south and north, from Jackson, Wyoming to Livingston, Montana. The gentle early morning fog that drifted up from the Southeast Arm of Yellowstone Lake contrasts with the massive and powerful forces which pushed this peak up, then scraped, bulldozed, and ground gigantic blocks from it to the plains and rivers below.

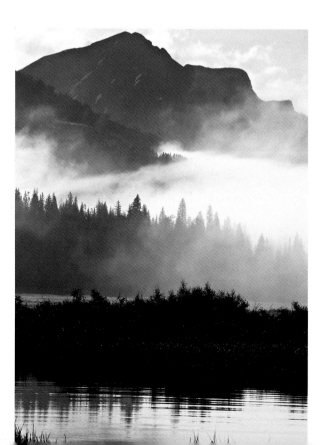

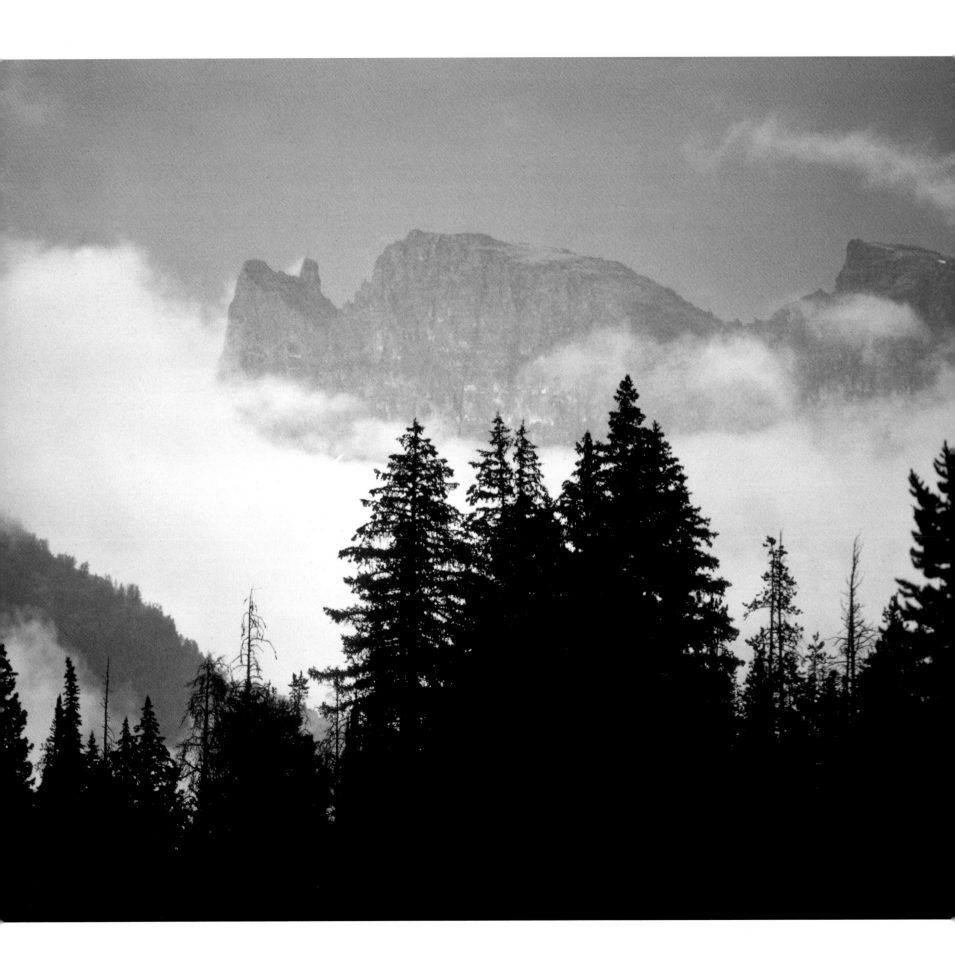

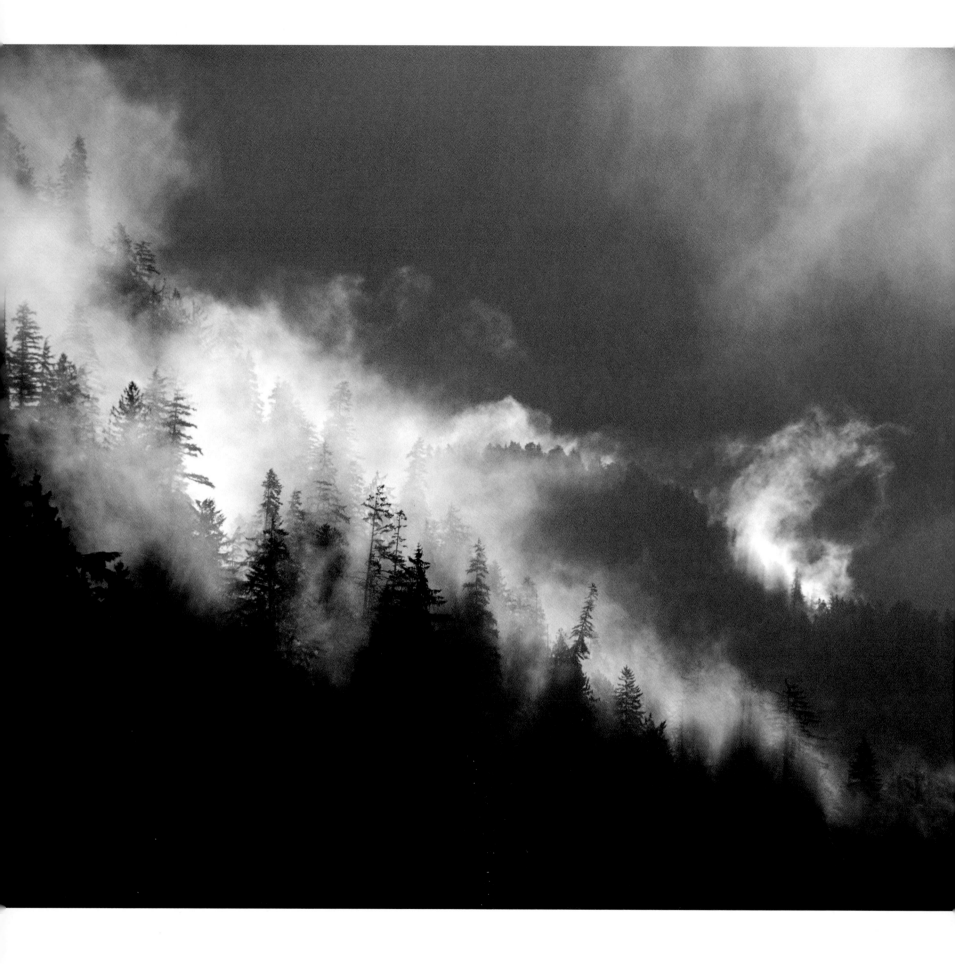

Moisture collects on vegetation in the cool dampness of nighttime.

When the morning sun begins to warm the land, the moisture climbs up out of its waiting spots and stretches, pulls and drifts into the awakening air, becoming briefly visible as fog at a delicate temperature between vapor and mist.

Great blue herons are summer residents, seasonally occupying most of North America below the limit of the taiga.

They feed on aquatic wildlife, including frogs, fish, and insects, and occasionally on mice and other small, terrestrial wildlife. This adult along Trout Creek stood motionless in the early morning fog waiting for small creatures to swim or hop within reach of its long neck and beak.

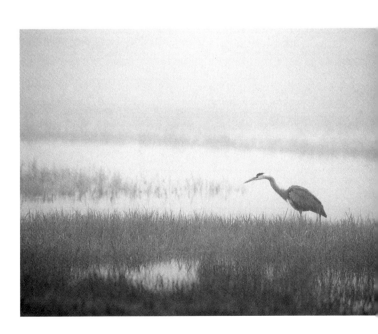

Clouds create constantly changing scenes in the sky.

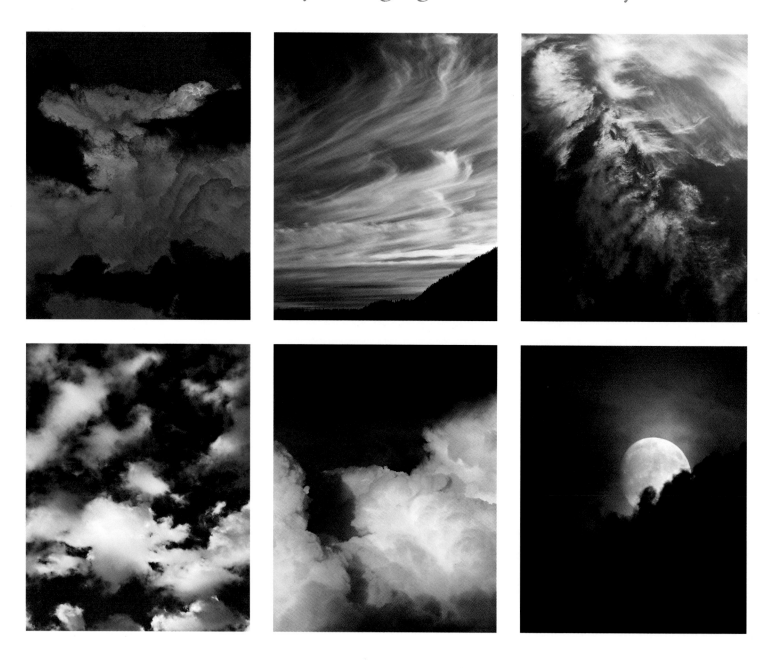

Light plays around and through clouds as they travel with the wind. Cirrus clouds are ice clouds occurring at altitudes ranging from 20,000 to 40,000 feet. Alto clouds range from 6,500 to 20,000 feet. Cumulus clouds are puffy heaps of water and ice, and stratus clouds appear as layers. Clouds are visible compositions of minute particles

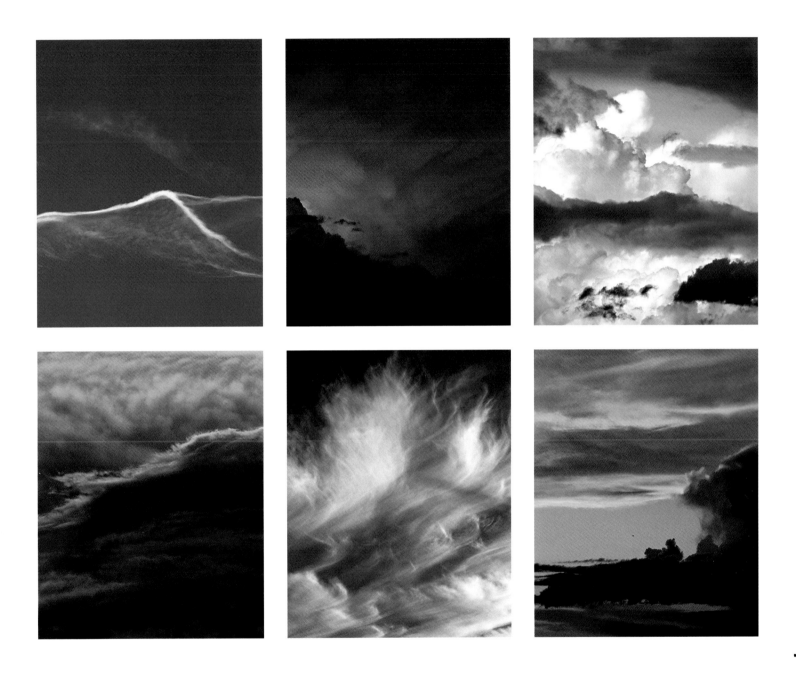

of dust, minerals, water, and ice. Warm air can carry more moisture than cold air, so when a warm air mass meets a cold air mass the cooling process can create some sort of precipitation. Winds move the air masses, so by noticing the wind's direction and intensity and observing the height, shape, and changes in clouds, we can anticipate weather changes. It is also just nice to see the colors and dynamics of the giant piles of moisture sailing back and forth above us in their infinite variety.

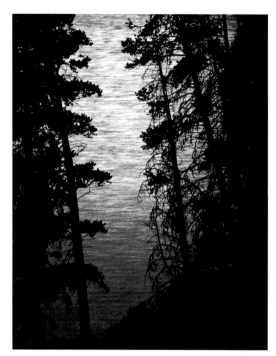
Moonlight on Yellowstone Lake.

Every twenty-
nine plus days
our moon moves
around us and
gets in a position
opposite the sun.

It is then called a full moon because we
can see the fully illuminated surface.
On clear nights, this rocky mirror casts
reflected sunlight down on our night
landscapes, creating bright shadows
and reflections like this across the still
surface of Yellowstone Lake.

Colter Peak,
rising full moon.

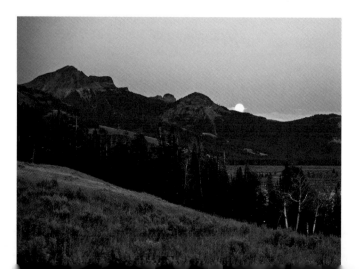

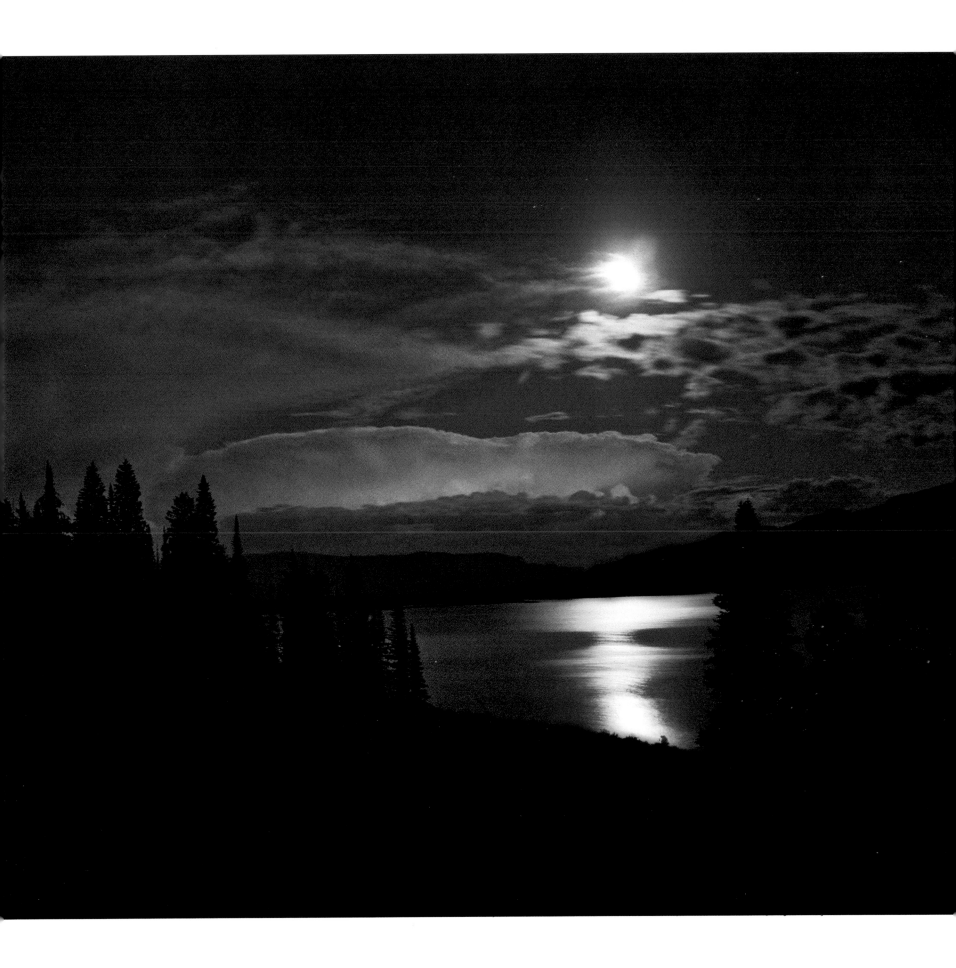

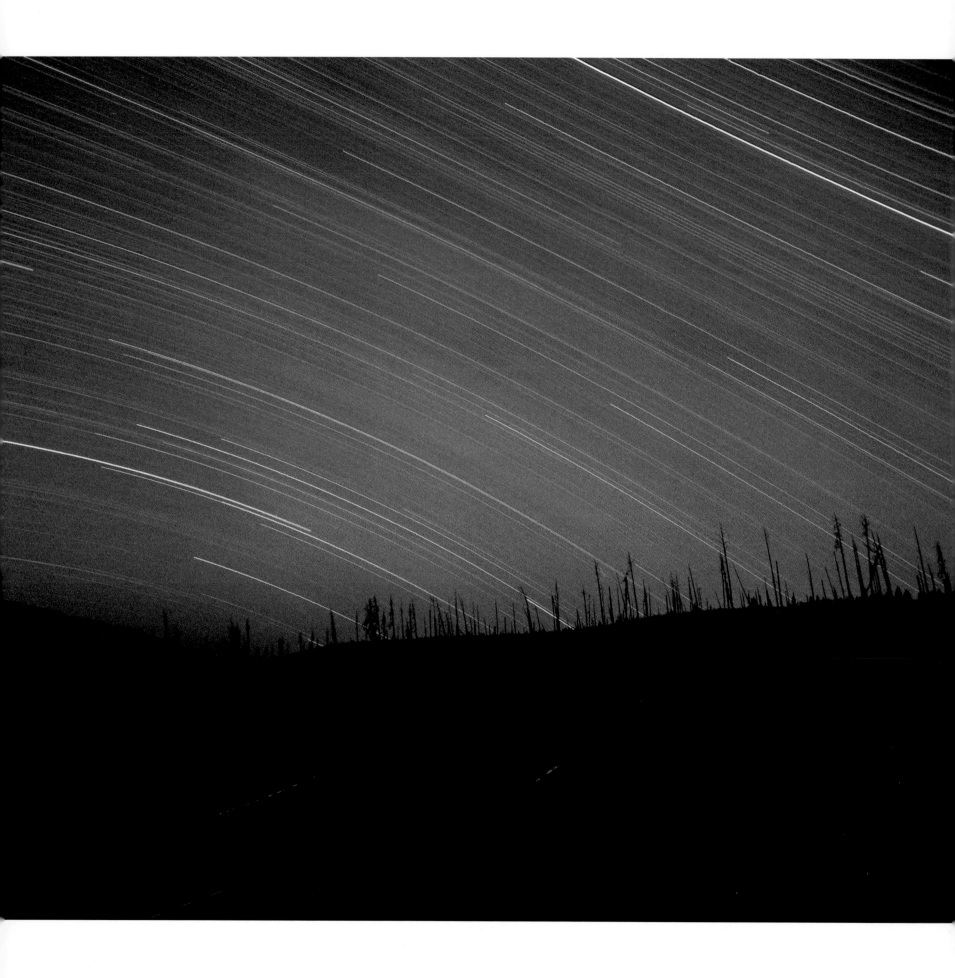

During this five hour exposure the stars appeared to move across the sky in arcs.

Stars are many different colors and rarely is a star track white. The star's color is created by its temperature, cooler ones are reddish and hotter ones are bluish. Some of the 2500 or so visible stars are actually galaxies each containing billions of stars. The only stars we can see with our naked eye are in our local galaxy, the Milky Way.

Large storms on the sun are sending gamma rays of energy which excite molecules in our atmosphere causing them to glow like a fluorescent light bulb.

As the sun's radiation skims past the earth in the stratosphere above us at night, we can sometimes see this spectacular phenomenon which is called aurora borealis in the Northern Hemisphere or "northern lights." The shimmering, sometimes very bright colored lights are one of the magical wonders of the night sky. When I was a small kid on my family's ranch in South Dakota, I saw them quite often, and my dad told me the shimmering shapes were the shadows of Eskimos walking on the ice at the North Pole.

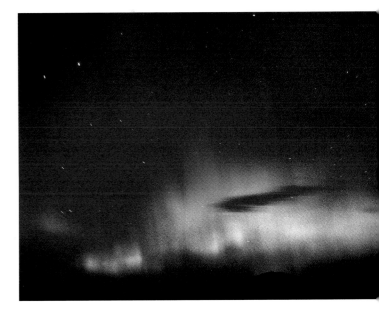

While on a fifty mile back-packing trip from Jackson Hole to Yellowstone Lake, we camped one night near the mouth of Trapper Creek.

In the dark I set up the camera on a tripod facing north to Colter Peak and Turret Peak. During the ten minute exposure, I walked in front of the camera going from one tent to the next and illuminated each with a small hand-held flash by firing the flash behind each tent toward the camera. The clouds blurred as they blew across the sky, the stars appeared to move, and the landscape was lit by a three-quarter waxing moon.

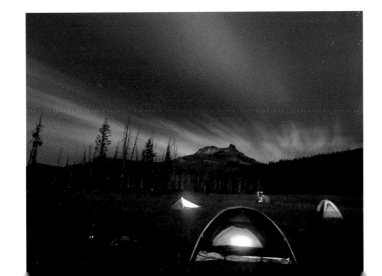

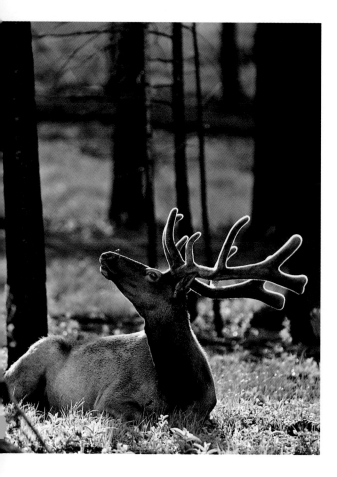

Bull elk lose their antlers
in April and immediately
start to grow them back.

By early summer their antlers are at
least half grown and still covered
with a short dense fuzz called velvet.
Above this resting bull, on the ridge
to the left, he watched another bull
elk walk and graze in the damp green
vegetation resulting from the open,
wetter ground after the fires of 1988.

Lamar Valley on a sum-
mer evening presents
the best of Yellowstone.

It is home to nearly all of the creatures of
the Park. It contains a wild free flowing
river, uncounted springs, ponds, and small
streams, a major feature of the central
Rocky Mountain chain (the Absaroka
Mountains), and rich stands of grasses,
forbs, shrubs and trees. The comfortable
temperature and still air at evening make it
a perfect place to relax and enjoy the Park.

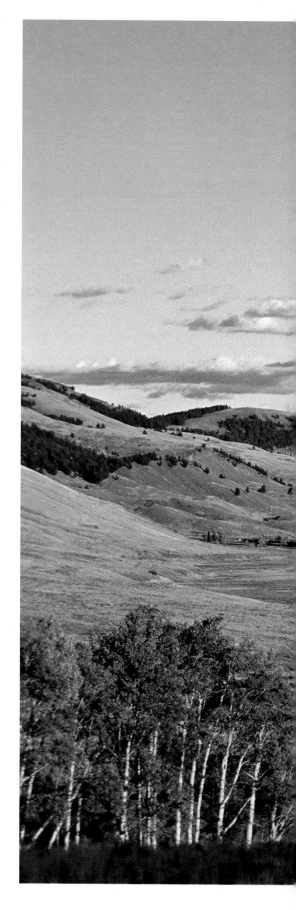

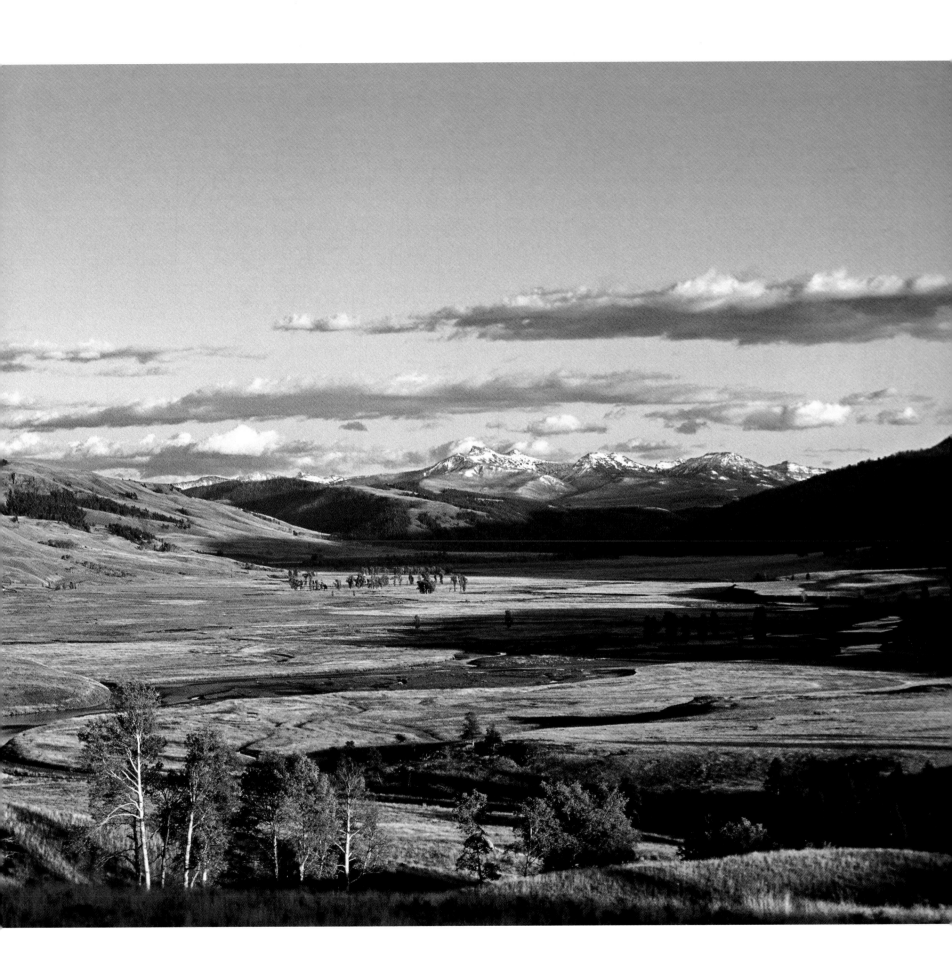

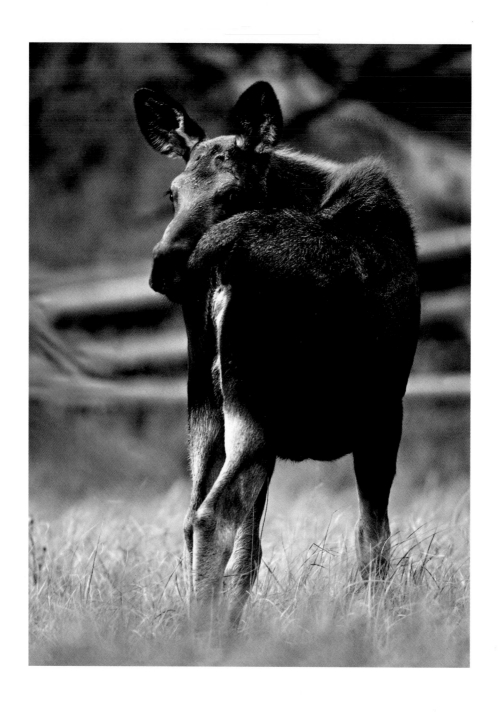

Near the end of its first
summer this moose calf
was fat and healthy.
Comfortable in a meadow near the
Northeast Entrance she approached
her first winter well prepared to
survive, even though she had no
idea yet what winter was.

TOM MURPHY

Tom Murphy's photographic passion and specialty is Yellowstone Park. Since 1975 he has traveled extensively within its 3400 square miles, hiking thousands of miles and skiing on dozens of extended overnight trips in the backcountry. He has skied across the park twice, once on a 14-day solo trip. Two things motivate him to travel carrying a heavy backpack: a desire to see Yellowstone's wilderness backcountry and to photograph the behaviors of free-roaming wildlife and the colors, shapes, and textures of the land.

His photographs have been used, both editorially and commercially, in numerous regional, national, and international publications. Clients include: *Life, Architectural Digest, National Geographic, Audubon* and *Time. Newsweek, The New York Times Magazine, National Geographic Adventure, Esquire,* and others have sent him on assignments.

His first book, *Silence and Solitude, Yellowstone's Winter Wilderness,* won a 2002 Montana Book Award. The video, *Silence and Solitude,* produced by Montana Public Television, earned an Emmy nomination for Tom's photography. *The Light of Spring,* the first book of a four-volume set entitled *The Seasons of Yellowstone,* was printed in 2004. His second book of the series, *The Comfort of Autumn,* was published in 2005. The PBS *Nature* program "Christmas in Yellowstone," featured Tom skiing through the Park and his winter photography.

He donates the use of his photographs to environmental groups, supporting their efforts to preserve wildlife and wild land. In 1984 he graduated with honors from Montana State University with a Bachelor of Science in Anthropology. He lends his backcountry skills to the Park County Search and Rescue team, which he helped to organize in 1982. He was the first person licensed to lead photography tours in Yellowstone Park in 1985, and still offers photography classes in the Park. He also teaches workshops and special seminars for camera clubs, nature centers, and institutions such as the Yellowstone Association and Montana State University.

WILDLIFE PHOTOGRAPHY ETHICS

Good wildlife photography ethics assume that all creatures have a right to go about their lives without interference from us. The best wildlife photographs illustrate what an animal's life is like. How does it make its living? How does it interact with its environment? How does it respond to others of its own species and to different species? How does it play? What are its feeding, traveling, resting, and other behaviors like? If a photographer disrupts an animal's actions, not only is he distracting and modifying the animal's life and potentially causing it harm, he is not going to photograph natural behavior. I am not interested in photographing an animal's response to me. I want to show the beauty and uniqueness of a creature's daily life.

To avoid disturbing an animal's daily routine, it is best to use long telephoto lenses. An automobile is one of the best blinds from which to photograph in national parks. You must observe and understand wildlife's behaviors. Learn to read their body language and if your presence is disturbing them, even 300 yards away, leave at once. I think of myself as a visitor in their living room and try to be a humble and considerate guest.

ACKNOWLEDGEMENTS

A sincere thank you is always necessary for any successful project.

Thank you to Bonnie for her continued love, support, help, and encouragement in my life as a photographer.

To Cindy Goeddel for her untiring help with computers and file preparation under crazy deadlines.

To Edie Linneweber and Janet Bailey for help proofreading.

To Adrienne Pollard for her wonderful work assembling and presenting 30 years of my summer images in this book.

To the wild lands of Yellowstone and to the innocent beauty of all the creatures who live there.